Ian Verstegen

Arnheim, Gestalt and Art
A Psychological Theory

SpringerWienNewYork

Ian Verstegen
The University of Georgia Studies Abroad Program
Cortona, Italy

© 2005 Springer-Verlag Wien · Printed in Austria
SpringerWienNewYork is a part of Springer Science + Business Media
springeronline.com

Product Liability: The publisher can give no guarantee for all the information contained in this book. The use of registered names, trademarks, etc. in this publication does not imply, even in the absence of a specific statement, that such names are exempt from the relevant protective laws and regulations and therefore free for general use.

Typesetting: Camera ready by author
Printing: Börsedruck Ges.m.b.H., 1230 Wien, Österreich

Printed on acid-free and chlorine-free bleached paper
SPIN: 11553045

Library of Congress Control Number: 2005933044

ISBN 10 3-211-28864-3 SpringerWienNewYork
ISBN 13 978-3-211-28864-1 SpringerWienNewYork

PREFACE

When one hears the words, the 'psychology of art,' one is likely to think of the name of Rudolf Arnheim. Because of his great productivity we have been fortunate to hear the latest words of wisdom from this remarkable nonegenarian, almost up to the present day. But while Arnheim the personality is always intriguing, his system risks being left behind. Although Arnheim has remained in remarkable contact with younger scholars around the world, his ideas have risked alienation from their basic gestalt basis. This book is a presentation of the whole unified Arnheim through the lens of a living, breathing Gestalt psychology.

Arnheim's two complementary works, *Art and Visual Perception* (1954/1974) and *The Power of the Center* (1982/1988) will surely hold their own in visual art theory for some time to come. But Arnheim, himself, never attempted to provide a general psychology of art. Nor, it seems, did he presume he ought to. In fact, he once wrote that the book by Hans and Shulamaith Kreitler "may well claim to have established the psychology of arts as a discipline" (1973, p. 647). As much as that may have been true then, it is much less true now. Arnheim has by now written on every subject of the psychology of art and a general approach may be said to exist, if not in one place. This work is an attempt to bring into a single coherent statement this theory.

I began to discern in Arnheim's a unified approach centered on the idea of perceptual dynamics. *The Power of the Center* (1982/1988) raised new problems of theoretical exposition, and suggested that its compositional scheme was the key to this unified approach. Indeed, in *The Dynamics of Architectural Form* (1977) Arnheim suggested that "I have come increasingly to believe that the dynamics of shape, color, and movement is the decisive, although the least explored, factor of sensory expession" (p. 7); this, only three years before the book on composition. This suggested a central model based on 'the dynamics of architecture,' 'shape,' etc.

It gave me the suspicion that *Art and Visual Perception* (1974) could then be abstracted into such a form. This would then free the presentation of general principles (the chapters 'Dynamics' and 'Expression') and developmental aspects (the chapter 'Growth), which could then have their own separate presentation. I began describing my scheme to Arnheim and he reacted with interest, and surprise. It "is like a dam break in the hydraulic system of my work, which for most of my purposes is a system only because I look at items of my work one piece at a a time, whereas you are presenting it as a whole" (Arnheim, 1992b). As I

asked about the holes that had appeared with the scheme I had committed myself to, Arnheim at the same time was busy elucidating what he called the 'keystones,' the elementary ground concepts, of his theory that had been left unstated. The result is what I like to believe to be two highly complementary ventures.

This book began as the labor of an overambitious youngster, inspired by the gentle words of a retired sage-like figure in Ann Arbor, Michigan. I am very grateful to Prof. Arnheim for the generosity he showed me then, and over the ensuing years, providing me with a priceless experience of mentoring.

I brought an early draft of the book to maturity under the encouragment of Tiziano Agostini, Howard Gruber, Kendall Walton and Wolfgang Wildgen, as well as Alan Gilchrist and John Ceraso, the only two teachers of psychology I have ever had. A good push to get restarted was given by Lucia Pizzo Russo, Joseph Glicksohn, Michael Kubovy and Walter Ehrenstein. I wish to thank them all but especially Tiziano Agostini and Wolfgang Wildgen for their steadfast support over many years. To my beloved wife Louise, who has cheerfully come to accept the presence of Arnheim in our lives, I dedicate this book with thanks.

Cortona, Italy Ian Verstegen

TABLE OF CONTENTS

Introduction Why Arnheim? Why Gestalt? *1*

Chapter 1 Arnheim and Different Approaches to the
 Psychology of Art *8*

Chapter 2 Expression, Symbolism and Visual Thinking *19*

Chapter 3 The Senses, Perceptual Objects and their
 Dynamics *25*

Chapter 4 The Notorious Gestalt Brain Model *37*

Chapter 5 The Dynamics of Pictorial, Sculptural and
 Architectural Form *45*

Chapter 6 The Dynamics of Pantomimic Form *57*

Chapter 7 The Dynamics of Musical Form *71*

Chapter 8 The Dynamics of Poetic Form *83*

Chapter 9 Art in Comparative Perspective:
 Children, Adults, Cultures *97*

Chapter 10 The Dynamics of Microgenetic Artistic
 Development *105*

Chapter 11 Individual Artistic Development *115*

Chapter 12 The Dynamics of Differential and
 Psychopathological Artistic Form *125*

Chapter 13 The Dynamics of Cultural-Perceptual Form *135*

Chapter 14 Objective Percepts, Objective Values *141*

Appendix The Life of a Psychologist of Art *151*

vii

INTRODUCTION

WHY ARNHEIM? WHY GESTALT?

As we address Arnheim and his writings today, we are faced with the problem of the exposition of his theories, which has never been attempted, and the other problem of their defense, which is really not possible without some sense of the former problem. The very structure of this book is an implicit ordering of Arnheim's thought. It attempts to order this thought, however, in terms of basic psychology. That is, it seeks to work its way down, ever more specifically, from problems of general psychology, the problem of expression central to perception of works of art, to individual sense modalities that explain them.

It is impossible, however, to rest content with a mere exposition of Arnheim's positions. We are inevitably led to complete our understanding of his theories with the Gestalt psychology of his teachers Max Wertheimer and Wolfgang Köhler. But once this has begun we have to take account of the Gestalt psychology contemporary to Arnheim and ultimately that developing up until yesterday. I find it impossible to discuss Arnheim's views of perception without thinking of contemporary developments in perception, especially as proposed by European scientists working in the gestalt tradition.

This is not only true because one familiar with the work naturally sees the relationship but also because many dismiss Arnheim simply because they regard Gestalt psychology to be wrong, outdated or irrelevant. I will amply show, in the following chapters, both Arnheim's synthetic position and the ways it is bolstered and amplified in contemporary gestalt-style theory. For the time being, however, it is worthwhile to sketch the attraction of the gestalt ideal in the first place, one to which Arnheim contributed, but to which he was also attracted.

It is tempting to ascribe the gestalt position of an 'analytic holism' or else an 'organic materialism' to a unique intersection of ideas fermenting in the Weimar Republic in Germany with Romantic ideas reaching back to Goethe and beyond to Spinoza. Writing of his teacher, Max Wertheimer, Arnheim (1986) wrote how "Spinozistic was the notion that order and wisdom are not imposed upon nature but are inherent in nature itself; of great interest also was Spinoza's idea that mental and physical existence are aspects of one and the same reality and therefore reflections of each other" (p. 37).

But the most exciting thing to Arnheim was the contemporary promise in the sciences of his day. According to Gestalt thinking, the world and the human mind both share principles of

ordering. It is not a matter of imposing order on nature or escaping in our minds an irrational outer world, rather, the ways our minds work is precisely due to the principles that order nature. This thinking is evident in the work on 'physical gestalts' by Arnheim's other teacher Wolfgang Köhler (1920; Arnheim, 1998).

More specifically, Gestaltists hold to a variety of doctrines that are appealing, and for which they have consistently found experimental support. There is obviously the famous gestalt appraoch to perception, about which much more will be said. The incorrect epithet 'the whole is more than the sum of its parts' has been applied to this thinking but the real doctrine is that we perceive the world as ordered, clear-cut and meaningful. This has wide ranging ramifications for Gestaltists who have used ideas of perceptual organization well beyond perception.

Much more than mere perception, an image of humanity attaches to ordered perception. We perceive the bounty afforded by some things and the lack missing in others. The need felt by a helpless child is a command to help. Even in those famous cases which Arnheim's colleague Solomon Asch (1952) investigated, in which a group gangs up on an individual and tells them that an obviously longer line is actually shorter, that person reacts rationally, trying hard to reconcile their basic trust in interpersonal communication with the facts before their eyes. Unfortunately, as so many gestalt doctrines, this has been interpreted beyong recognition as evidence that group pressure can make us do practically anything (Friend, Rafferty & Bramel, 1990).

There is a strong tendency in Gestalt psychology to hold back at the seeming irrationality of findings, whether they be in Freudian rationalization, conformity studies or investigations of the effects of needs and desires on perception, and think through the epistemological consequences of the 'naive relativism' seemingly evident in the results. It is too easy to invoke an irrationalist model of human motivation until we consider what the consequences of our own status as scientists, subject to the same foibles. When we ignore these consequences we commit what the philosopher Maurice Mandelbaum, in an appreciation of Arnheim's teacher Wolfgang Köhler, called 'the self-excepting fallacy' (Mandelbaum, 1984; Verstegen, 2000b). In fact, we soon discover that such irrationalism is not as rampant as we think and it is much more interesting and representative of the real world to consider the balance of objective input and personal motivations that propel us.

There is no strong gestalt movement today in social psychology but numerous studies throughout the field show a consistency with gestalt interests and give further impetus to the image of humanity propounded by the Gestaltists. The brilliant work on altruism and the environment as a cause for motivation by Michael

and Lise Wallach as well as Henri Zukier is a case in point (Wallach & Wallach, 1983; Wallach & Wallach, 1990; Zukier, 1982). These works confirm in a larger sense what I wish to confirm for Arnheim and perception. The gestalt school has a necessary scientific message to import that uniquely solves many important problems.

Unfortunately, as in the case of social psychology, the aims of Gestalt psychology have been misunderstood in perception. The most common response is ignorance. The hopeful starts of the gestalt school were not quantifiable, it is argued, to make a lasting impression on the field, which had to wait for the cognitive revolution. A more positive interpretation has been offered by David Murray, in his recent book, *Gestalt Psychology and the Cognitive Revolution* (1995). He argues that many principles championed by the cognitive revolution, including cogntive schemas, organization and prototypes, were first discovered by gestalt psychologists.

While often true, this interpretation fails to account for the lack of recognition of Gestaltism by the pioneers of Cognitive Psychology. In fact, the scientism or positivism of Cognitive psychology set it apart from the aims of Gestalt psychology, and this very quality has more in common with the spirit of Behaviorism that Cognitivism is universaly considered to have replaced. More skeptical interpretations of Cognitivism have emerged from the Gestalt camp (Vicario, 1978; Henle, 1990), not least from Arnheim. The need for control, prediction and immediate operationalization of contemporary psychology is alien to the aims of Gestalt psychology.

Now is probably the first time that an adequate defense of Gestaltism has been able to emerge. After the sometimes-curmudgeonly defenses of Gestalt positions by Arnheim and others, a new generation with a new objectivity has emerged to honestly examine some of the main precepts and assumptions of psychology and its theoretical underpinnings. Foremost have been anti-representationalist philosophers of mind who look to phenomenologists (especially existential, like Heidegger and Merleau-Ponty), from which the advantages of the allied Gestalt viewpoint naturally emerge (Petitot, Roy, Pachoud & Varela, 1998).

Unfortunately, psychological thinking on art has bifurcated into a technical and often unenlightening perceptualism (Solso, 1994; Zeki, 1999) and a speculative Freudianism. Perceptual psychology's inability to address meanings is nowhere clearer than in its discussions of visual art. Normally, little more is accomplished than pointing out percepual mechanisms or illusions in actual works of art. There is a new interest in looking at questions the way Arnheim proposed, and a new conviction that he and Gestalt psychology were on the right track. To this conviction this book is addressed.

3

Its structure is basically divided into three parts: foundational principles, these principles applied to the various arts, and then the developmental aspect of art. Of foundational principles, the next chapter discusses "Arnheim and Different Approaches to the Psychology of Art." Regarding the desirability of an Arnheimian psychology of art to be dependent on our definition of psychology, an attempt is made to first define this in reasonable terms, and see where Arnheim fits in. After discussing the virtues of a *perceptual* approach to art, a distinction is made between 'Cognitive Nativism' and 'Cognitive Inferentialism,' the two dominant schools of perceptual research today. Introducing the Gestalt alternative, I face the question of the degree to which we can say that a Gestalt school still survives. Then, after addressing the tenebility of its central principles of Relational Determination and Simplicity, I sketch the work of other researchers whose Gestalt works on the arts complement those of Arheim.

Chapter 2 goes on to address concepts that are important for all psychology, but particularly important for the psychology of art, namely, the concepts of "Expression, Symbolism and Visual Thinking." Beginning with the idea of emotion as a functional relationship between subject and object, we first must grant a phenomenal reality to expression. Then, a psychology of structural similarity (isomorphism) underlying expression, metaphor and symbolism is possible. Metaphor arises because of differences in juxtaposed levels of abstraction and symbolism. The abilities to recognize the commonality of genera is abstraction. The gestalt doctine of singularity (prägnanz) accounts for abstracted saliences in perception. On the other hand, when these singularities are instead sensibly compared and manipulated, on their way to a new order, productive – or as Arnheim (1969) calls it, visual – thinking occurs.

Chapter 3, "The Senses, Perceptual Objects and their Dynamics," addresses the fundamental differences between seeing and hearing as a foundation for the arts expressed in those modalities. Nevertheless, in spite of differences, general gestalt principles of organization – Wertheimer's famous laws – can be applied generally. Arnheim in *The Power of the Center* has proposed a simple system of perceptual centers generating dynamics between them, and bounded by various formats, a surprisingly powerful system. Arnheim's theory of composition, then, becomes a more specialized account of perceptual dynamics. This is the basis for the rest of the book.

First, however, Chapter 4 addresses the "Notorious Gestalt Brain Model," the model proposed by Wolfgang Köhler that has been universally dismissed and with it the entire Gestalt school. While criticizing the particular way in which it was presented, the

overall spirit is defended and much confirmation for it is found in current work on brian modeling and dynamics. I conclude that such an approach cannot be done away with, for its monistic spirit drives the things that is most attractice about Gestaltism, its monistic naturalism.

Chapter 5, "The Dynamics of Pictorial, Sculptural and Architectural Form," begins the second part of the book, the discussion of individual media. These are not concrete media, like 'painting' or 'cast-bronze sculpture,' but abstracted modalities of (1) envisagement, sculpture, architecture and more. This chapter includes the three visual modalities. Pictures contain shapes, which are perceptual centers. These develop meaning within the confines of the format, the frame, page or whatever. The object can be an object in its own right when the format becomes the environment around it. Sculptures are centers containing sub-centers but the format is instead the virtual axis created by the vertical. Buldings, finally, are complicated by the fact that they (and their sub-centers) are inhabited, creating a constant interaction between inside and outside, plan and flow, elevation and outside aspect. The building itself, as a center, then interacts with the landscape or urban fabric.

Chapter 6, "The Dynamics of Pantomimic Form," discusses the psychological principles underlying visual action. 'Pantomimic' is intended to capture both real ('absolute') movement, in which a single body is observed in continuous space, and 'edited' movement, made possible by the technology of film, video and animation. Of absolute movement, we have dance and acting, and both interact with the format of the stage. Similarly, edited action has the frame of the film to work with.

Chapter 7, "The Dynamics of Musical Form," applies Arnheim's ideas to music. Tones are centers that derive meaning from the kind of scale they interact with. In the western diatonic scale the major and minor modes of the scale are the clearest means to work with. The arbitrary tonic chosen then chains the tones to the recurrent ordering of the scale. The tone moves up this scale and down it, as a coming-toward and a moving-away-from, with attached notions of striving and rest. Harmony, instead, is a 'vertical structure' that similarly moves with the composition. Together with the meter, phrase dynamics are developed, and larger compositional orderings.

Chapter 8, "The Dynamics of Poetic Form," applies the dynamics of centers to language. Language can be more (memento) or less (message) poetic. It has numerous layers, the visual, the tonal, the syntactic and semantic. Verbal dynamics mitigate between stable centers of nouns and pronouns. Against the background of a verson of the Interaction Theory of Metaphor, poetic meanings develop in complex interaction of juxtaposed mental

images that draw out new meanings. Larger structures emerge too with degrees of centeredness and diffuseness, helping determine the style of the work.

The third part of the book treating development begins with Chapter 9, "Art in Comparative Perspective: Children, Adults, Cultures." This chapter critically introduces the place of development within the gestalt tradition, challenging the view that Gestalt theory cannot model such phenomena. Reflecting on a theory of development as perceptual differentiation, the gestalt view is distinguished from Werner's and Piaget's related approaches. More particularly, Arnheim's inspiration in the works of Gustaf Britsch is discussed. A reconstruction of Arnheim's general theory of artistic development is undertaken to affirm its generality but not over-specification of the path of growth.

This leads directly to the discussion of short-term development, Chapter 10, "The Dynamics of Microgenetic Artistic Development." Various tasks like artistic problem solving are modeled on the gestalt concept of microgenesis. Perceptual microgenesis is a fact of perception, the qualitative unfolding of percepts over very short durations. It shows a structure of increasing differentiation that is useful for discussing creative thought. Such problem solving takes a similar route, but is regulated by the motivational desire to decrease tension. There can be forward moves and backward steps, and these can be modeled as dynamic cases of satiation and then reorganization. Case studies from Arnheim's discussions of writing poetry and Picasso's working habits are presented.

In Chapter 11, "Individual Artistic Development," Arnheim's theories of childrens' art are framed within a life-span perspective of continuing artistic differentiation. In general, the individual passes from a perception and depiction of generalities to a conquest of reality, and finally a contemplation of that reality. Motivation drives the artist over their life-span with a desire to make their actions correspond with their self-image. The earliest stages of artistic production are outlined from Arnheim's writings on child art, and supplemented with the writings of Claire Golomb and Lucia Pizzo Russo. The importance of the *representational concept* is reiterated, and the necessity of a theory of differentiation that does not commit the intellectualist error in regarding circles as concrete objects but instead generic 'things.' The development of objects and compositions are outlined, with fruitful analogies to the compositional principles of *The Power of the Center*.

Individual differences and pathologies are next considered in Chapter 12, "The Dynamics of Differential and Psychopathological Artistic Form." The individual is modeled as a dynamic system with certain systemic tendencies that can determine individual differences. The consequences for the creativite individual are

sketched, as supplemented with the consonant theories of Michael Wallach and Howard Gruber. Next, organic psychoses are discussed with the particular case of autism, and functional psychoses with the case of schizophrenia. Although unrelated etiologically, the artistic productions of the two pathologies represent an interesting hypertrophy of the basic formative principles of art making. Finally, neurosis and art therapy is treated. The mandate to make the reality of the patient's artwork conform to the shared reality of sanity is stressed.

Chapter 13, "The Dynamics of Cultural-Perceptual Form," is a discussion of the effects of culture on the creation and reception of art, without suggesting that cultures develop according to any particular pattern. While cultures select for diverging perceptual skills according to ecology and institutional practices, the important thing is that skills and the kinds of art that result from them, are lawfully determined. This point has been underutilized in discussions of art and culture.

In the final chapter (14), "Objective Percepts, Objective Values," the preceding three chapters are used as temporal frames of reference to analogize to the gestalt nature of the spatial frame of reference utilized in the second part of the book. In this way, potentially relativizing aspects of perceptual learning – set, emotion, mental development, personality and the like – are isolable and help one discover the 'objective' percept. This then leads one to objective values, which are the reason art has a part of our lives in the first place. Arnheim argues that values are always instrumental and require that we specify the context in which we find value. Value can be discovered, and confirms the role of psychology as an underlaborer in the understanding of cognitive life.

CHAPTER 1

ARNHEIM AND DIFFERENT APPROACHES TO THE PSYCHOLOGY OF ART

The 'psychology of art' attempts to apply psychological principles to art. Psychology is – or attempts to be – a 'science,' and so the psychology of art is the application of scientific 'principles' of psychology to art. Aesthetics and all 'critical' approaches to art are (typically) based on principles of logic and argumentation, and in this sense, the psychology of art can never be the *only* approach to art. To be sure, many have turned to psychology as a way of getting away from the subjectivity of 'mere' aesthetics, but based upon a division of labor, there are certain matters upon which psychology can never make the final conclusion. Perhaps the best we can hope is the injection of psychological debate into aesthetics; but psychology will not envelop aesthetics, as Comte hoped sociology would envelop history.

Terms like 'science,' and 'psychology,' are by no means self-evident principles. Even a synthetic definition has the advantage of providing a standard of consistency within a particular work, regardless of the fact of its truth. Here, 'science' is defined as the systematic, experimental search for universal principles applicable to the organic and inorganic world. 'Psychology' is the scientific search for universal principles applicable to human behavior (Mandelbaum, 1984, pp. 158-170).

In our definition, psychology differs from sociology in the fact that the data studied by sociologists (when they are truly sociological) are based upon how societies differ from one another; psychology, on the other hand, possesses data applicable to everyone (Mandelbaum, 1984, pp. 171-183). To take the example of socialization of class, class itself is sociological, whereas the universal way in which individuals adapt to roles and norms of society is psychological. The psychology of art leaves to the sociology of art analogous problems. How an artist's guild arises in a society is a sociological question, how an artist deals with individuality and conformity to guild structure might in large part be psychological.

The psychology of art is as old as psychology itself. Gustav Theodor Fechner, one of the founders of the psychophysical method, published his *Vorschule der Ästhetik* in the mid-nineteenth century in which he reported studies on preferences for forms. As Arnheim (1980) has written, at least three of the earliest, influential texts on aesthetics were by psychologists. In addition to Fechner's *Vorschule*, these included Theodor Lipps's *Ästhetik* (1901) and Herbert Langfeld's *The Aesthetic Attitude* (1920). As we shall see

8

shortly, some of these original approaches are still exerting influence in the present day psychology of art.

It is my contention that Arnheim's perceptual psychology of art serves a fundamental need in studies of the psychology of art. We need such a psychology of art because until a rigorous psychology exists for the simple level of perceiving, it will be difficult to apply more developed principles that rely on more fundamental levels of psychological functioning, like the personality and processes of motivation. Arnheim's many criticisms of psychoanalytic interpretation can be seen in this way. That is, he reacts to it the way he does not so much for its inferior explanation for an identical phenomenon, but rather because of its scientific positioning.

Psychoanalysis deals wth the working of the unconscious in the artistic works of artists. Psychoanalytic theories have come a long way from so-called 'vulgar Freudianism' in which pointed objects are interpreted as phalluses, and concavities as female genitalia. These theories, in which everything was straight-jacketed into the schematism of the Oedipal situation, were criticized by Arnheim many years ago.

One of the most fruitful avenues to pursue lately is object psychology. Melanie Klein shifted attention from the Oedipal situation to the pre-Oedipal world of mother-child relations. Adrian Stokes has been the most significant to apply her ideas. Also important in object-theory is Winnicott's idea of transitional objects. Peter Fuller, Richard Kuhns, and J. Randolph have suggested uses of such Winnicottian ideas and Arnheim (1992, p. 13) has even admitted that works of art can be treated as such 'transitional objects.' Finally, there is the theory of Jacques Lacan and his followers.

What Arnheim would object to is a somewhat naive epistemological idea common to many psychoanalytic treatments that sees unconscious drives as working blindly without feedback from the environment. Furthermore, Arnheim has been disappointed with the inability of most psychoanalysis to respond to the greatness of works of art. Arnheim points out that Freud saw his theories most applicable to popular art, as for instance, pulp novels, and the like. In "Creative Writers and Day-Dreaming" (1908/1985), Freud saw the dream as a case of wish-fulfillment, and compared works of lesser art to similar kinds of wish-fulfillment.

Because Gestalt psychology attempts to explain many aspects of meaningful perception at an elementary level, it promises to serve as an important fundamental level of analysis. If, as Arnheim argued many years ago, a round form represents for a child 'thingness,' it cannot be interpreted as representing some other idea that psychologists might like to foist upon the child. Without a psychology sensitive to such factors, the speculative psychologist

9

will operate at a level of generality that is too great to exhaust certain formal characteristics of the work that are necessary to dispense with before further speculation is possible.

Therefore, regardless of whether we follow Arnheim and use Gestalt psychology, perceptualism is extremely important for the psychology of art. I shall review the contemporary situation in perception, but first let us ask how much of a right we have seeking out some kind of gestalt appraoch today.

Cognitive Nativism vs. Cognitive Inferentialism

If Arnheim's theory can be classed as a perceptualist approach to the psychology of art, there are distinct advantages it has over other approaches. For one, Gestalt theory's blending of realism and the formative power of the human mind strikes a compromise between two extreme perceptual views that I am calling Cognitive Nativism and Cognitive Inferentialism. Some of the theories I will be discussing are not often classed together and our failure to think of them together has blinded us to the real advantages of gestalt theorizing. But when the alternatives are cast in the way that I shall cast them, then the gestalt alternative emerges almost as a necessary antidote.

Cognitive Inferentialism and Cognitive Nativism are different ways to name Helmholtzian inferentialism and Gibsonian direct theory, the two alternatives in perceptual theorizing. But the terms are chosen to widen the net. Take Gibson's theory for example. He has a particular theory of perception that emphasizes the direct perception of reality through the 'pick-up' of invariants in the environment. But this approach is also compatible with sensory-physiological theories of perception based on lateral inhibition (Jameson & Hurvich, 1975; Jameson, 1989; Ratliff, 1992). Chomskyan innatism and also the ethology of Konrad Lorenz are compatible. All three theorists stress native abilities and while the latter two believe in some kind of rationalism, the important point is that each stresses unlearned abilities and the sufficiency of stimulation for perception and thought.

Likewise, Helmholtz's theory is based on 'unconcious inference' which in Helmholtz's own guise was based partly on judgment and past experience but has been rehabilitated by Irvin Rock, Julian Hochberg and Richard Gregory to work on the computation of incoming stimuli. But the approach is also similar to various theories emerging from the Cognitive Sciences. One of the virtues of this classification, in fact, is to stress that the promise of Gestalt psychology was not necessarily fulfilled with the cognitive revolution. 'Cognitive' can mean many things. But regardless, Inferentialism argues for the lack of sufficiency of perception to guide perception and thought, hence cognitive operations.

10

There have been many criticisms pointed at both schools, loosely conceived. The Gibsonian school is anti-naturalistic in not wishing to discuss physiology and neural functioning. It is simply bracketed out, until an 'ecological optics' can be developed (Prentice, 1951; Arnheim, 1952; c.f., Epstein & Park, 1964; Epstein, 1977; Proffitt, 1999). Problems remain when perceptual phenemona like lightness and co-planarity are 'coupled' and are not picked up directly by stimulus relationships (Epstein, 1982). An interesting fact, unforeseen by Gibson, has recently come to light. With all his emphasis upon higher order variables, Gibson never stopped to consider that higher order variables, themselves, could be ambiguous in the sense that first order variables are. But after examining the projective geometry of certain stimulus arrays, Cutting (1986) has found that there are often multiple higher order variables, and that the visual system still has to choose between them.

But there are further problems, more closely aligned to art itself. If for Gibson sensation is all there is, we wonder then what space is left for imagination and the free play of thought. In fact Gibson has had a notoriously difficult time discussing anything other than representational art (Arnheim, 1979). Followers of Gibson like Hal Sedgwick and Sheena Rogers (1996) have used the horizon-ratio relation to investigate pictorial depth in pictures to great effect. However, when we are not seeing a naturalistic rendition of a scene the theory has little to say. The simplicity solution in perceiving allows the human mind to see new relationships in what are admittedly non-adaptive stimuli.

For the Inferentialists, the amount of processing is just too immense. And there is always the problem of the homonculous; who is directing the cognitive operations? If perception is like solving a problem, who determines that it is a problem (Kanizsa, 1985)? On the other hand Inferentialism can discuss most aspects of art, but that is precisely the problem. New cognitive operations and taking-into-account can always be hypothesized and modeled.

Gestalt psychology defines perception as a problem of perceptual organization. Depending on prevailing conditions, the stimulus is organized into the simplest percept (according to known laws of physics). This makes perception neither cognitive nor homoncular, nor ungrounded in physical principles. While the concept of organization has always been accused of being vague, it has advantages over both Gibsonian and Helmholtzian approaches, and especially in the areas they cannot explain. Both simple images under reduced conditions of stimulation and rich images with ocularmotor cues absent can be handled with relational information organized according to a simplicity principle.

11

At the most elementary level, say, with two points of light moving perpendicularly to one another, the theory simply predicts that the two will be seen to be moving toward and away from each other. As complexity increases, the number of higher order variables likewise increase (and we recall that Gibson got this idea from Koffka, his senior colleague at Smith College for several years). Here oculomotor cues become irrelevant because there is so much relativistic information available. In this way, impoverished laboratory situations as well as everyday perception can be explained.

Here what is usually described as a flaw in Gestalt theory is actually its strength. What I call below the "notorious brain model" (ch. 4) of Gestalt psychology usually discounts it from serious consideration. But reflection on molar physical processes capable of reflecting isomorphically units of perception and behavior was intended to bridge precisely the gap between the realism-without-mechanisms of the Gibsonian school and the infinite-regress-of-processing of Inferentialism.

Moving on to the arts, the gestalt approach has other distinct advantages. The sensory-physiological school works with mechanisms that are simply too primitive to be the carriers of the depth of content of works of art. Helmholtzian theory does not have this problem because associatons and knowledge can be called into play in interpretation. But this goes to the point of triviality, because both normal perceiving and understanding a great work of art are no different. Gibsonian theory has troubles in that being so literalistic, it is only comfortable with naturalistic art. Simple percepts found in non-representational painting are analogous to those experimental set-ups hated by ecological theory. But Gestalt psychology can not only explain their perception, but also point to the ways in which meaning can arise in them.

Alive or Dead? The Gestalt Approach to Perception

All would agree that Arnheim practices a 'Gestalt Approach to Perception,' but beyond his own ideas can such a 'Gestalt approach' be said to exist? I believe it does and that it is necessary to expose it so that Arnheim's writings make sense and find their defense. In fact, whenever Gestalt theory has defended itself against attacks (Köhler, 1959; Luchins, 1953; Rock, 1960; Henle, 1990), this has indicated that at least some scientists considered themselves 'Gestaltist.'

As a matter of fact, the survival of the Gestalt movement has been in question since the untimely deaths of Koffka and Wertheimer in the 'forties. Around 1960, Wolfgang Metzger responded to the charge that the Gestalt approach to perception was 'überholt.' Since the retirements of Metzger's second generation of Gestaltists, the rubric has progressively weakened.

I would like to try to demonstrate that the Gestalt approach has historically been a unified approach to perception. This can be accomplished by reviewing a little history. First of all, no one questions the unity of the school previous to 1945, that is, previous to the end of World War Two. But as already mentioned, during the war Koffka (d. 1941) and Wertheimer (d. 1943) passed away. And even though Kurt Lewin (d. 1947) is most clearly associated with social psychology, his passing soon after the war served to weaken the unity of the school.

Köhler, himself, continued publishing into the 'fifties and 'sixties. But by this time his students carried on the work of the school. Köhler's students, like Arnheim himself, included 'Gestalt' in the title of scientific papers. Arnheim, Hans Wallach – representing those trained in Berlin – as well as Solomon Asch, Mary Henle – all contributed to the *Sourcebook of Gestalt Psychology* (Henle, 1961).

In America, Wallach was only joined by William Prentice (c.f. 1951, 1956, 1959) and Nicholas Pastore (c.f. 1956, 1960) as true perceptionists associated with the gestalt school, and this would seem to weaken the idea of the continuity of the school. Characteristically, Prentice eventually left experimental psychology for university administration, but not before contributing the important, "The systematic psychology of Wolfgang Köhler" (1959). But this is to ignore Europe – particularly Germany and Italy – where Gestalt psychology flourished during this time, and Arnheim was very close to his colleagues in Europe.

In Germany, Wolfgang Metzger, Edwin Rausch, Wilhelm Witte, among others, remained through and after the Second World War. Already in 1936, one year after the publication of Koffka's *The Principles of Gestalt Psychology*, Metzger published the first edition of *Gesetze des Sehens [The Laws of Vision]* (1975), which would see two more editions (1953 and 1975). Furthermore, in 1941, he published his general text, *Psychologie*, which also went through several editions (Metzger, 1941). Around the same time, Edwin Rausch published one of the most definitive works on geometrical illusions, *Struktur und Metrik figural-optischer Wahrnehmung* (1952).

In Italy, the Meinongian Vittorio Benussi had taken a post after the First World War, and introduced experimental psychology into the country. His student Cesare Musatti took over the chair in Padua, which Benussi had occupied before his suicide. There, Musatti steered his ideas in the direction of the Berlin gestalt theory, and through his students and near contemporaries – Fabio Metelli and Gaetano Kanizsa – formed a triumvirate of researchers.

By the 'fifties, Musatti in Milano, Metelli in Padua and Kanizsa in Trieste formed the nucleus of Italian Gestalt psychol-

ogy. Needless to say, the German and Italian psychologists were extremely close and it is said that Metzger – somewhat reminiscent of Koffka coming up to Berlin from Giessen (c.f., Heider, 1983) – would visit from Germany and tour the laboratories of Metelli and Kanazsa with his friend, Musatti. While Musatti left experimental psychology in the 'fifties for more speculative work, Metelli and Kanizsa remained to represent Gestalt psychology (Verstegen, 2000a).

In the late 'fifties, a new generation of students began appearing – the theoretical 'grandchildren' of Wertheimer, Koffka and Köhler. In America this was primarily at the New School for Social Research, where Arnheim taught along with Solomon Asch, Mary Henle and Hans Wallach. In Germany, the psychological Institute of the University of Münster was the center of Gestalt psychology, where both Metzger and Witte taught. And as mentioned before, Metelli was in Padua and Kanizsa in Trieste.

Notable American students were Dorothy Dinnerstein and Irvin Rock, who were the first to earn their doctorates at the New School after the Second World War. Other students were John Ceraso, Sheldon Ebenholtz, and William Epstein. In rare cases, students like Ceraso – who was a research assistant to Solomon Asch at Swarthmore – had direct contact with Köhler. In the mid-sixties, doctorates were granted by the Institute for Cognitive Studies, Rutgers, where Asch, Dinnerstein, Howard Gruber, and Rock taught.

It is characteristic that probably none of the students of the so-called 'New York school' would call themselves 'Gestaltists,' in sharp distinction from their European counterparts. Ceraso might be an exception, and Alan Gilchrist, a product of Rutgers, recently entitled a paper "Developments in the gestalt theory of lightness perception" (1990).

In Münster, the most importants students of Metzger's were Suitbert Ertel, Lothar Spillman and Michael Stadler. In Italy, Paolo Bozzi, Walter Gerbino, Osvaldo da Pos, Marco Sambin, Giovanni Vicario and Mario Zanforlin, and all began to publish their experiments. It might be said that the Europeans watched with great interest the emergence of the American cognitive revolution. Much of it must have seemed superfluous to them, who were possessed of a greater sense of the history of psychology (Verstegen, 2000a).

The Americans reaction can be attributed to the unsuccesful cultural transmission of the gestalt school to America. Gestalt psychology always seemed mysterious, and unscientific to them. Even older psychologists like Fred Attneave and Wendell Garner shared this view (c.f., Henle, 1990). Perhaps if they had the intimate knowledge of the earlier and subsequent German literature that Carroll Pratt or Harry Helson had, they would have had different opinions.

Be this as it may, none of them accepted the gestalt name. Some, such as Irvin Rock, seem to have devoted their entire professional careers to coming to terms with their New York training – Rock, most recently, reverting back to a pure Helmholtzian position. But one finds that if one compares the work of some of these non-gestaltists, their work is indistinguishable from Europeans of the same age.

William Epstein (1977, 1982, 1988, 1995; Epstein and Park, 1964), for example, would not call himself a gestalt psychologist, but his thoughtful reviews of theoretical issues in perceptual psychology since about 1960 follows the development of European gestalt theory itself. His consistent positioning between old-style inferential theory and direct realist, ecological theory is exactly paralleled in gestalt theory.

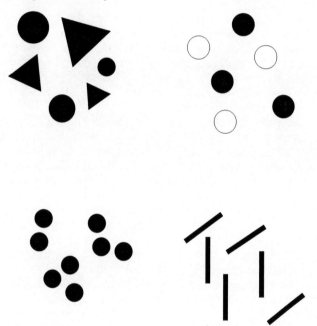

Fig. 1, Wertheimer's laws as instances of grouping by similarity, after Arnheim (1974)

Gestalt psychology has experienced a revival, sometimes under the adoption of the so-called 'Cognitive Revolution.' However, one still finds misunderstandings and a condescending opinion by those emerging from the computer and cognitive disciplines. Arnheim has had no small part in trying to correct matters, emerging as a major interpretor of the gestalt tradition (Arnheim, 1986b, 1992, pp. 200-214; Perkins, 1986). A rapproachment is

15

being accomplished by scientists who are coming to appreciate their historical ties to Gestalt psychology in their schooling as well as by other scientists, mostly American, who are trying to understand the true meaning of the gestalt tradition. Examples are Michael Kubovy (1986) and Stephen Palmer (Robertson, 1987).

Relational Determination and Simplicity

Gestalt psychology won its reputation with shape perception, and every introductory textbook of psychology describes Wertheimer's famous 'laws of visual organization' (Wertheimer, 1923/1939). Wertheimer enunciated a number of laws – such as the law of shape, color, proximity and orientation – although as he said in his text he was only outlining general principles that were in no sense absolute. Arnheim (1974) reinterpreted these as instances of a common principle of *similarity* (**Fig. 1**).

More important to Wertheimer was the concept of *prägnanz*, or the clearcutness or pithiness of visual forms. In other words, given a particular stimulus configuration, we tend to see the most clearcut, pithy, organization possible. Individual laws are only subordinate to this general principle. Köhler hypothesized that the brain was directed by energy minima and this has come to be known as the 'simplicity principle.'

The principle of prägnanz has been accused of being vague and mysterious. Arnheim tried to help matters. But Erich Goldmeier (1982) has revitalized the theory so well that any criticism should take cognizance of his theory, and only then can a criticism be properly leveled. Goldmeier takes advantage of the translation of singularity, which means that a prägnant form is singular in the sense that it is the form to which other forms are similar, and not vice versa. The mysterious tendency toward prägnanz is nothing more than the tendency toward stability.

The tendency toward stability in the phenomenal field is also a product of a tendency toward stability in brain processes. The simplicity principle has been subjected to various attempts at a metric (Hochberg, Attneave, Leeuwenberg) and has been accused of being vague because it is difficult to decide on an area where this simplicity is applied. There is a strong *ad hoc* quality to the simplicity principle but it has also been fruitfully defended (Hatfield & Epstein, 1985).

The substance of the gestalt theory of figural perception can be summed up in the concept of relational determination based on the field metaphor (Koffka, 1935; Witte, 1966; Metzger, 1975, chapter 18; Rock, 1990). Gestalt psychology has been led by the field metaphor, and the determination of perceptual effects by the state of the rest of the field. Thus the way in which a line is perceived is based upon the influence of the surrounding stimuli.

16

Gestalt psychologists have gone on to explore all of the traditional problems of figural perception and proposed and experimentally tested their explanation based upon relational determination. As Rock (1990) has pointed out, some phenomena are more easily treated with the concept than others, but on the whole it is a fruitful concept for their explanation. It continues to be important, for example, in the explanation of figural illusions (Erikson, 1970) and anomolous figures (Sambin and Pinna, 1987).

Recently, dynamic principles have become the centerpiece of the theory of perception of Steven Lehar (1999), who bases the emergent form of an anomalous contour of a Kanizsa triangle, for example, on the action of vectors (**Fig. 2**). These various models are all based on vectors in a field and with this in mind it can be seen that Arnheim has basically provided his own interpretation of Wertheimer in his *The Power of the Center* (1982/1988). This will be outlined in the next chapter.

Fig. 2. The creation of an anomalous contour (from a Kanizsa triangle), according to Lehar (1999)

Toward the Explanation of the Meaning of Art

When we think of Gestalt psychology and art, we immediately think of Rudolf Arnheim, who has already been mentioned. But the basis of a gestalt approach to art goes back even before him. All of the founders of Gestalt psychology, which included Arnheim's teachers, had theories of the psychological foundations of the arts (Koffka, 1940). Among these we must mention Johannes von Allesch, Erich von Hornbostel, Max Wertheimer. There was also a notable school of art history, which focused on problems of visual structure and color relationships (Kurt Badt, Otto Pächt, Hans Sedlmayr, Ernst Strauss) (Verstegen, 2004).

Along with Arnheim, the most important commentators of his generation were Victor Zuckerkandl and Carrol Pratt (Arnheim, 1975). Arnheim's remarkable longevity and the distrust of 'schools' in the scientific temper of America has discouraged any followers of Arnheim in America (Verstegen, 1996). Notable, however, is Claire Golomb at the University of Massachusetts, who

works on children's art (c.f. ch. 11). In Europe, however, one must take note of the writings of Alberto Argenton (1996), Augusto Garau (1984/1993), Manfredo Massironi (2002) and Lucia Pizzo Russo (1988, 2004) in Italy and Max Kobbert (1986) in Germany (c.f., Bonaiuto, Bartoli and Giannini, 1994). The semiotic work of Fernande Saint-Martin (1990) is indebted to Arnheim, and utilizes a dynamic methodology very amenable to Arnheim. I shall draw frequently on these works in the following, which point to a vigorous and lively research tradition that is almost unknown in America.

CHAPTER 2

EXPRESSION, SYMBOLISM AND VISUAL THINKING

With the general outline of Gestalt psychology made one can move to the realm closer to art proper. Indeed, some critics have charged that there is nothing wrong with Gestalt psychology but rather the way it is presented by Arnheim that is at fault. Much of the benefit of the gestalt approach is its ability to deal with problems of expression.

Many use the arts to enlighten aspects of object perception but the real domain of the psychology of art, the part that shows how a psychological model can do justice to the profundity of the human mind as well as its artifacts, is expression. But there is still a gap between the symbolic and expressive life of people and their creations.

How is emotional life related to the experience of objects? Is it independent or is it related; is it dominating or parasitic? To begin we can insist on some sub-stratum of meaning that operates cross-modally. One of the most utilized methods of attacking this expressive life is with the tool of the semantic differential. Developed by Charles Osgood (Osgood, Suci & Tannenbaum, 1957; Osgood, May and Miron, 1975) and put to good effect in his neo-Behaviorist psycholinguistics, it is a useful tool. In the work of Dan Berlyne and his school it has been used extensively for understanding expression. And the gestalt psychologist Suitbert Ertel actually worked with Osgood, producing impressive variations on the semantic differential technique (Ertel, 1964, 1969).

Although it is a powerful statistical tool, some important criticisms have been leveled against the technique by gestalt-oriented psychologists based on its irrationalist bias. Work by Dean Peabody (Peabody & Goldberg, 1989) has pointed to its inability to separate descriptive traits from emotive traits. Since descriptive traits are cognitive, it fails to show how emotion derives from cognition. Ertel's and Peabody's insights ought to be brought together to form a more adequate statistical tool that can uncover real underlying structural patterns, rather than statistical artifacts.

More promising is some sort of multi-dimensional model of expressive lexical terms based on psychological poles of real phenomenological meaning. Arnheim (1962/1966) distinguished three levels in the perception of affects. First, he identifies a crucial cognitive stage of the identification of objects. This could correspond to the affect as it is experienced. Then, there is the expressive and motivational component, which are identical. This could correspond to the perceptual expression which is available to other perceivers. Finally, there is the 'emotional,' the level of tension of the

act as it is perceived by the person themself. The positions of the psychologists of emotion, Joseph De Rivera (De Rivera, 1977; De Rivera & Grinkis, 1986) and Bernard Weiner (1986) are in large agreement with Arnheim. From the computational side of psychological research, there are interesting corroborating developments (Thagard & Nerb, 2002).

They, like all gestalt thinkers, take it for granted that an affect is fundamentally a relationship between two things (c.f., Asch, 1952; Heider, 1958). It is no accident that Arnheim's model in *The Power of the Center* treats centers and their eccentric centers almost on an individual model. Just as individual affects arise in relationships between people ('anger,' 'disgust'), so too artistic expression arises in the vectoral relations between centers. And just as affect is the perceived attributional relations between actors, expression is the outcome of perceptual organization of perceived units.

In his essay, "Emotion and feeling in psychology and art" (1966), Arnheim is always careful (as I was above) to use the rationalist term *affect* that is found in Descartes and Spinoza. 'Emotion' was left as a subsidary level of excitement pertaining to the rational basis of affect. Arnheim's reforms have not been followed in general psychological theory where the term 'emotion' retains its popularity, however, they are particularly apropos in artistic studies because when we view art, we do not experience genuine emotions.

This terminological precision points to Arnheim's dissatisfaction with a term like 'aesthetic enjoyment' or 'aesthetic emotion.' These trace aesthetic experience back to hedonistic interpretations of art. But if art is a much more serious matter, concerning cognitive material, then the semantic message rather than a mere sensation is at issue.

Expression
It is a feature of Gestalt thinking to grant the expressive value of percepts. The world issues a 'requiredness,' and expressive qualities communicate this. Thus Gestaltists have tried to elevate the mistakenly named 'tertiary qualities' (Pratt, 1962; Bozzi, 1990). Gibson's idea of affordance has tried to retain something of this meaning but characteristically the meanings it has captured are largely literal. Gibsonian affordance tells us when we see a woman but they cannot make us feel, as Koffka said, 'Love me.'

There has been little effort to grant the inherent expressiveness of artistic form. The rebirth of empathy theory (e.g., Crozier & Greenhalgh, 1992) simply shows how scientists are only willing to look elsewhere to grant expression. Recently, Arnheim (1988b) invoked the research of Heinz Werner's 'sensory-tonic' theory of perception (e.g., Werner & Wapner, 1954) to bolster his own, but

once again this location of expression in the tonus of the body and not in percepts themselves is unduly weakening of his true position.

In the same way that Arnheim is suspicious of emotion and feeling, he is suspicious of an uncritical invocation of physiognomic perception as the basis of the arts. This marks a difference between Arnheim and theorists he and Gestaltists are often grouped with, like Heinz Werner. Physiognomic perception, while certainly quite real, implies regression, syncretism and instead Arnheim nominates metaphor-like processes that recognize the isomorphic structural qualities of diverse sensory situations (ch. 9).

Arnheim does not derive metaphor from physiognomic perception but rather vice versa, physiognomic perception from metaphor (Glicksohn & Yafe, 1998). In this he shares similarities with recent work by Michael Wallach, Nathan Kogan and George Lakoff. Arnheim would agree with Wallach and Kogan's (1965) statement that "to respond to the physiognomic properties of things and events involves an act of metaphor, an act of simile, or an act of signification" (p. 144).

The gestalt position is slightly different, however, from the cognitive position of Lakoff. Lakoff founds metaphoric analogies on mediated associations that he calls 'grounding, but which are relatively physicalistic or behavioristic. They refer to the coincidence of features rather than structural similarity. This has consequences for the way a metaphor is apprehended. For Lakoff, when a metaphor is invoked, you are left with the stock response (e.g., 'life is a journey') and you are done (Tsur, 1999).

Cognitive or structural models like that of Clark and Clark (1977) are better. In such a system unmarked features are valued as positive, and marked as negative. The unmarked features at the ends of the analogous scale correspond to each other: thus, fast vibrations are perceived as 'high' tones, slow vibrations as 'low' tones. Greater height and more frequent vibrations are the unmarked (more salient) extremes of their respective scales, and thus they are matched.

Gestalt psychologists have traditionally emphasized this doctrine of the 'Unity of the Senses' (Hornbostel, 1939; c.f., Marks, 1978). Thus there are structural affinities between the different senses and when they are compared we can metaphorically note these affinities. This is just another expression of the gestalt idea of isomorphism, except that it does not relate to the perceptual and electrochemical levels but between perceptual realms.

Not unlike physiognomic perception, synaesthesia has also been equated with metaphor (Marks, 1978). As has been pointed out by Kennedy, this disrupts the traditional asymmetrical relationship between vehicle and topic of metaphors (Kennedy, 1990). It is best to regard synaesthesia as a genuine phenomenon of human

21

perceiving that is based once again on real structural affinities between the senses; however, it must proceed metaphorically.

Abstraction, Symbolism and Visual Thinking

When a metaphor is active, it plays with levels of abstraction in order to lay bare a deeper structural affinity between two perceptual images. Thus the structural features are the raw given in the environment that allows for symbolization. This is so because the symbol, according to Arnheim (1969), "portrays things which are at a higher level of abstractness than is the symbol itself" (p. 138).

Such symbolism is common in all the arts but differs in its use due to the nature of the individual media. Language, for example, seems to be somewhere between music and vision in terms of abstraction. It is characteristic of Arnheim's thinking that the notion of a symbol is completely perceptual and he dispenses completely with any kind of logical semiotic classification. Anticipating Peirce's discussions of icons, Arnheim responds that images are pictures "to the extent to which they portray things located at a lower level of abstractness than they are themselves" (p. 137). This is his solution to long-standing semiotic difficulties relating to sign, icon and index. It is not based on arbitrary criteria but rather levels of perceptual abstraction; symbols are of a higher level of abstraction, and pictures a lower level of abstraction, than the thought they represent.

There are two competing aspects of Arnheim's thinking on 'the intelligence of the senses' here that have never really been acknowledged. There is on the one hand the ability of the senses to contain universal or abstract information. And there is on the other hand, the manipulation of images for productive thinking. We might relate the two by saying that individual percepts already contain abstract content, just as a work of art can be called the abstracted solution to an artistic problem. It is, however, the manipulation of symbols within the work of art that represents the problem-solving aspect of creation and the means to the solution of the final work. I will briefly touch on these two distinct issues.

In a classic paper, "Perceptual Abstraction and Art" (1966), Arnheim considered the 'intelligence' of the senses by pointing to a fact now taken for granted in Cognitive Psychology, the abstracting nature of perceiving. The gestalt theory of *prägnanz* takes care of abstraction because in providing stable nodes with which the mind can economically organize stimuli, it creates the ability to hold many examples under one rubric. As Arnheim says "all perception is the perceiving of qualities, and since all qualities are generic, perception always refers to generic qualities."

When Arnheim wrote his article his was a lone voice. Now there are many more excellent approaches, dealing both with per-

ception (Stephen Palmer) and cognition (Eleanor Rosch). *Prägnant* or 'singular' perceptual forms or cognitive objects are exemplary and dictate the assymetrical relationship between these objects and those that are *similar*. However, the old linear model of monotonic dependence between variation of stimuli and phenomenal qualities still persists in some cognitive psychology (Zimmer, 1986). The difficulty of quantifying *prägnanz* once again frustrates cognitive psychologists but it is a necessary concession to the facts.

By its very nature perception contains abstraction but it also possesses another form of intelligence in the spatial opposition of agents to embody patterns of thought. Rather than relying on manipulation of codes, Arnheim has been a strong proponent that productive thinking relies on the manipulation of spatial variables. Thus in the case of a logical problem, spatial modeling provides the synthetic judgment of the necessity of the solution. Arnheim gives the example of the logical syllogism: If A is taller than B, and B is taller than C, is A taller than C? This opacity of the words hinders a successful solution of the problem, until it is thought of in spatial terms. Arnheim's ideas have been confirmed by other researchers (Huttenlocher, 1968).

Today, there are several different theories that go on to use some sort of spatial analog of a problem situation and look to its manipulation in movement for the development of analogies, categorization, and other productive outcomes (Croft & Thagard, 2002). Similarly, the use of diagrammatic reasoning is another big research interest that may amplify Arnheim's position. Knauff and Johnson-Laird (2000) found, for example, that easy visualization was not so responsible for reasoning as easy spatialization. The most promising model of problem solving today is the theory of mental models (Johnson-Laird, 1998). The creation and manipulation of mental models allows for productive thinking. The question arises as to whether or not it is compatible with Arnheim's emphasis on visual thinking. Johnson-Laird distances his idea of models from mental images but it is possible that the two are speaking of the same thing, for when Arnheim translated his book into German, he chose the more generic term for 'visual' to be *Anschaulich*.

The dominant paradigm in research on thinking is certainly information processing. There is some hostility between this approach and traditional gestalt thinking, because the former in its classic guise is about the manipulation of elements according to a preexisting code, rather than being adaptable to novel ('productive') situations (Wertheimer, 1985). Arnheim's *Visual Thinking* (1969) provided much evidence for this case, and was used prominently by Hubert Dreyfus in his influential studies, *What Computers Can't Do* (1972) and *What Computers Still Can't Do* (1992). The challenge of the solution of novel solutions will be with computer

models for a long time. But lest we believe that Gestaltists are simply against computers, the important point is that a computer is needed that supersedes binary operations – regardless of how fast – in the direction of complex networks. The advent of connectionism is a start but the most promising model so far is the synergetic computer developed by Herman Haken and his collaborators.

The senses are intelligent in two ways: by posing objects in relationships that reveal productive solutions to difficult problems and by already classifying objects according to abstract principles. In either case, the relationship of elements that promote understanding derived from the cognition of this relationship reveals expression, which lies in the juxtaposition of unalike elements (sensory objects, mental images).

CHAPTER 3

THE SENSES, PERCEPTUAL OBJECTS AND THEIR DYNAMICS

Arnheim presumes to offer universal principles for the analysis of the various arts, but there are obvious differences between various media (painting, music, literature) and the sensory modalities through which they are communicated, principally hearing and vision. Arnheim's early work on the parallel worlds of film and radio provide a good paradigm from which to consider these differences. His pioneering essay, "A forecast of television" (1957), addresses this question so directly, I shall cite it at length.

> *The eye gives information about shape, color, surface qualities, and the motion of objects in three-dimensional space by registering the reactions of these objects to light. The ear reveals little about the objects as such; it only reports on some of their activities, which happen to produce sound waves. On the whole, the eye takes little interest in the nature, place, and condition of the light sources that make the light rays fall upon the retina. The ear is interested in the source of the sound; it wants the sound waves, on their way to the ear-drum, to be as little modified as possible in order to keep the message from the source unaltered. Sound is produced by an object but tells us little about that object's shape, whereas the eye, in order to fulfill its task, must reckon with the fact that a suitable likeness of a three-dimensional object must be at least two-dimensional. Any sense organ can register only one stimulus at a time so that the eye in order to produce a two-dimensional recording has to consist of numerous receptors that operate one next to the other. The mosaic that results from this collaboration of the receptors depicts three dimensional space and volume as best it can. The time dimension, which is available in addition, uses the change in stimulation in each receptor to record motion and action.*
> *A different situation is found in hearing. The sounds that exist in auditory space at any one time are not recorded separately but add up to one, more or less complex vibration, which can be received by a single membrane, such as the ear-drum. This unitary vibration may be produced by the simple sound of a tuning fork or the complex noises of a crowd of excited people or a symphony orchestra. To some extent the ear succeeds in teasing the complex vibration apart, but it offers scant information about the locations of*

25

*the different sound sources. The ear, like the eye, operates
with a battery of receptors, and they, too, are arranged in a
two-dimensional surface. The receptors of the cochlea are
parallel fibers, as different in length and tension as the
strings of a harp, and apparently for a similar purpose. The
'strings' of the cochlea seem to be activated by resonance
when vibrations of corresponding frequencies impinge
upon them. This means that the ear uses its receptor field to
distinguish between pitches, whereas the eye uses it to dis-
tinguish between spatial locations (p. 157).*

According to Arnheim, then, the eye tells us about things
and their relations, while hearing reports exclusively on what things
do; it is silent about what they are otherwise. "A bird, a clock, a
person exist aurally only as their singing, ticking, speaking, weep-
ing, or coughing; they are characterized only by their adverbial
properties and exist only as their properties endure" (1986, p. 67).
Vision deals in concrete objects, hearing in forces.

Perceptual Objects
These givens about vision and hearing are the starting point for art.
But it is nevertheless possible to speak generally of 'perceptual
objects,' and in addition general principles of 'unity,' 'balance'
and finally 'dynamics.' The problem manifests itself in
Wertheimer's laws of grouping, which develop the way units are
formed in mental representations and, in fact, Wertheimer's princi-
ples were originally intended to cover both the visual and auditory
realms. At the end of his classic study of stroboscopic motion
Wertheimer makes reference to the similar problem of phenomenal
grouping in musical perception (Wertheimer, 1912/1961). The
musicologist Victor Zuckerkandl (1956, p. 136), in fact, goes so far
as to say of Wertheimer's study that "often we should have to sub-
stitute 'tone of a certain pitch' for 'thing in place' and we should
have a perfectly valid statement concerning heard instead of seen
motion."
There are two issues here, the identity of gestalt laws for
seeing and hearing, and the representation of works of art as a spa-
tial mental image. As for the first problem, any problem of tempo-
ral organization can be described with spatial concepts. Figure and
ground effects can be achieved with both vision *and* hearing, as can
any number of perceptual illusions. Giovanni Vicario (1982) has
further demonstrated this convincingly in elegant demonstrations
leaving no doubt that temporal organization refers ultimately to
spatial organization. Kubovy and Van Valkenburg (2001) concur
with the joint application of gestalt laws in vision and hearing as
applied generically to 'auditory and visual objects.'

26

The formality of Wertheimer's gestalt laws was prominently contested by the psychologist Geza Révész (1937). Working in hearing and haptics, Révész questioned the simple extension of organizational ideas of visual perception to other sensory modalities, thus denying, for instance, that hearing was spatial. Interestingly, Gombrich has cited Révész's criticisms as an indirect criticism of Arnheim (Sacca, 1980-1). The gestalt psychologist Wolfgang Metzger (1953) did make a response in which the universality of gestalt laws to sense modalities other than sight was reaffirmed.

There is some confusion because there is also a tendency by gestalt theorists to affirm the spatial character of tones. Révész was especially opposed to this, and the affirmation of a *Hörraum* might have seemed to slight hearing in favor of vision (rather than simply affirming analogous perceptual laws of grouping). However, there seems to be good evidence for this dimension of auditory percepts. The gestalt theorist Erich von Hornbostel was the most prominent to affirm this (Hornbostel, 1926; Zuckerkandl, 1956, ch. 15, Bozzi and Vicario, 1960).

This is still distinct from the second problem of the tendency to form spatial mental images of temporal percepts. Works of art must have some sort of visual representation in order to be understood. It must be understood as a complex of pure interactions of forces. This is of course true of static works of art, like paintings. But is equally true of temporal works of art. The symphony or the novel is perceived as organized wholes when grasped in their simultaneity. In order to press his point, Arnheim (1974) asks, "When the dancer leaps across the stage, is it an aspect of our experience, let alone the most significant experience, that time passes during that leap? Does she arrive out of the future and jump through the present to the past? And exactly which which part of her performance belongs to the present? The most recent, elapsed second of it, or perhaps a fraction of that second? And if the whole leap belongs in the present, at which point of the performance does the past stop?" (p. 373).

Time is then a qualified aspect of the experience of a temporal work of art. What rather happens is that the viewer of a dance continually relates aspects into a larger whole. "While listening to music, the hearer weaves relations back and forth and even coordinates phrases as matched pendants, e.g., in the return of the minuet after the trio, although in the performance they are delivered one after the other" (1986, p. 71). 'Matching pendants' occurs whenever two successive parts are similar, and they collapse into a single symmetrical unit.

There is much evidence that this in fact how artists of temporal works work. Arnheim (1974) cites a famous letter attributed to Mozart, in which the composer discusses thinking of a work of

music: "[The theme] becomes larger and larger, and I spread it out more and more widely and clearly, and the thing really gets to be almost completely in my head, even if it is long, so that thereafter I survey it in my mind at one glance, like a beautiful picture or handsome person. And I hear it in my imagination not in sequence, as it will have to unfold afterward, but, as it were, right away all together (*wie gleich alles zusammen*)" (p. 374, his translation). The musicologist Victor Zuckerkandl (1973, 22) has also said of music, "Can a gestalt come about anywhere but in space, where it unfolds with all its parts all at once in simultaneaity and where it offers itself to the observation without receding immediately?" And Arnheim points out also that Heinrich Schenker's concept of the *Urlinie* "is an eminently visualizable notion" (1992, p. 36).

Turning next to unity and balance, it is interesting that the Gestalt psychologist Wolfgang Metzger (1941), suggested that *all* perceptual objects also have a perceptual center. This explains why we are able at all to see something as an object at all. When a spot is determined by the visual system at which all relations may be understood, the stimulus is understood as a thing in its own right. Giovanni Vicario and his coworkers (Beghi, Vicario and Zanforlin, 1982; Davi, 1989; Savardi, 1999) have recently provided a mathematical formalism for determining the perceived center of any configuration. There is also evidence that three-dimensional objects have perceptual centers of reference. The biological regularity of plants and humans means that a simple 'center of moment' from which all movements are related is immediately perceivable (Gerbino, 1983).

When something purports to be an art object, it has to fulfill special functions. The artistic theme has to be exemplarily *ordered*. Then and only then can it be said to be an example of structural order. Thus, balance is absolutely required if they are to attain the status as art objects. "Under conditions of imbalance, the artistic statement becomes incomprehensible. The ambiguous pattern allows no decision on which of the possible configurations is meant. We have the sense that the process of creation has been accidentally frozen somewhere along the way" (1974, p. 20). Works of art require balance because they require finality to be valid statements on the human condition.

Some critics have felt uneasy about Arnheim's elevation of the necessity of centeredness in artistic composition (Schufreider, 1986). They have insisted, for instance, the center is not even active in particular compositions. But we have already seen that centeredness is a quality of all circumscribed perceptual objects, and (say) Mondrian paintings do not provide a sufficient counterexample. In Arnheim's (1988) words, "as soon as we are faced with a closed

space...the enclosure mobilizes a field of visual forces that creates a balancing center and organizes around it" (p. 107).

The basic problem for composition is, therefore, how perceptual centers can interact with a format and find a *balancing* center. I have already pointed out (ch. 3) that centricity allows for unit formation. Whether or not a balancing center is 'retinally' or 'tympanically' present, they are nevertheless intuitively perceived. This makes obvious sense with painting, but with the case of a sculpture, architecture, dance and film, too, the balancing center must be perceived. Especially in the cases of literature, there is no physical stimulus to correspond with, and yet it must be perceived for the work to be comprehended.

The centricity of the composition makes makes the work of art a unified whole, makes it a readable statement, and provides it with a measure of finality. When Arnheim speaks of 'the power of the center' he is expressing just this importance. Let me discuss each of the concepts in turn. The nature of mentally represented wholes provides a clarifying statement for the arts: "a [work of art] must be perceived as some kind of visual image if it is to be understood as a structural whole" (Arnheim, 1986, p. 80). There is no doubt that all works of art rely on time for their understanding, this suggests that such concepts as time must be more carefully delimited. As I will try to show, Arnheim's theory cuts through many critical difficulties about 'spatial form' in literature, and time in paintings, etc.

Perceptual Dynamics
Naturally, the arts become important repositories of thought and wisdom, visual correlates of complex ideas. However, Arnheim has gone further to provide a grammar as it were of the way that such meaning develops. The first assumption of the theory is that all objects and by extension all artistic objects, visual (the visual arts), aural (music and speech sounds), or verbal (poetry) are centers of perceptual energy and attraction. The problem of composition is therefore how these centers of energy can meaningfully interact. When Arnheim speaks of such objects, he calls them *perceptual* centers. Perceptual centers interact, first of all, with each other, creating eccentric vectors of action. They, furthermore, interact with 'frames' or 'formats,' which are really larger perceptual centers which serve as frames of reference for these relative elements. Any format can, and often does, become a perceptual center in a larger frame of reference.

Perceptual objects are centers and are the variably independent units with which we are interested. Any perceptual object "constitutes a dynamic center because it is the locus of forces issuing from it and converging toward it" (1988, p. 225). Depend-

ing on the scale of magnitude, grouping elements from below we may arrive at the whole work as a center, or we may subdivide from above to the elements, which then become centers in their own right.

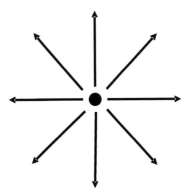

Fig. 3. The centric compositional system

To elaborate this with diagrams, let us look at a dynamic center with vectors emanating from it (**Fig. 3**). It is a source of energy, which emanates from its center. Here we treat a vector as, " a force sent out like an arrow from a center of energy in a particular direction. When a system is free to spread its energy in space, it sends out its vectors evenly all around, like the rays emanating from a source of light. The resulting symmetrical sunburst pattern is the prototype of *centric composition*" (p. 4; see also Arnheim, 1974, pp. 23-6).

The principal compositional characteristic of centers is *weight*. Arnheim (1988) defines perceptual weight as "the dynamic power inherent in an object by virtue of its conspicuousness, size, shape, location, etc" (p. 229). We might go further and say that weight is produced following the rules of organization in any particular modality. Arnheim (1988) thus gives his first rule for the compositional effects of weight.

A. Weight increases attraction

Most usually in conjunction with the anisotropy of space, discussed below, weight is next increased by distance.

B. Distance (I) increases perceptual weight when perception is focused upon the center of attraction.

Arnheim likens this 'rubber-band effect' to potential energy in physics. Weight generated by distance is only increased, however, when an object is anchored to a base. Otherwise,

> [distance] (2) decreases attraction when perception is anchored in the attracted object.

This means to say that when the object itself is considered as a center, it loses its anchoring to the old center. B (1) and B (2) are mutually exclusive ways of looking at a composition and point to the problem of the dual nature of the dynamics of centers which hinges on what capacity as center they are perceived to be, and is further treated below.

The behavior between *perceptual* centers must take place within some finite context. This is the larger format. I already mentioned that while the limit to which an artist supports or doesn't support a format is a matter of choice, the organizing influence of any 'closed space' is not.

A format is nothing more than a large perceptual center that serves as a perceptual framework for the action occuring under its perceptual power. This concept is brought out nicely in the German word *Figurfeld*. The figure is a field, but the figure is also a figure, depending on the resolution with which you approach the relative strength of the various perceptual systems.

The idea of format has found elaborate study in Gestalt psychology as the frame of reference, or *Bezugssystem* (Koffka, 1935; Witte, 1966; Metzger, 1975; Rock, 1990). While as an explanatory concept it often remains outside of contemporary accounts of perception, Gestalt psychology holds to its necessity for a proper account of perception. The frame of reference is only the most important centric system of the work of art. It is therefore the 'common component' to which all others are 'relative.' All centric systems have tonic qualities, but the format is the most important for the whole work of art.

The frame of reference is a general psychophysical problem that extends into the time dimension as well, for instance, to tempo. It is in the context of *any* format, therefore, that the composition must find its balancing center. The format has a special status because it is ultimately the frame of reference of the work. As we shall see, as soon as we move (say) a painting from one room to another, we have changed the frame of reference of the work itself. But this is accidental and not related to the work itself (see ch. 22).

If a center, and by extension a format, "is the locus of forces issuing from it and converging toward it," the forces are constituted of vectors. And if a center of energy is the prototype of a centric system, then an individual vector is the prototype of an

31

eccentric system of dependence. Vectors are therefore "forces generated by the shapes and configurations of perceptual objects" (1988, p. 229, slightly amended).

The power of **Fig. 3**, above, depends only on its strength as a center of energy and develops purely centrifugal behavior. " A different situation comes about when a second object is introduced into the neighborhood of the first...the original center responds to the presence of another one, a centric orientation changes into an eccentric one. The primary centric system is no longer alone in the world; it acknowledges the existence of other centers by acting upon them and being acted upon by them" (1988, p. 5). This is represented in **Fig. 4**.

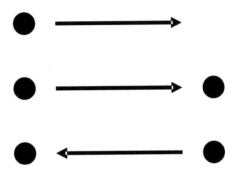

Fig. 4. Centers reacting to centers, the basis of the eccentric compositional system

The relationship between the two systems, or more specifically, the interplay between centrically oriented systems and eccentric vectors is not mutually exclusive. Arnheim (1988) says "if we distinguish perceptual objects from one another by calling them volumes or vectors, we are adopting a convenient simplification, to be handled with caution" (p. 150). As we saw before in the discussion of weight, the identification of exactly is a center determines how weight will be determined.

The complexity of the interaction of object and action is suggested by Arnheim in the following way:

> In **Fig. [5]** we see the spatial order to which the compositional forces conform, whereas **Fig. [6]** schematizes the behavior of these compositional forces themselves within the given framework. In both cases the combination of two rather disparate patterns makes the relationship quite intricate. In the framework of spatial order it allows for the simultaneous presence of focused and homogeneous space

but complicates the order by creating a tricky relation between curves and straight lines. In the framework of vectorial dynamics it produces the tension and discord needed by the artist when he represents self-centered behavior as trying for a modus-vivendi with outward-directed behavior (p. 9).

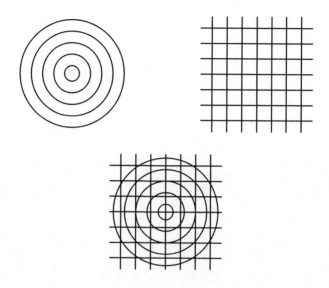

Fig. 5. Superimposition of the two compositional systems

All works of art are subject to one particular perceptual distortion that is similarly highly symbolic, the anisotropy of space. Arnheim defines anisotropism as "the asymmetry of gravitational space, by which the nature and behavior of perceptual objects change with their location and the direction of the forces they emit and receive" (p. 225). Perceptual anisotropy has been known since Mach and has been investigated by gestalt psychologists as an example of a prägnant, or singular, orientation of percepts (Koffka, 1935; Rock, 1973). We can see that the earth is the one perceptual center relative to which it is most difficult to consider the weight of objects. In this sense, while we can affirm that the way of looking at a center-as-base is alternate, the earth as a center usually 'wins out.'

All works of art share in the symbolism of anisotropy. Symbolically, moving upward involves the overcoming of weight, a liberation, from the ground; moving downward is experienced as giving in to the gravitational attraction, a passive letting go (Arnheim, 1974, p. 30-3). This cannot be underestimated in the understanding of all the arts, including music. The vertical represents the

33

dimension of contemplation, a concept which we shall have the opportunity to clarify in the next chapter. Here, it may suffice to say that up and down relations tend to preserve the relation between subject and object, without any getting "entangled with the vectorial configuration within the plane of the configuration itself" (1988, p. 38).

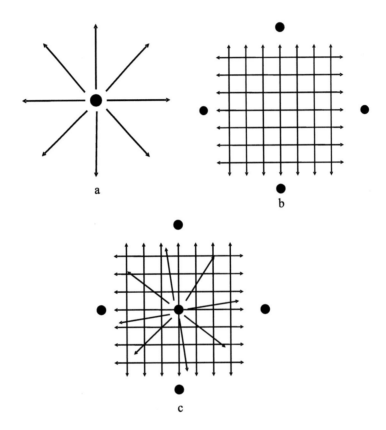

Fig. 6. The behavior of forces within a format

There are further asymmetries in the perceptual field, in particular the right-left asymmetry, whereby the left and right sides appear to be of different weights. Arnheim (1988) says that, "The left side is endowed with special weight; it assumes the function of a strong center with which the experiencer tends to identify...The left side is also a hub, where more weight can be tolerated" (p. 47; also Arnheim, 1974, p. 33-6). Consequently, if the vertical represents the axis of contemplation, the horizontal represents the dimension

of interaction, time and narrative (Arnheim, 1977, p. 54). And so we have the foundation of graphic meaning.

Departing from Wertheimer's laws of perceptual grouping, Gestaltists affirm the universality of their principles for sensory explanation. In this sense, the schematism provided by Arnheim in *The Power of the Center* suggests itself as a powerful reformulation of Wertheimer and a basis for a general Gestalt psychology of art.

CHAPTER 4

THE NOTORIOUS GESTALT BRAIN MODEL

Over fifty years ago, in 1949, Rudolf Arnheim published a remarkable article in the *Psychological Review* entitled 'The Gestalt Theory of Expression' (Arnheim, 1966). Basing his observations on the physiological theory of his teacher, Wolfgang Köhler (1940; Köhler & Wallach, 1944), Arnheim attempted to explain the expressiveness of visual forms as the psychological or phenomenal counterpart to the 'stresses' and 'strains' of the underlying visual processes themselves. For example, given a bowing column before us, the illusion of 'bowing' is due to the compromise between a minimization process which seeks to reduce the column to a straight line, and the proximal stimulation which records the slight entasis at the center of the column; the compromise survives in our visual percept.

Arnheim went on to elaborate his ideas in *Art and Visual Perception* (1954/1974) where he reiterated that the visual expressiveness of forms could be attributed to some kind of field-like process occurring in the visual cortex. Later, anticipating some developments in non-linear dynamics, Arnheim in *Entropy and Art* (1971) saw perception as a compromise between minimization ('catabolic') processes and proximal stimulating ('anabolic') processes.

Arnheim's model has suffered with the fate of the gestalt theory of brain functioning. By most estimations, this theory was fatally crippled in the 'fifties by counterdemonstrations by Karl Lashley, Roger Sperry and Karl Pribram (Lashley, Chow & Semmes, 1951; Sperry, Miner & Myers, 1955; Pribram, 1971, 1984). Köhler had reasoned that the cortex operates as an electric field and his various critics supposed that he had refuted Köhler when they found that cats or monkeys could still perceive after conductive metal foil, needles and metal-based creams had been inserted into their brains – an operation that ought to have disrupted any electric field. Even though gestalt psychologists have insisted that the counter-demonstrations were not decisive (Henle, 1984), it is significant that Köhler's theory has not been supported in toto.

Still, the advantages of Arnheim's theory should be appreciated. He took a hazy subject – the expressiveness of visual forms – and provided an empirical model. This is in sharp distinction to the general trend in such studies where the best that is hoped for is the elicitation of verbal judgments of the expressiveness of forms which are then analyzed with powerful statistical instruments like the semantic differential (Osgood, Suci & Tannenbaum, 1957). In the

following I want to point out ways in which Arnheim's intuitions might be rehabilitated, in the same way in which gestalt brain models are no longer being simply dismissed and are receiving a second look.

The Gestalt Brain Model: Isomorphism

The Gestalt Brain Model is based on 'isomorphism,' which suggests that neural processes and perceptual experiences share some common form or structure (Köhler, 1940; Köhler & Wallach, 1944; Scheerer, 1994). This common form is only intended to be topological or functional, and Köhler rejected the so-called identity theory of brain functioning that says that perceptual states just are brain activities. This is often misunderstood about Gestalt theory, and Arnheim's writings must be framed in this particular way.

Arnheim (1949/1966) actually sought to extend this state of affairs to complete the picture and suggest how we might extend levels of isomorphic structure through intermediary levels:

A. Observed Person
I.	State of mind	psychological
II.	Neural correlate of I	electrochemical
III.	Muscular forces	mechanical
IV.	Kinesthetic correlate of III	psychological
V.	Shape and movement of body	geometrical

B. Observer
VI.	Retinal image of V	geometrical
VII.	Cortical projection of VI	electrochemical
VIII.	Perceptual correlate of VII	psychological

Since Arnheim was most interested in the isomorphism between expressive contents, it led him to look beyond the brain-consciousness isomorphism. Thus interesting is the fact that Arnheim includes the geometrical level at which isomorphism must be communicated between two people communicating. This leaves open the possibility of stimulus gradients that can communicate expressive contents in the manner of Gibson.

Gestaltists like Arnheim attempt the difficult task of privileging neither the phenomenal nor the physical, so they are neither *physicalists* nor *phenomenalists* (Epstein & Hatfield, 1994). Phenomenological experience is given its due, but at the same time so is the transcendent brain functioning that we learn about through science. Since Gestaltists refuse to limit reality to lived experience, but see it critically interacting with a transcendent reality, they are *critical realists* (Bischof, 1966; Mandelbaum, 1964). Thus we have

38

to distinguish between our phenomenal *self* and our transcendent *organism* (**Fig. 7**; Köhler, 1938).

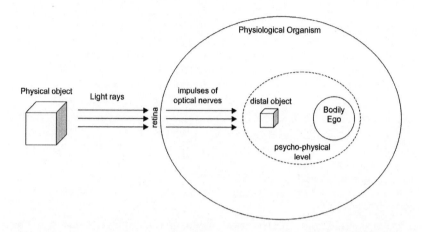

Fig. 7. The Critical Realist System of Epistemology, after Bischof (1966)

For this reason Arnheim (1994/1996, pp. 144-50) calls consciousness 'an island of images.' Such distinctions are not abstract but point to the difficulties of psychological explanation of the arts. The philosopher Monroe Beardsley (1979) has discussed the problem of 'objective' and 'psychological' language in Arnheim's theories and complained they become intertwined in his writing. Arnheim would answer that we need both, used properly when speaking of the transcendent world or the phenomenological world.

We can also say that perceiving is not an isolated activity for in our very acts of perceiving we make causal inferences about the world that are quasi-scientific. Thus we make phenomenal observations about the arts (or the world) that guide hypotheses about underlying processes, and these lead to observations. There is no point of innocence.

Keeping the Field Metaphor, Jettisoning the Specific Mechanisms
Naturally, Köhler made several assumptions about the brain in the 'fifties which underestimated its complexity and his ideas about simple fields of action, although suggestive, cannot be supported at the level of proposed mechanisms. At the same time, the emerging science of point recordings of the action of feature detectors – picking up sensitivity to a bar, texture or grating – was lamented by

39

both Köhler and Arnheim (1971). Contemporary accounts of microscopic dendritic arborization and feature detectors – the so-called 'neuron doctrine' – still cannot account for the complexity and richness of human perception, suggesting that some more global perspective is still needed. Spillmann & Ehrenstein (2004) point out that the old, mechanistic picture of single cells has been overcome by a much more impressive field-like ability to capture relational data. These in turn suggest larger coordination, leading to the concept of 'perceptive neurons' (Baumgartner, 1990) for cells that respond as though they mediated the presence of illusory contours (with neither a physical, nor retinal stimulus correlate).

What must be kept is the meta-theory. Arnheim partially did this in his little work, *Entropy and Art* (1971), in which this psychologist courageously took on notions of entropy to argue that physics had yet to develop tools to deal with the 'upward' character of physical systems. At this very time, cybernetics and systems theory was just giving way to the first discoveries of synergetics and catastrophy theory.

Two recent interpretors of the gestalt tradition have done precisely this. The first was Arnheim's colleague, Erich Goldmeier (1982), who obtained his doctorate under Wertheimer in the 'thirties in Frankfurt. In the context of a theory of memory, Goldmeier likened 'prägnant' or prototypical forms to minimization wells in a hypothetical brain process. Goldmeier, who was also trained in physics, had catastrophy theory in mind when he made his analogies.

Around the same time, Michael Stadler in Germany was developing a brain theory based upon the principles of synergetics of the physicist Hermann Haken, with whom he collaborated. Stadler was an ideal candidate to continue Köhler's approach and had written on after-effects based on Köhler's model as early as the 'sixties. Like Goldmeier, Stadler agreed that prototypical forms could be likened to potential wells in a hypothetical space or else to synergetic 'attractors' governing the process. Stadler's approach has been slightly more dynamic than Goldmeier's, allowing for gestalten to emerge spontaneously from processes in which synergetic processes are at work.

Both Goldmeier and Stadler believe that the spirit of Köhler's theory was correct, even if the specific mechanisms he proposed are not. As Stadler and Peter Kruse (1990) have written, "the apparent incompatibility of the analytical and the holistic system view seems to be more a fruitful starting point than an embarrassment" (p. 35). In the same vein, Steven Lehar has argued that what is required of neurobiological speculation is 'perceptual modeling,' that is, seeking hypothetical physical processes and mathematical formalizations adequate to capture phenomenal data.

Such an example is his Gesalt bubble model (Lehar, 2003). They hold out the eventual hope that the integration of phenomenological properties of the perceived world can ultimately be reconciled to natural processes through a proposed isomorphic relation linking them. These properties include expressive properties.

Arnheim's Tentative Suggestions

In 1982 Arnheim published his *The Power of the Center* (1982/1988), a theory of artistic composition. Arnheim improved his theory by going beyond the simple anabolic-catabolic model of the minimization of proximal stimulus. More specifically, Arnheim posited that there must be 'centering' mechanisms and 'vectoral' or translatatory mechanisms engaged in every perception. Centering mechanisms are closely related to unification, and the creation of unitary or grouped percepts. Vectoral mechanisms divide percepts. Crucially, however, they also 'enliven' centered percepts with eccentric vectors of action.

Let us take our old example of the column. The column, insofar as it constitutes a unitary object, is a 'center.' It also possesses, at the same time, a strong directional element, and is in another sense a kind of pointing line. The swelling can be characterized as the struggle going on by the visual processes trying to resolve the dilemma posed by centricity and eccentricity. The visual system 'wants' (I do not mean to suggest actual rationization) to treat the column as a simple pointing line, but it asserts itself around the middle, hence the expressive swelling.

Arnheim has to a degree kept abreast of contemporary psychology, and has gone so far as to suggest connections between his theory and other, non-gestalt (or neo-gestalt) approaches to perception. In particular, he noted the affinity between his proposed mechanisms and those developed by a group of psychologists presently modeling the brain upon the formalisms of Lie algebra (Dodwell & Caelli, 1984; Arnheim, 1987a). Unfortunately, beyond Arnheim's suggestions, there has not been any response from the Lie algebra camp. With this said, I want to make a few of my own suggestions, which may point to further affinities between perceived expression and contemporary brain models.

Expressive Forms as Nearly Singular Forms

In his analysis of memory, Goldmeier (1982) upheld a controversial doctrine that need not concern us here: that memories autonomously change over time toward 'better' or more singular memory traces. What is extremely useful from Goldmeier's analysis is his characterization of such non-prototypical forms as particles at the top of the hypothetical potential well. Consider a parallelogram that strives toward a square regularity (**Fig. 8**). This figure was first used

by Rausch (1952) to underscore the difference between the geometric structure of a shape and its perception; this also captures perfectly the dynamic strain toward this more regular shape.

What is significant here is the idea that the expressive form is also the non-singular form. This is the same condition outlined by Arnheim for percepts that still have a resistance or are not completley minimized. But it adds to it the added clarification of depicting the process itself as a hypothetical potential well. What we emerge with is the generalization that *expressive percepts deny prototypality and singularity*. One could align this dynamic approach to Michael Leyton's (1992) computation modeling of perception as a reconstruction of their history. A dented can is a can-with-a-dent. Expressiveness can arise due to the stresses and strains away from prototypical objects (c.f., Østergaard, 1996).

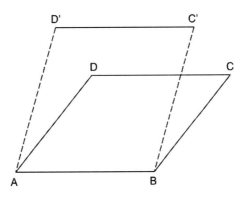

Fig. 8. Singular (D', C') and Nearly-Singular (D, C) forms, adapted from Rausch, 1952)

The Implicit Structure of the Basic Rectangle

If this is a useful generalization, we can go on to elaborate a tentative synergetic exploration of a basic aspect of expression initiated by Stadler. Already in 1954 Arnheim outlined "the basic form of a square" as a way of demonstrating how the square or rectangular form of the format of painting contributed to the expression of the work. In the second edition Arnheim referred to an experiment by the Swedish psychologist Gunnar Goude and there have been further research in the Gestalt school (Schulz, 1973; Savardi, 1999; (**Fig. 9**).

More recently, Stadler and his collaborators used the serial reproduction method (not accidentally, also to demonstrate the autonomous change of memory traces) to explore this problem

more thoroughly (Stadler, Richter, Pfaff & Kruse, 1991). They had subjects who were shown a point on a rectangle reproduce the point on a test rectangle. Beginning in the middle, all of the points ultimately migrated to the four corners. According to synergetic theory, Stadler named these 'attractors,' and constructed a potential landscape in which particles would tend toward these wells.

Fig. 9. The Implicit Structure of the Basic Square

Arnheim had argued that the center is a strong center (or 'attractor') but this contradicted Stadler's results. The center seemed to be particularly weak, because the points invariably left there. However, the two points of view could be reconciled if it were assumed that a larger test point, a disk as Arnheim and Goude had used, would remain put with numerous serial reproductions. In this way, both the center and the corners, in conformity with Arnheim's original speculations, would be the attractors.

What is significant about Stadler's research is the psychophysical experiment of reproduced points and the hypothetical correlation with a brain model that could be assumed to follow such synergetic principles. It is not decided where in the brain or by what mechanism it could happen, but some perceptual process clearly favored certain solutions and disfavored other solutions, thus revealing an underlying order.

Generalizing the Model

The principles discussed so far are most suggestive as the underlying causes of perceptual dynamics and expression. But more can be said about the underlying physiology of for example visual thinking. In the last chapter I sketched the role of mental images in visual thinking. When Arnheim stresses the role of perceptual comparison for a logical task, for example, there has to be brain correlate for this too.

Kosslyn (1994) uses compelling neurological evidence to make the case that visualization uses the same physiological resources as vision, that mental images are generated by the triggering of elements of our visual system. In fact, he has even left open the possibility of isomorphic neural correlates of mental images (Kosslyn, 1995, pp. 290-2). The study of mental images has not been able successfully to work with complex images like the activities of artists with fruitful results. But simpler chronometric phenomena were studied by other psychologists like Roger Shepard that are still necessary for visual thinking. Shepard who showed a linear relationship between time and angular turn in rotation tasks has had his findings verified with observing regional blood flow and recording of the neuronal population vector (Georgopoulos et. al., 1989).

It would certainly please Arnheim to discover that all forms of expression might derive form a single basis. But there has been some recent evidence that face processing differs from visual object processing (Desimone, 1991). This suggests that while expressive dynamics are due to the very nature of perceiving, 'physiognomic' perception might be parasitic upon our natural ability to perceive and interact with people. However, it is not yet clear whether or not object and face processing are totally different.

To some, gestalt speculation on the brain has been an unfortunate diversion from an otherwise laudible phenomenological method. However, as already outlined, there is no gestalt theory without a materialistic worldview. Although a strict theory of psychoneural isomorphism propounded by Köhler has indeed been eclipsed, new considerations of brain functioning have taken up the dynamic worldview, opening new possibilities both for Gestalt psychology and for Arnheim.

44

CHAPTER 5

THE DYNAMICS OF PICTORIAL, SCULPTURAL AND ARCHITECTURAL FORM

As I have already indicated, Arnheim's companion works, *Art and Visual Perception* and *The Power of the Center* constitute a complete theory of pictorial dynamics. It will simply be left to me in the following to represent and, if possible, further integrate some of this material. In this sense, "The dynamics of shape" (1966c) and *The Power of the Center* (1988) take some precedence over the earlier, more famous, work.

I wish to point out that, although Arnheim was mostly concerned to *apply* gestalt principles to art, this was also where he maintained his identity as a Gestaltist and where he defended the theory against criticism. The kind of theory outlined in Chapter 2 was defended by Arnheim from two principal directions. On the one hand Arnheim defended gestalt theory against inferential theories of visual perception (Richard Gregory, Julian Hochberg, Irvin Rock), and on the other he defended the theory against the naive view that pictures were surrogates for real things and could only be treated as such (J. J. Gibson).

While Arnheim made a significant contribution to color perception (Arnheim, 1984/1994; 1987), the following exposition will overlook this subject in the interest of simplicity. Needless to say, this theory is quite novel and develops important ways in which meaning can arise through syntactic relationships between colors. This theory has been developed prominently by Augusto Garau (1984/1993; c.f. Gilchrist, 1990).

Each of the various arts we shall be exploring show a certain phenomenal range of meaning. To introduce Arnheim's terminology, pictorial works may vary in the degree to which they are a self-image as opposed to a likeness (1966). "A picture may be called a *self-image* when it is taken as a visual expression of its own properties, and a *likeness* when it is taken as a statement about other objects, kinds of objects, or properties. The first conception, more elementary, can exist without the second; the second, more sophisticated, combines with the first" (1987, p. 48).

The Dynamics of Shape
The dynamics of shape is dependent on the arrangement of elements in two dimensions. We may imagine, first, this plane as well as a secondary depth plane that may variably interact with the first. The first is closest to the true requirements of the pictorial mediumand the overwhelming concern of most of the world's art, from decoration of pottery, textiles and architecture to the most differen-

tiated products of late western capitalism. Even so, Arnheim points out that there is no truly 'flat' picture in the sense that simple figure and ground effects invariably assign depths to simple shapes.

The most fundamental element of the picture is the line. The most important of lines in general, and the one that is also favored developmentally in children's art, is the 'object line' (Arnheim, 1974, pp. 219-223). The line itself constitutes an object. Arnheim also investigated 'contour' lines, or lines that mark the termination of the edge of an object, and 'hatch' lines, or those that give texture to an object. In a rigorous extension of Arnheim's principles, Manfredo Massironi (2002) has added in addition 'crack' lines that are sorts of contour lines within objects (pp. 104-112).

The mutual interaction between elements and ground has led Arnheim to develop the notion of figure and ground, first discussed by Edgar Rubin (1921, see also Koffka, 1935, Metzger, 1975; Rausch, 1982). Arnheim conceives it as a special case of the larger problem of the dual nature of vectors. Recall that in the figure-ground effect, the views are mutually exclusive. Arnheim elevates this to a general principle which says that the objectual reading of an object excludes seeing it as subject to the dynamics of other centers. This view has gained some support recently (Sambin and Pinna, 1987).

This give and take between parts and whole in a picture explains the paradox that pictures show dynamics yet balance around a center. Dynamics are read when action and reaction are played out between perceptual objects, while perceived *together* they themselves become a unit. Individual parts may be quite dynamics but the whole is determined by the gestalt tendency toward good form.

What is most interesting in this context is the way in which Arnheim has specified how pictures have to present clear-cut pithy statements, the very origin of visual intelligence. His discussions of the requirements imposed by the medium have been upheld by the research of Alf Zimmer (1995), who shows how the human visual system tends to improve visual forms over their geometric and projective literalities. This refers back to competing theories of visual perception and the fact that the *prägnant* attractors of stable perceiving guide solutions more so than literal geometry, elevated by ecological theory in some of its guises.

When more elements are introduced into a picture, they interact as centers, thus giving rise to expression. Centers embody self-sufficiency and develop identity. Vectors relate them to each other. As noted in the Chapter on the Brain Model, these fundamental perceptual facts may or not bypass information on face processing where they provide the basis for physiognomic readings of visual stimuli. Arnheim provides a materialistic way to explain

these higher order expressive effects based on simple, combining elements.

In the gestalt tradition, there has been research on the objectivity of expressive judgments attached to visual forms (Scheerer & Lyons, 1957; Wallach & Kogan, 1965). More recently Kogan, Connor, Gross, and Fava (1980) have developed the Metaphoric Triads Task (MTT) on 'congifurational metaphors' (as opposed to conceptual and physiognomic metaphors). This work should be coupled with that of Arnheim to provide a comprehensive theory of the origins of visual expression.

To see how Arnheim's principles might be applied to an actual work of art, we may look at Franz Kline's *Painting #2* (1954). It is because all works of art have a 'structural skeleton' that Arnheim is particularly comfortable with such a non-representational work. In fact, things only become easier with a representational work, where the underlying configuration takes on a deeper meaning when we associate the fundamental spatial symbolism with characters. In Kline's painting, there are several spontaneous strokes of calligraphic black paint on a white ground. They create a loose lattice, but each of the lines is not a true horizontal or vertical. By implying a balancing center but giving it no retinal presence, the work plays around a virtual axis, creating a tension. The dynamics arises because of the viewer's acknowledgment of this virtual axis.

Pictorial Depth

Arnheim defines pictorial composition as the arrangement of elements in two dimenions because pictorial depth is a secondary phenomenon. Following, Koffka (1935; see also Zimmer, 1995), depth is for Arnheim and comes about like all expression, as tension in deformation. It can be characterized in the following four ways (from Arnheim, 1974):

1) a pattern will appear three-dimensional when it can be seen as the projection of a three-dimensional situation that is structurally simpler than the two dimensional-one (p. 248).

2) When we call the three-dimensional version the simpler one, we mean that it wins the trade-off (p. 261).

3) no aspect of visual structure will be deformed unless space perception requires it (p. 263).

4) the percept will correspond to the shape of a foreshortened physical object when, and only when, this shape happens to be simplest figure of which the projective pattern can be seen as a deformation (p. 272).

47

Reading two-dimensional pictures in depth is argued to be natural by some theorists (like Gibson and Gombrich). However, Arnheim (1988) argues that it always sets up an ambiguity because the frontal plane must be organized as well as that of the depth projection, and the two can only be reconciled by a sort of 'angular projection.'

Spatial Format

In the original edition of *Art and Visual Perception* (1954) Arnheim discussed the 'structural map' of the square (p. 3). As amplified in chapter 4, Arnheim demonstrated that the square had strong 'attractors' in the center but also in the corners, which contributed just as much to the dynamics of a visual pattern as the elements presented on it, by themselves. He has since discussed the structure of the rectangle (cf. Stadler et al., 1991), and of the tondo, ellipse and square (Arnheim, 1974, p. 13, 1988, pp. 72-108). Each different format provides different possibilities for the artist. The traditional upright rectangle suggests a timeless iconic quality of state, the horizontal rectangle action and narrative. The square and tondo have further properties.

Format has become important for twentieth-century art because of attempts to 'override' the center of the composition. In a review of *The Power of the Center*, Geoffrey Schufreider (1985) took Arnheim to task for his suggestion that the center induced by the format cannot be overridden. He noted the works of Piet Mondrian which purposely suspend final rest in their elements. In the new version, Arnheim affirmed that the meaning of Mondrian's works lies precisely in a virtual center that the painting does not supply. That is, it is because the artist frustrates a natural tendency that they are of interest.

The Environment as Format

It has already been said that a picture relates little to its environment because it is so self-contained. The 'naive realists' discussed above, however, have elevated the question of the geometric projection of perspective pictures to a undue level, which according to Arnheim (Arnheim, 1972, 1977) is largely academic. He points out, first of all, that the vanishing point does not require that the viewer stand there. For instance, in the case where the vanishing point is outside the picture this is obviously an impossibility. Here Arnheim anticipates Michael Kubovy's (1986) ideas on the 'robustness' of perspective.

Further, Arnheim has objected to the over reliance on photographs in such discussions which tend to exaggerate the effects of optical distortions. He thus pointed out that Pirenne's photographic distortions of the Andrea Pozzo ceiling in the church of San Igna-

zio, Rome, are not that great in person (Arnheim, 1989, p. 233). Arnheim (1977) signals his rejection of the pure inferentialist view according to which we consciously 'take into account' our position relative to the picture: "Other special physiological mechanisms serve to attribute displacements of the retinal field correctly to either the locomotion of the viewer or the rotation of the object, although those mechanisms cannot account for the constancy of shape and size" (p. 283).

Tellingly, Arnheim rejects an over-literal ascription of perspective space to even naturalistic scenes. The most famous cases here are Velasquez's *Las Meninas* and Manet's *Bar at the Folies-Bergier*. The perspective scene does not usually possess the level of abstraction that would demand us to locate all objects in it rigorously. It is the precisely the 'robustness' of perspective that allows us to enjoy scenes without taking them as surrogates of real things.

SCULPTURE

Arnheim's treatment of sculpture has been almost as rich as his treatment of the pictorial arts. In a very real sense, the compositional principles can be applied to sculpture by a simple transposition into three dimensions. Most psychologists do not recognize it as such, but Arnheim's writings on the perception of three-dimensional objects – like works of sculpture – represent an important extension of gestalt organizational ideas to the spatial dimension. Arnheim's theory of object expression, for instance, offers an interesting alternative to Gibson's theory of affordance (Gibson, 1979).

Gibson, let us recall, says that affordance of an object is directly perceived, but sometimes wrongly! In contrast, Arnheim makes the more reasonable assumption that the implementational quality of an object like a tool is more or less fitting. An object's fitness to fulfill an implementational function is more or less made visible by the object itself. A jug, for instance, should express receiving, constraining, or giving, according to its conception, and it may be more or less succesful at doing so. But a jug that looks like a football, cannot be said to directly afford receiving and giving.

Arnheim would most likely accept most enthusiastically those aspects of Gibsonian experimentation like self-motion through apertures and up stairs (Warren, 1995). This is the movement of previously mental properties that are being relegated to the realm of perception. But as with the case of picture perception, making a sculpture too much like a real thing (or picture too much like a real scene) derives it of fundamental symbolic function (c.f., Epstein, 1993).

The notion of self-image and likeness introduced in the last chapter were in fact first proposed with sculpture in mind. Arnheim

(1966) used the example of a statuette of St. Francis common to many gardens and a lifelike robin on a bird feeder. The abstracting Saint is a self-image in that it refers to itself and is self-sufficient while the robin is a token of something else, thus referring outside of itself. This is the continuum along which sculptural works are made.

The Dynamics of Space

If we compare paintings to sculptures, we can see that painted *objects* are more akin to sculptures than the pictures themselves. That is, sculpted objects are treated much like perceptual centers, which interact most of all with the vector of gravity, and to a lesser extent than in painting, with the format. However, when we think of subordinate centers of a sculpture, the entire sculpture indeed becomes more like a picture. Or, conversely, if we have a number of figures, they and their virtual surrounding are much like a picture.Thus, the dynamics of individual sculpted works are similar to that of individual centers in painted works. And just as painted centers interact with the frame, so too the sculptural center interacts with the surrounding space.

One of the most important mechanisms in the dynamics of three-dimensional space is the figure-ground relation. We recall that convexity in line drawings usually gives them a figural quality and in the same way concavity gives the background the figural quality, as if the line drawing has become an aperture through which we see the ground of the figure. Convexity in sculpture works the same way. Whereas in two-dimensions concavity makes gound perception more likely, in three-dimensions it gives the air around an object an active role.

Arnheim first discovered this in his analysis, "The Holes of Henry Moore" (1966), and extended it to a well known comparison of Maillol's *Resting Nude* and Henry Moore's *Reclining Figure*. The Maillol figure, in conformity to the main tradition of western sculpture, is voluminous and self-contained, whereas the Moore figure composed of concavities imply an outer force. In spite of the passivity of the similar theme, the Maillol's relatively passive treatment is actually much more active than Moore's.

Dynamics and expression are developed in analogous ways as with pictures. The various sculptural centers as they are related through eccentric vectors determine directed tensions. An example is Barnett Newman's *Broken Obelisk* (1968). This highly geometric piece features a broken obelisk, apparently upside-down and balancing on its point on a pyramid. The work can be read in a number of ways, upwards and downwards, but the most interesting view is the way the two primary centers come together at the precarious point. The strength of the visual alignment is overriden by our

50

knowledge of the massive metal materials, providing the paradoxical meaning of the ensemble. Once again, these principles are even more applicable with a naturalistic sculpture. But even in the most basic geometric work this symbolism will always underly it.

Format
The format for sculptural form lies in the Cartesian coordinates; the vertical and horizontal. Unlike in painting, these are only virtually given because there is no actual frame, therefore one might wonder if compositional format is more relaxed in sculpture. Arnheim (1989a) says:

> even when sculptures avoid all vertical and horizontal elements, they cannot be said to be 'atonal.' The weights and masses are likely to be distributed around the center of the sculpture in such a way that the whole composition is balanced around a virtual spine (p. 232).

Arnheim gives the example of Myron's *Discobolos (Diskus Thrower)*, a good copy of which is found in the Museo delle Terme in Rome. The discobolos is actually quite a complicated figure, composed of many obliquities. Yet, although they deviate away from the virtual spatial framework, they "play around it as a melody plays around a tonic" (p. 232).

The same principles hold for more ordinary objects, like works of industrual design. Arnheim (1977) gives an analysis of Mies van der Rohe's *Barcelona Chair*, and notes how the counter-clockwise tilt of the seat and backrest create a dynamic tension away from the spatial coordinates but at the same time indicate the presence of humanity. The x-form of the welded supports curves inward to yield to the weight of the person it is supporting but at the same time indicate a perfect arc which visually resists any collapse (pp. 263-5).

In such cases, we are dealing with one vertical axis with a horizontal axis swinging around it indifferently. But there are other cases – relating to materials already discussed – that afix the horizontal axis as well. Representationally 'early' sculptural forms executed in stone often strongly retain the original quadrature of the original block of material and follow more strongly the fixed vertical and horizontal axes (Arnheim, 1977, p. 57).

Classical theorists of the Renaissance stated that a sculpture ought to be seen from many angles. Such a sculpture will enhance its 'object' character while other works, like Antonio Canova's *Paolina Borghese* are more 'pictorial.' Conceived as a pure frontal view, it shows Paolina reclining and displaying her body forward, almost to the point of discomfort.

ARCHITECTURE

Arnheim, of course, devoted a whole book to architecture, *The Dynamics of Architectural Form* (1977). As noted, this single work of Arnheim's perhaps best develops the kind of pure theory I am attempting here. Written just five years before *The Power of the Center*, it anticipates it in many regards, and keeps theoretical and genetic aspects separated as I have tried to do. My job here, then, is mostly to summarize what Arnheim has said.

Arnheim's book should be recognized as an important psychological contribution. Aspects of perceptual organization of volumes and more generally *environmental psychology* are given a sophisticated treatment. While not recognized in America, I will only point out that it *is* recognized in Italy as an important intermediate statement of the gestalt position, standing historically between the older treatments of Lewin, etc., and the present (e.g., Cesa-Bianchi, 1989).

As noted in the last chapter, the Gibsonian school has had a great deal of success in defining the optical flow input determining successful ego motion (Warren, 1995). But the same reservations can be applied to environmental perception where the Gibsonian approach can be too stringent when faced with the symbolic import of built and planned environments.

Arnheim (1977) has extended his discussion of self-image and likeness to architecture. Like the objects of industrial design, the building is a self-image the more it is shaped to suit its function. It is "essentially an implement, shaped to suit its function. By its appearance it simply defines itself and its own kind" (p. 216). An example is a primordial hut, a cabin or shack, devoted primarily to protective shelter.

Other buildings, however, serve to embody qualities of their inhabitants, and the overtone of symbolism predominates. "The general notion of protective shelter is embodied in the particular shelter serving a particular person or living group, and the position of man in his world is reflected in the inhabitant's moving about within his four walls" (p. 216). A succesful church, palace or home, says Arnheim, concentrate on these effects.

Like sculpted objects, I shall treat buildings as centers. As we have seen, these too acknowledge the earth, and more forcefully than sculpture. Buildings, themselves, can be looked as centers within a format, be it landscaped or urban. And one can go in and explore the sub centers of a facade, or interior, or plan.

The Landscape

The building is always found in some context, be it urban or rural. In the latter case, we may speak of the traditional study of land-

scape architecture. These general properties include some surprising parallels with pictorial composition.

For example, a left-to-right asymmetry seems to exist in landscape designs as well. Arnheim (1989a) make the interesting notice of such an asymmetry in traditional Japanese gardens. The garden is normally designed with a dominant object on the left, a cascade for example, and the view si led to the right, often with the flow of water. This is called 'strong hand' composition. This is yet more cross-cultural evidence for the universality of the lateral asymmetry of visual space.

Traditinally anisotropy is found in landscape design too. "There is an almost complacent stability in patterns spreading within the horizontal plane, whereas upward and downward movement implies a dramatic interaction with the force of gravity. In the abbot's garden of the Nanzenji temple in Kyoto, there is a most impressive accumulation, raising the visitor's glance from rocks and spherical shrubs near the ground to treetops rooftops, and finally the slope of a wooded hill beyond the precint" (1966, p. 134).

Urban Format

Arnheim (1988) points out that his concepts of 'center' and 'format' find a correspondence in urban form in Kevin Lynch's (1960) notions of 'node' (p. 72 f.) and 'district' (p. 66 f.), and here it is worth noting that Lynch was a student of Arnheim's friend, Georgy Kepes. A district might in the scale of a city be a node in its own right, but when one focuses in to a level of sufficient magnitude it becomes a district, much like the frame of a painting. When we speak of urban format in the most general sense, we mean the city as a whole district in which whole neighborhoods may be nodes.

Quite generally, the inherent force of a 'district' upon a 'node' is much like that in Arnheim's 'structure of a square,' in which the frame of the square sets up variable forces upon its interior. Evidence of this at the level of environmental forces has been given by Alf Zimmer (1986), who has in fact shown that city spaces are completely non-Euclidean and that topological constraints of occlusion and, to a lesser extent, besideness, were the most salient cues to spatial localization.

When speaking of a city, Arnheim (1977) has outlined two compositional extremes. "At one extreme distinct orders may border upon one another with no pretense to a unity governing them all. Quite legitimately, there may be no relations between them other than the connecting links required for minimal interaction. At the other extreme are settlements in which a common purpose obliterates all distinction – for example, military camps or medieval

fortress towns. Such settlements are laid out according to simple geometrical schema. The same is true for founded cities, dreamed-up utopias, and the unrestrained fancies of city planning" (p. 202).

In the two cases, the power of the urban center has a different strength. While there is a great charm to old towns which are 'grown,' rather than designed, the kaleidoscopic complexity of the meandering roads may provide a great challenge to developng a mental map of the outlay. At its worst, one reaches the equivalent of Mondrian's 'atonal' paintings when a modern megopolis like Los Angeles leads to a 'forlorness' (Lynch, 1960, p. 32 f.). No better is the deadly perfection of the utopias mentioned above. Ideally, an urban area has a hierarchic structure, "in which an overarching order reaches only as far and as deeply as the functinal unity between components" (p. 202).

A good example of a medium-scale district is a square, or simply (to avoid reference to right-angularity) a crossing. As we would expect, "the more circular a square, the more self-contained it is" (p. 85).

Building and Environment
Buildings occur in natural and urban landscapes; both provide compositional formats which set us dynamics to which the building reacts, not unlike a work of art to its frame. The building within the landscape can either be an outgrowth of nature, or a rational declaration against it. The former view, of Le Corbusier and Frank Lloyd Wright, sees building as 'organic' and shaped in the manner of natural forms. The latter view, of French gardens of the seventeenth century, sees building as the rationalization of chaotic nature.

According to Arnheim so-called 'negative space' contributed by environmental formats has to be acknowledged as potential 'figure' too. Therefore not only can the center, the building, act or be acted upon. But the space can be an actor as well. If we take the case of buildings surrounding a square, the convexity of any three-quarters of the square can be seen as the receivers of outward forces which the buildings attempt to check. Since the square is only hollow space, it might seem that it has no contribution, but while it is true that there is no 'contour rivalry' – an accompaniment to the figure-ground problem – the square does virtually assert itself (Arnheim, 1977, p. 86).

Plan and Elevation
A complex set of relations exist in architectural compositions. "To deal properly with a building," says Arnheim (1988), "one has to consider it as a three-dimensional volume, extending in length as much as in height and centered around a place somewhere in the middle of its interior space" (pp. 197-8). This implies relations not

only between length and height, but both together in the whole of the building together.

Superficially, two aspects of a building may be identified, that of vision and the elevation and that of movement and interaction and the plan. "Since the arena of action is the horizontal dimension, the ground plan tells us how a building serves as the object and organizer of human activity" (p. 54). Arnheim says that there are varying degrees of transparency with which the plan is revealed, but in any case it has to be ultimately intelligible to be successful.

When the facade of a building is looked on its own, it has requirements very similar to a picture. It must be held together centrically. Arnheim (1988, pp. 191-2) points to the facade of the church of *Santa Maria della Spina* (c. 1250) at Pisa. He discusses how the business of the small church in aspiring to spiritual heights while weighing solidly on the ground, is made possible by a small concession to its unity as a composition. He finds that it is held together by the small 'microtheme' of the canopied figure of the virgin. The same cannot be said for the Romanesque church of *San Miniato al Monte* in Florence. This facade of odd-numbered piers splits itself in half, and its front floats apart with no strongly observable unity.

Furthermore, elevation has to express the building's relation to gravity. Every building embodies a fundamental relationship to the earth, whether trying to soar and leave it or comfortably rooting to it. Visually, verticality relies on unimpeded directionality of the upward vectors, and a weakening of the centric unity of the façade while conversely a rooted visual quality gives in to this centricity but goes further to win some downward vertical extension.

The old problem of the dynamics of the column is a problem of elevation. Arnheim (1977) conceives of the column as an eccentric system with enough bulk to gain identity as a centric system as well. The degrees of concession to centricity, to swelling and yielding, symbolically relates the architect's understanding of the building to its own weight. A modern Corbusier may stand unconvincingly and indifferently on thin posts whereas a classical building bows almost imperceptible with its traditional entasis.

Inside and Outside the Building

While the elevation and the plan of a building are useful shorthand approaches to organizing separate dimensions of the work, we already mentioned another requirement that they be meaningfully brought together into a synoptic whole, intelligible to both the architect and the experiencer of the building.

The architectural elevation and plan are, thus, only the most superficial aspects of a larger problem of exterior and interior

55

space. That is, how does the exterior form of the building, including the facade, interact with the interior space, including the plan? This is not a problem of figure and ground. Inside the Statue of Liberty, or an attic or crawlspace this problem presents itself – an interior with a figural quality. The above problem is different.

According to Arnheim (1966), "the internal shape corresponding to the external convexity of a cupola is not so much a concave hollow surface as it is a second, internal dome, made of air" (p. 4). These two 'nested volumes' do not provide a difficulty for visualization, themselves, but it is rather the fact that they are practically experienced from two loci. For instance, it is the facade that provides the spectacle of elevation, while in the interior we feel elevated ourselves.

In fact, the practical purposes of inside and outside are so varied that the problem presents itself as a real one. Some 'transparency' between the two is necessary. For instance, Arnheim (1989a) says that Eero Saarinan's chapel at M. I. T. defeats inside-outside transparency by covering the interior with a wavy screen" (p. 26). Further examples are Jörn Utzon's Opera House in Sidney and Soufflot's Pantheon in Paris which fail to convincingly assure us of the common origin of inside and outside (1977, p. 101). Of course, the degree of transparency between an external shape and an internal shape can be an aspect of style. Some buildings, like a Romanesque church, offer no surprises. But in any case some transparency is necessary.

The Interior

Even though the temporal mobility associated with architecture does not detract from its identity as a spatial art, it remains an essential aspect of its perceptual functioning. Arnheim, in fact, devoted an entire chapter to this problem in his *Dynamics of Architectural Form* (pp. 144-61). We only briefly touched upon urban localization, and within the building itself there are similar problems of intelligibility and way-finding.

The dynamics of shape can be generalized to two and three dimensions relating to pictures, sculptures and buildings. In all cases there is a clear interaction between centers, formats and the vectors that arise between them. Although Arnheim has written most on these visual arts, it is more important here to show that they form but one part of a larger psychology of art.

CHAPTER 6

THE DYNAMICS OF PANTOMIMIC FORM

Arnheim's discussions of the dynamics of visual action (hereafter 'pantomimic' form) were developed through his early preoccupation with film. His influential book, *Film as Art* (1932/1957), was published when he was only twenty-eight years old, and the bulk of what Arnheim has written on pantomimic form had its beginnings in film (Aristarco, 1951; Carroll, 1988; Dudley, 1978). However, this was merely an early point of departure and these same observations were extended to other arts like dance.

Arnheim's writings on film, and by extension on other pantomimic art forms, are often regarded as a kind of formalistic theory, and grouped with those of Eisenstein, Pudovkin, etc. Formalism is then considered to have been historically succeeded by realist (Bazin, Kracauer) and, ultimately, ideological (post-structuralism), criticism. Below, I shall have occasion to challenge this simple dichotomy, but it is accurate that after the nineteen 'thirties no prominent 'formal' theory of film was put forwarded. Thus the only book that Arnheim (1948) ever recommended in print was Renato May's *Il Linguaggio del Film* (1947). Only in the past few years have 'formalist' theories once again gained popularity and Arnheim's (1997, p. 183) challenge to ideological theories that "aesthetic laws [are nothing] other than laws of practical effect" is still pertinent.

It is telling that the neo-formalist school of David Bordwell (1989) and Noel Carroll have made use of a constructivist model of psychology consonant with inferentialist theories of vision (ch. 1). The constructive nature of the theory masks its basically psychological structure, while seeming to address more conventional aspects of content. The virtue of Arnheim's approach is that it resolutely remains with the visual without denying that beyond it. Recent approaches that look to ecological and dynamic semiotic impulses end up with a position not far from Arnheim (e.g. Grodal, 1997).

Already in Arnheim's student days, Gestalt psychologists were discovering the ways in which visual motion perception worked, and further how expressive qualities could arise out of these elementary mechanisms. By far, the most conspicuous of these investigations were those of Albert Michotte (1946/1962) on the perception of causality. Also important were Kurt Lewin's studies of *Ausdrucksbewegung* (expressive movement), which recent scholarship has indicated, also influenced the film-maker Sergei Eisenstein (Bulgakowa, 1992).

Of Arnheim's generation of Gestalt psychologists, seminal work continued to be produced by Karl Duncker, Erika Oppen-

heim and Hans Wallach on motion perception (for a review, Koffka, 1935, Wallach, 1965; Wuerger, Shapley & Rubin, 1996). Only the work of Fritz Heider, Gunnar Johansson, Gaetano Kanizsa and Fabio Metelli, however, explored both the functional and expressive aspects of motion perception. While Arnheim was well aware of the research of Heider, Kanizsa and Metelli, Johansson's (1975) first analyses of biological motion just preceded his second edition of *Art and Visual Perception* (1974) and were not incorporated into it.

Nevertheless, in the following I shall loosely adopt Johansson's model for a continuing background of Arnheim's theory because it represents both a rigorous mathematical approach that can also explain expression, and also has seen great extension in recent years in the work of James Cutting (1986), Dennis Proffitt and Johansson's school (Jansson, Bergström & Epstein, 1994), among others. The choice may seem strange in light of the fact of Johansson's avowal of a Gibsonian theory and Arnheim's own disappointments with Gibson (see ch. 1). But Johansson has also objected to certain aspects of Gibson's theory as well, and Johansson's acceptance of spontaneous organization makes this even clearer.

A further clarification can be gained by extending the paradigm of self-image and likeness (Arnheim, 1966). Similar to the examples given in painting, a pantomime can be highly abstract as a non-representational, animated film or highly realistic as an eyewitness film of some factual happening. At either extreme of self-image or likeness there are two essential ways of constituting a pantomime.

In order to briefly sketch the theory, we speak simply of motion, whether it is real or merely apparent (stroboscopic). We may call moving objects 'centers' which have functional dependence upon 'frames of reference' (Duncker) or 'common components' (Johansson) or 'formats' (Arnheim). The dynamic or vectorial quality of moving objects arises in the gradient of stimulation of temporal phenomenal cues.

REAL MOVEMENT - Dance

Obviously, the human form is the pantomimic form par excellence. But even in this canonical case there is a great complexity. The head and limbs serve as centers in motion within the framework of the body. Or the body serves as a center in motion within the framework of its immediate space. Or numerous dancers serve as centers in action amidst the format of the stage. In practice all interactions occur.

The body as a format has its own balancing center. According to Arnheim (1966), this has been intuitively located at the solar plexus. Ultimately, however, this is a matter of style. Historically distinct styles emphasize the upper part of the body and the

pelvic area as stylistic poles. La Meri divides Western and Eastern dance along this dichotomy: "The occidental dances from the waist down; the oriental from the waist up" (1964).

As a further outline of the format of body movements, Arnheim (1992) cites Rudolf von Laban's 'space crystal,' the polyhedric framework of body's movements in twelve different directions (p. 130). When Arnheim's students (1966) experimentally specified some of the dynamic constituents of different dance expression, he chose as relevant categories of analysis the center of movement (which, as we have seen, can have three meanings), the direction, tension, shape and range and speed. All can be subsumed under center-vector.

As Arnheim has noticed, his formulations bear comparison to other pronouncements of Laban. "The three variables of the...system are qualitative: *Space* refers to the path of the movement, which may be straight and direct or flexible and indirect; *Force* indicates the difference between vigorous strength and delicate weightlessness; *Time* distinguishes between slow lingering and a sudden start" (p. 408).

Arnheim's directed experiments also demonstrated the unanimity of form chosen by a dancer to shape a particular content such as 'strength,' 'sadness' (p. 71). This study was followed up in a series of exhaustive studies by the Italian psychologist Marco Sambin (1989). Theoretically, the isomorphic explanation could be explained with some of the formulations of the Laban student, Irma Bartenieff. Her "Effort Shape method teaches the dance students in the Laban manner not to aim for a particular shape of movement but for the movement impulse. This makes good sense, because it develops expression from dynamic action. Instead of performing curves and lines with her limbs, the dance makes her body move freely through space or push space out of her way, plow through it, press against it, etc. My guess is that the dance understands such meaningful action as coming down ultimately to the antagonistic innervations of flexor and tensor" (1989a, p. 92).

Acting

Live acting is a pantomimic art yet it does not have the concentrated expression of dance or the artificial manipulation offered by editing. Acting partaking neither in the artistic opportunities offered by dance and film art is therefore inadequate by itself, and requires supplementation by speech or song. Its status as a subordinate piece of the work is further pointed out by the limitations of stage action. As Goethe pointed out long ago, stage cannot partake except with difficulty in an epic style, and is best suited to drama. This further points to the text of the play.

While the western tradition has occasionally advised against realism in acting (Diderot, *Paradoxe sur le Comédie*), Arnheim finds in the traditional dramatic form of the Japanese *onna-gata* a proper approach to acting. The Kabuki actor, who may be an elderly, paunchy gentleman plays the part of the maiden. He does so, however, "not by perverting himself into effeminancy or by simply adopting the girl's behavior, but by shaping a stylized image of her external character through the instrument of his own body" (p. 76). Obviously, this is only possible if the performance is kept at a level of abstraction that will allow the maiden's character to be perceived.

Arnheim (1989a) recalls that the great Kabuki actor Baiko, after a performance, clarified that the style of the acting was actually quite realistic. "He showed us that although he will use his fan instead of a cup to take a sip of sake, he will strain his neck and lips to keep the imaginary liquid from dripping" (p. 24)

Format

The conditions for viewing pantomimic form parallel very closely those for visual images in general. In the case of painting, we have seen that the factor of depth raises questions about the intelligibility of the frontal plane which the visual action must serve. Depth introduces a competing view that distorts the frontal plane and also the correspondence between represented structure and seen structure, giving rise to the problem of 'angular transposition.' A similar problem occurs on stages, and can be grasped if we consider the optimal centric composition, the Japanese mandala, flat upon a stage setting.

It can be seen that, "the horizontal plane...suits the theater as a place of ongoing action but interferes with it as an object of contemplation. The situation predisposes the viewer to active participation in what he sees rather than to detached observation...The viewer – the dynamic center for whom the show is intended – sees it either from one side and therefore as compressed and encumbered or from above and therefore unnaturally...the conflict created by the imposition of an eccentric projection is basically unresolvable" (1988, p. 43).

Pantomimic form evidently arose from a social situation of religious ritual, and was an interactive form of expression. Like so many western art forms, however, it has devolved into object of contemplation. Classical ballet is the extreme example of this. Laban's distinction between 'ritual gymnastics' and 'temple dancers' points to this problem of format. The contemporary might wish to overcome the format of the temple dancers as for instance in classical ballet, but it cannot be done by simply abolishing the stage.

The effect of physical distance became evident in recent years when the performing arts tried to undo the separation introduced by the theaters and concert halls of recent centuries between players, actors, and dancers tucked away on the stage and the audience congregated in the house...Actors running through the aisles or front row customers tangling with Chekov's three sisters in a 'theater in the round' accomplished little beyond creating territorial disorder. It became clear that such a reintergration would require nothing less than a return to a different social relation between performers and audience, that is, a return to collective gatherings in which actors and spectators were participants in rituals embracing them both (1986, p. 73).

A more succesful solution may be found in the arrangement of the stage of the Kabuki-za Theater in Tokyo, which occupies the long side of the house. "Long and low, it can display crowd action without crowding. Figures can be distanced from each other by generous intervals without losing contact" (1989a, p. 2; on the Noh theater, cf. 1988, p. 146).

EDITED MOVEMENT

We have just described the human form as it is stylized in dance; now we discuss the possibilities of an inherently richer visual medium, film, gained by its possibilities of editing. Film is richer in the sense that it can capture both the 'dramatic' style of stage, as well as the 'epic' style of a mobile art like poetry (Arnheim, 1957). As already stated, by film Arnheim means something particular. On the one hand he means the pure painting in motion that does not suffer from the problems of admixing realism and artifice. On the other hand he means a photographic realism that embraces real things and happenings.

Arnheim (1974) discusses the psychological underpinnings of stroboscopic motion (pp. 387-92), departing from Wertheimer's (1912/1961) classic study. He uses Wertheimer's metaphor of the neural 'short circuit' that can account for both real and merely apparent motion. Earlier I pointed out that in dance, and acting, identity of elements does not generally pose a problem for composition, because in no case is there a skipping of intermediate phases of dancers or actors. Film, however, by its very nature is a discontinuous medium and the problem of phenomenal identity is absolutely central.

As Arnheim (1974) says, the viewer knows "only what he sees" (p. 392), therefore the director must preserve identity across leaps, and make sure that different things are seen as different. Fortunately, gestalt psychology early occupied itself with problems

61

of phenomenal identity (Koffka, 1935) which greatly enlighten Arnheim's discussion of such points in his *Film as Art* (1957) and *Art and Visual Perception* (1974).

Perhaps the most fundamental of these factors is the 'Ternus effect,' wherein similarity of shape maintains phenomenal identity in spite of physical displacement (**Fig. 10**; Ternus, 1939). Continuing the metaphor of the 'short circuit,' Arnheim lists factors of similarity and proximity as promoting identity. He says, "we are not dealing so much with fusion as with the creation of coherent shape in the time dimension" (p. 388). Subsequently, the Bremen psychologist Michael Stadler and his collaborators (Stadler, Stegnano and Trombini, 1979) have demonstrated the tolerance of various figures to being stroboscopically transformed into one another. They uphold the centrality of gestalt principles of organization in temporal visual perception.

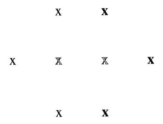

Fig. 10. The 'x' on the left shifts to the right (bold); the shadowed characters represent unchanging forms yet a simple shift of the 'x' is seen.

Montage

We have been speaking of what is called 'continuity editing,' wherein editing is utilized in order to preserve continuity and coherence. By its very nature, however, all film could be called montage in the same way that it is stroboscopic. Thus every frame presents a problem of identity, not to mention the necessary editing that is required to develop the filmed action. The classic Russian directors prefered to understand montage in this radical way. While it helps to press the problem Arnheim, instead, limits his use of the term montage to editing *with an observed discrepency* (1957, p. 101).

Arnheim seems to wish to admit that in the case of photographic action, for instance, a single cut is of a spatially continuous object. Until the sequence is cut, the body photographed must pass through all intermediate points; therefore, only animated sequences represent an actual frame by frame case of montage. Since in the case of single extended cuts no strict problem of identity exists,

expression here arises in the same way as in acting and dance. To go further, we can say that even in extended animated sequences where a single view point is given or strong phenemonal identity is preserved, expression also arises in the same way. Arnheim in fact makes the interesting challenge that no qualitative difference exists between the two kinds of visual action. In other words, an organic thing may move mechanically and an inorganic thing may look organic.

In such cases we can refer back to the earlier discussion of dance. If we do wish to speak of montage, Arnheim (1957) has provided a list of its principal means (p. 94 f.). Attempting to go beyond the schemes given by Pudovkin and Timoshenko, Arnheim nevertheless says his list is not intended to be "exhaustive, and certainly is not so. It is only meant to be a skeleton, to give a general survey" (p. 98). I would add that subsequent to the composition of this list in the 'thirties, Arnheim never had the opportunity to seriously consider revising it.

Principles of Montage

I. Principles of Cutting.

A. Length of the cutting unit
 1) Long strips. (The shots that are joined together are all relatively long. Quiet rhythm).
 2) Short strips. (...are all relatively short. Usually employed in cases where the shots themselves are full of rapid action. Climactic scenes. Effect of tumult. Quick rhythm).
 3) Combination of short and long – into long strips suddenly one or more quite short pieces. Or vice versa. Corresponding rhythm.
 4) Irregular – series of strips of variable length, neither definitely short nor long. The length dependent on the contents. No rhythmic effect.

B. Montage of whole scenes
 1) Sequential. (An action played straight through to the end. The next joined to it, and so on).
 2) Interlaced. (The scenes are cut up small and these parts are fitted in with one another. Alternate continuation of one and the other scene. Crosscutting).
 3) Insertion (of scenes or single frames in a continuous action).

C. Montage within an individual scene

1) Combination of long shots and close-ups. (by long shot, which is a relative term, is to be understood one which puts the subject of the close-up in a wider context).

a) First a long shot, then one or more details of it as close-ups. (Timshenko's 'concentration').

b) Proceeding from one detail (or several) to a long shot including this detail. (Timoshenko's 'enlargement').

c) Long shots and close-ups in irregular succession.

2) Succession of detail shots (of which none includes the subject of the others). (Timoshenko's 'analytical montage'). As in I B, in the combining of whole scenes, so here within the individual scenes, montage may be used for succession, crosscutting, or insertion.

II. Time Relations

A. Synchronism

1) of several entire scenes (Timoshenko's 'parallel events;' Pudovkin's 'synchronism') joined in sequence or crosscut. In sequences usually connected by continuity titles: 'While this occurred in X, in Y...'

2) of details of a setting of action at the same moment of time. (Successive showing of events taking place at the same time in the same place. The man is here, the woman is there, etc.) (Timoshenko's 'analytical montage'). Unusable.

B. Before, after

1) Whole scenes, succeeding each other in time. But also inserted scenes of what has happened ('memory') or of things that will happen in the future ('prophetic vision'). (Timoshenko's 'return to past time' and 'anticipation of the future.')

2) Succession within a scene. Succession of details which succeed one another in time within the whole action. For example: first shot – he seizes the revolver; second shot – she runs away.

C. Neutral

1) Complete actions that are not connected in time but only as regards content. Eisenstein: The shooting of worklmen by soldiers cut-in with an ox being slaughtered in a stockyard. Before? After?

2) Single shots that have no time connection. Rare in narrative films; but, e.g., in Vertov's documentaries.

3) Inclusion of single shots in a complete scene. For example, Pudovkin's symbolic montage: 'joy of the prisoner.' Shots inserted without time connection with the event.

III. Space Relations

A. The same place (though different time)
 1) In whole scenes. Someone returns to the same place twenty years later. The two scenes succeeding each other or crosscut.
 2) Within a single scene. "Compressed time." A leap forward in time so that one sees in unbroken succession what is happening in the same place but actually after a lapse of time. Unusable.

B. The place changed
 1) Whole scenes. Succession or interlacing of scenes which occur at different places.
 2) Within one scene. Different partial views of the place of action.
 3) Neutral. The same as IIC (1-3)

IV. Relations of Subject Matter

A. Similarity
 1) of shape
 a) of an object. (A round hillock follows on the rounded belly of a student.)
 b) of a movement. (A playground swing in motions follows on the swinging pendulum of a clock.)
 2) of meaning
 a) Single object. (Pudovkin's montage: Laughing prisoner, brook, birds bathing, happy child.)
 b) Whole scene. (Eisenstein: The workmen are shot down, the ox is slaughtered.)

B. Contrast
 1) of shape
 a) of an object. (First a very fat man, then a thin one.)
 b) of movement. (A slow movement followed on a very rapid one.
 2) of meaning
 a) Single object. (A starving unemployed man; a shop window full of delicious food.)
 b) Whole scene. (In the house of a rich man; in the house of a poor one.)

C. Combination of similarity and contrast

1) Similarity of shape and contrast of meaning. (Timoshenko: The feet of a prisoner fettered in a dungeon and the legs of dancers in a theater/ Or: the rich man in an armchair, the rebel in the electric chair.)

2) Similarity of meaning and contrast of form. (Something of this sort in Buster Keaton as Sherlock Holmes. He sees a huge picture on the screen of a couple kissing each other, and kisses the girl in the operator's box.)

Cinematography

Not only did Arnheim address problems of editing, but also of cinematography. The branch of film devoted to cinematography is opposed to mise-en-scene as that which the camera does to the scene. Arnheim extensively treated of this problem, not only providing a table of principal mechanisms, but also discussions of cinematographic problems of color and framing. Below Arnheim's "formative means of camera and filmstrip" are given (from Arnheim, 1957, pp. 127-32).

Summary of the Formative Means of Camera and Filmstrip

1. Every Object Must be Photographed from One Particular Viewpoint.
> Applications.
> a) View that shows the shape of the object most
> characteristically.
> b) View that conveys a particular conception of the object
> (e.g., worm's-eye view, indicating weight and forcefulness).
> c) View that attracts the spectator's attention by being unusual.
> d) Surprise effect due to the concealment of the back side
> (Chaplin sobbing; no!—mixing a cocktail!)

2. Objects are Put Behind or Beside One Another by Perspective.
> Applications.
> a) Unimportant objects are hidden by being wholly or
> partly covered; important objects are thereby emphasized.
> b) Surprise effect by the sudden revealing of what had been
> concealed by something else.
> c) Optical swallowing-up – one object comes in front of
> another and obliterates it.
> d) Relationships indicated by perspective connections (convict and prison bars).
> e) Decorative surface patterns.

3. Apparent Size. Objects near the front are Large, and those behind small.
> Applications.
> a) Emphasizing of individual parts of an object (feet thrust toward the camera come out huge).
> b) Increase and decrease of size to indicate relative power.

4. Arrangement of light and shade. Absence of Color.
> Applications.
> a) Molding the volume and relief of the object at will by placing of lights and shadows.
> b) Accentuating, grouping, segregating, hiding by the arrangement of light and shade.

5. Delimitation of the Size of the Image.
> Applications.
> a) Selection of the theme of the picture.
> b) Showing the whole or a part.
> c) Surprise effect. Some object, which was always present but had been cut off by the frame, suddenly comes into the picture from outside.

6. Distance from the Object is Variable.
> Applications.
> a) Objects can be made small or large.
> b) Choice of optimal distance (a pin, a mountain).
> c) Relativization of dimensions (doll's house – human house).

7. Absence of Space-Time Continuum
> Applications: Montage.
> a) Showing beside (and among) one another, episodes that are separate in time.
> b) Juxtaposition of places that are actually separate.
> c) Presenting the characteristic features of a scene by showing selected portions of it.
> d) Combination of things whose connection is not one of time and space but of meaning (symbolic) or shape.
> e) Imperceptible montage. Illusion of altered (fantastic) reality (sudden appearances and disappearances, etc.).
> f) Rhythm of the sequences of shots by 'short' or 'long' montage, etc.

8. Absence of Spatial Orientation.
> Applications.

a) Relativization of movement: static things move, or moving things stand still.

b) Relativization of spatial coördinates (vertical, horizontal, etc.).

9. Lessening of Depth Perception
 Applications
 a) Perspective alterations of size (cf. point 3) made more compelling.

 b) Perspective connections in the plane projection (cf. point 2) made more compelling.

10. Absence of Sound
 Applications
 a) Stronger emphasis on what is visible; as, for instance, on facial expression and gesture.

 b) Qualities and effects of unheard sounds specially brought out by their being transposed into the sphere of the visible (suddenness of revolver shot – birds rising).

11. The Camera is Mobile
 Applications
 a) Representation of subjective states such as falling, rising, swaying, staggering, giddiness, etc.

 b) Representation of subjective attitudes such as the individual being always the center of the scene (i. e., of the plot).

12. The Film Can Run Backwards
 Applications
 a) Reversal of the direction of movements.

 b) Reversal of events (fragments join to make a whole object).

13. Acceleration
 Applications
 a) Visible acceleration of a movement or an event; change in the dynamic character (to symbolize bustle).

 b) Compression of time (the breathing of flowers).

14. Slow Motion
 Applications
 a) Visible retarding of a movement or an event; change in dynamic character (laziness, gliding).

 b) Lengthening of periods of time (showing more clearly events that pass very rapidly).

15. Interpolation of Still Photographs.
 Applications
 a) Sudden stopping of movement; paralysis (Lot's wife).

16. Fading in and out, Dissolving.
 Applications
 a) To mark breaks in the action.
 b) Subjective impressions: waking up, falling asleep.
 c) Stronger contact and coherence between two pictures by dissolving one into the other.

17. Superimposition (Multiple exposure).
 Applications
 a) choas, confusion.
 b) indication of relationship by juxtaposition and superimposition.
 c) Indication of symbolic similarities.
 d) Modifications of reality (wraiths).

18. Special Lenses.
 Applications
 Multiplication, distortion.

19. Manipulation of Focus.
 Applications
 a) Subjective impressions: waking up, going to sleep.
 b) Suspense by gradual exposition ('appears slowly').
 c) Directing the spectator's gaze to the back or the foreground.

20. Mirror Images.
 Applications
 Destroying, distorting an object (or the 'world').

Film Format
The format of the film is the way in which the image is framed by the screen. Arnheim (1988) says that "The balancing center of the film image does not belong as much to what is shown on the screen as it does to the image's frame. Like the crossed threads in a telescope or gunsight, the balancing center of the framework is imposed upon a passing scene. That scene conforms much less to the compellingly to the framework because, being in motion, it constantly changes in relation to it. Also, it has no static structure within itself; it is a flow of transformations, during which its center moves

from place to place. Consequently, composition in performance is more transitory, much looser than in the immobile arts" (p. 214).

Even so, the director has some control on how much the image is pictorialized by changing what is called the aspect-ratio of the image, referring to the ratio of height to width. The classic cinema was very paintling-like with a modest width. Along with other developments such as sound and color, the aspect ratio has been widened. Arnheim (1971a) disparages at this development and says that, "the wide screen...has gone a long way toward destroying the last pretenses of a meaningfully organized image" (p. 5).

Changes in the introduction of digital media coupled with Arnheim's famous negative pronouncements on the talking film, might make his approach appear hopelessly outdated (Carroll, 1998). Arnheim's extensive arguments against talking films cannot be considered here but suffice it to say that whatever the industrial exigencies that push new technologies into our lives, the concentrated effect of expressive form carries the film. Similarly, as Arnheim (1996, pp. 24-30) himself argued in regard to the digital revolution, this innovation has merely accelerated the rethinking of the arbitrary distinctions between genres of visual action, between organic and mechanical. Arnheim's reflections, based on sound psychological principles, will continue to enlighten this enterprise.

CHAPTER 7

THE DYNAMICS OF MUSICAL FORM

It is unfortunate that Arnheim never devoted himself primarily to music, using it mostly for comparisons with the visual arts. He did, however, write the important essay, "The dynamics of musical expression" (Arnheim, 1986; Larson, 1993), which was pertinently written after *The Power of the Center* (1988), and is based upon its compositional principles. It shall provide the basis for this chapter.

But this should not obscure the fact that Gestalt psychology and music have had a passionate relationship. Christian von Ehrenfels himself wrote minor operas in the Wagnerian style and Carl Stumpf was the most important authority on *Tonpsychologie* of his generation. Stumpf's principal work was continued by his student, Wolfgang Köhler (1923), while another student, Erich M. von Hornbostel (1975), continued another of Stumpf's specialities in ethnomusicology. Both taught Arnheim in Berlin. It was Max Wertheimer, however, who was important for a gestalt psychology of music because he included music in his lectures on the psychology of art. Unfortunately, nothing is known of their content except for student's recollections of the 'physiognomic game' in which Wertheimer would improvise on the piano to match the personality of some student, the identity of which was guessed (usually correctly; see Heider, 1983).

Of Arnheim's generation, there were important works on music from the gestalt perspective, Kurt Huber's *Der Ausdruck musikalischer Elementarmotive* (1923), Carroll Pratt's *The Meaning of Music* (1931) and Leonard Meyer's *Emotion and Meaning in Music* (1956) are prominent examples. Most compelling for our present purposes, however, was the work of the musicologist Victor Zuckerkandl (1896-1965), who devoted himself to the task of a gestalt analysis of music to parallel Arnheim's of visual art, and in fact he published his major work, *Music and the External World* (1956), two years after Arnheim's *Art and Visual Perception* (1954). Arnheim never recalls actually meeting Zuckerkandl, although he greatly respected his work. It is significant that in the same way that Arnheim provided more contemporary psychological foundations for the formulations of thinkers like Wölfflin, Zuckerkandl was himself a disciple of Heinrich Schenker, the famous author of the 'Schenkerian method.' Schenker and Wölfflin are often seen to contribute to a similar formal analysis. Arnheim who included the history of music in his doctoral study and played the violin his entire life, was very much relieved of writing about music! Thus in the following I shall rely on Zuckerkandl to fill in details left by Arnheim's general theory.

71

Writing on music as a self-image, Arnheim (1992) says that music "has essentially the character of an event happening at a particular place and time and appearing as a part of a setting. This is especially evident when music fulfills a defined function in a social setting, a ceremony, a funeral, a celebration" (p. 30). However, music can also point by its meaning beyond itself. Then, instead of being a part of some present happening, it depicts a subject 'beyond itself' and is a likeness.

As noted in Chapter 2, Arnheim defends a cognitive view of expression, thus he never repeats the cliché that 'music expresses the emotions,' a viewpoint seconded by Meyer and Zuckerkandl. This also makes Arnheimian approach amenable to recent cognitive approaches that are not explicity based on emotional triggering (Sloboda, 1985; Lehrdal & Jackendoff, 1983).

Arnheim's gestalt theory of musical form is entirely consistent with his larger theory of composition (Arnheim, 1988). Tones are perceptual *centers* which interact within the *format* of the scale. In Victor Zuckerkandl's (1956) words, approvingly quoted by Arnheim, (1974, p. 432), "The dynamic qualities of tones can be understood only as manifestations of ordered forces. The notes of our tonal system are events in a field of forces, and the sounding of each tone expresses the precise constellation of forces existant at the point of the field in which the tone is located. The sounds of music are carriers of active forces. To hear music means to hear the effects of forces" (pp. 36-7, translation corrected by Arnheim).

As in the other arts, a particular work of music must find an appropriate form for a particular theme. Arnheim (1977) thus follows Schenkerian theory is saying that "the particular quality of a particular work resides neither in its basic theme, which it may share with other works, nor in the surface texture of its style, but, as the musicologist Heinrich Schenker has taught us, in the 'middleground' of the design, which tells what the artist has accomplished by applying a style to a theme" (p. 252).

This is entirely consistent with Arnheim's larger theory in which the success of a work lies in its ability to find a suitable form for an intended content. Zuckerkandl (1973), further expounding the Schenkerian theory, develops this notion fully in his chapter "Hearing organic structure." He speaks of the core melodic progression in the background as the 'skeleton.' In the foreground are the detours that link core elements together. Both Arnheim and Zuckerkandl hold that while a simple tune and a masterpiece can share a skeleton, the way the complex foreground of the surface interacts with the skeleton determines its superior aesthetic value.

The Scale

Music is defined as tonal motion and in diatonic music the scale is the frame in which tonal motion can occur. In Western music, the scale has been developed from the joining of Greek tetrachords. The ancient tetrachord consisted of a half step followed by two whole steps in the ascending direction. Western music has inherited this form which it has inverted and doubled to form the major scale.

In the diatonic scale, "The scale is subdivided into two tetrachords of two full tones and one half tone each, the first reaching, in the key of c, from c to f, the second – after an interval – from g to c" (1969, p. 218). The two tetrachords have a 'figure' quality, and the interval between them, the step from the fourth to the fifth, that of 'ground.' Furthermore, the half-step at the end of each tetrachord has a constrictive feeling, like the placement of columns in a facade. This is especially true of the upper tetrachord because it also ends at the octave.

> This tendency toward closure is more pronounced in the upper tetrachord, which ends with the tonic, than in the lower. The lower owes much of its finality to the fact that it is readily perceived as the upper tetrachord of a related key, e. g., of the key of F in the case of the C scale (1986, pp. 218-9).

The two tetrachords are overlaid in a 'paradoxical manner' by the triad, which conversely structures the scale by three steps of unequal length. "In the major mode, the first step, a major third, contracts into a minor third, as though gathering its strength, and then stretches for the upward leap to the tonic" (p. 219). The third and the fifth function as platforms of stable rest.

The two systems of tetrachords and triad, "makes for ambiguity at many and perhaps all levels of the scale" (p. 219). Arnheim says, for instance, that the e of the C scale is in one respect at stable rest as a stage of the triad, but in tension as the constricted upper end of the lower tetrachord. "A tone will assume either the one or the other function and character, depending on the compositional context" (p. 219).

In Arnheim's words, "only because of this structural complexity of the diatonic scale, can Western music be derived from it" (1969, pp. 219). In twelve tone music, in which the intervals of the diatonic scale are flattened out into twelve equal half steps, "the framework changes so frequently as to be no longer distinguishable in principle from the attractive powers exerted by the single tones upon one another" (1986, p. 217).

Major and Minor Modes

Earlier, it was pointed out that the diatonic order is derived from the joining of two inverted, Greek tetrachords. This is only one scale of the diatonic order. It is is the major mode. In other words, the major mode begins with the first whole step. But one could also begin with the second, third, fourth or fifth note, in which case other modes would be activated. In medieval church music each of these possibilities, in fact, had a name as Dorian, Phrygian, Lydian, Mixolydian. In the seventeenth century, the two modes beginning with the first note (Ionian) and sixth note (Aeolian) remained the only ones in use, while the others fell out of use. These two modes are our modern major and minor modes.

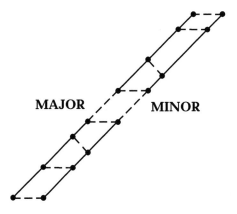

Fig. 11. The structural relationship between major and minor modes.

The vigorous and forceful perceptual quality of the major mode and the sad and melanchology perceptual quality of the minor mode has always been a primary candidate for conventionalist aesthetics. Arnheim (1986), however, affirms that "something much more direct takes place: one hears the sadness *in* the minor mode. The music *is* and sounds sad" (p. 221). Zuckerkandl (1956), in his chapter "Associationism," attempts to refute a conventionalist theory of the major and minor quality (c.f., Handel, 1989).

As Arnheim goes on to explain, "the decisive structural difference between major and minor resides in the position of the half steps. In its upward climb the major third pushes vigorously toward the completion of the lower tetrachord. In the minor, like a climber carrying a heavy load, the action sags back at the second step, which requires a double effort to reach the level of the fourth. This behavior becomes even more pronounced in the upper tetrachord,

where the climber already lags behind the brisk advance of the major at the first step, so that an even more excessive effort is required to reach the leading tone" (p. 220; **Fig. 11**).

Arnheim (1986) qualifies his structural explanation of the major and minor qualities by noting that the two did not have the same quality when the other modes were in active use. "[T]he minor mode displays the character is has for us only because it is perceived as a deviation from the major" (p. 222). But in this way its quality is in no way less spontaneous or real. Like all perceptual phenomena, mode quality is relationally determined.

The Tonic

A general tonic, if not more narrowly a traditional tonic, is naturally and spontaneously established in all music. While various explanations have been offered for this, Arnheim (1989a) attributes it to the gestalt tendency to simplest structure. "[It] makes us hear a musical interval such as C - E as based on the tonic C even though it could just as well be the fourth and six of G major or the minor third and fifth of A minor. These other percepts, however, would involve reference to an outer base and thereby introduce a tension that the law of simplicity makes us avoid" (p. 24).

This creates the complex situation where ascension or descension in a scale has to meet the recurring tonic. In Arnheim's words, "ascending pitch, like the hare of the fairy tale in his race against the hedgehog and his wife, has hardly liberated itself from the pull of the lower base when the magnetism of the final state of rest at the top begins to attract it" (1986, p. 220). Zuckerkandl (1956) similarly calls the dynamic quality of progression through a seven-tone scale *leaving* and then *reaching a goal* (p. 97). "Going away from the center of force, we immediately find ourselves going toward it, toward its repetition at the next octave" (p. 103).

The stable fifth of the scale is propitiously the point at which the tone ends its departure from and begins its advance toward the tonic. The situation, according to Arnheim, is not unlike the structure of a picture frame, which in the center modifies objects equally, but toward the upper and lower edges exerts its pull (1974, p. 40). The head of a portrait is then not unlike the 'leading' tone of the scale. (this will be qualified below).

Since tonality is a working of the tendency toward simplest structure, Arnheim is willing to agree with the composer Arnold Schönberg that there is no difference in principle between tonality and atonality. Arnheim (1986) says that, "It seems equally appropriate to describe tonality...as the limiting case in which the safety of a persistent base of reference is maintained at some length" (p. 225). Zuckerkandl (1959) seems to agree, for in writing on harmony says, "harmony...is not a black and white language...[I]t has

all the intermediate stages at its command, all the degrees of half certainty and half-doubt regarding the dynamic position of a chord" (p. 211).

Tonal Motion

In chapter 5, I pointed out that Wertheimer's principles of perceptual organization were intended to cover aural percepts, like music. In 1954 Arnheim wrote that these principles ought to be more fully explored in hearing (p. 380). Subsequently, psychologists (Paolo Bozzi, Giovanni Vicario) have mapped the spatial aspect of visual organization to the tonal height of hearing, with great success.

Instead of tone height, some psychologists speak of pitch, the perceived frequency of a sound. However, just as one never sees 'the color red' as such, one never hears 'the tone e' as such. In Wolfgang Köhler's (1915) venerable words, "pitches, whatever they may be, do not deserve the place hitherto accorded to them" (p. 97). Gestalt psychologists, therefore, speak of tones and leave pitch to physicalistic interpretation of sound (Hermann von Helmholtz). While for Arnheim the tone is a perceptual *center*, he calls it the 'tone-creature.'

Tones in music do not properly succeed one another, but face the same problem of phenomenal identity as it is found in stroboscopic motion (Ternus, 1936). The tone-creature is actually most often maintaining a phenomenal identity throughout a composition; a point first made by Zuckerkandl (1956). Phenomenal identity of a tone has two ways of being maintained, either through temporal or through tonal proximity (Bozzi and Vicario, 1960). Since most often tones are continuously sounded, the main burden of identity falls on tonal proximity. In what is known as a compound melodic line, one instrument sounds like at least two distinct voices. This is a breakdown of phenomenal identity, and is purposely used when one instrument is to indicate two voices.

Compared to harmonic movement, which I discuss below, tonal motion is a simple matter. It involves simply the change of place of an invariant agent. It is the genetically prior way of conceiving of tone, to which harmony is added as a sophistication.

Tones gain their character by position in the scale. Intervals are mere pitch distances, and cannot by themselves determine the character of the seven-tone scale. "A tone's place and function within the scale," therefore, "determines its dynamics" (1986, p. 219). Thus, because of the above discussed complexity, one never hears 'the tone e' as such, and one cannot hear a neutral interval. The succession of the two tones of different pitch, e-a, will be heard as the tone e with a particular dynamic quality and the tone a with a different dynamic quality (p. 91). Zuckerkandl emphasizes that intervals are not heard by pitch distance, but by the dynamic quali-

76

ties of tone syllables (*do re mi fa sol...*). The succession of e to a is a 'fourth,' not by pitch distance but because it matches *sol-do* and this in turn is known to be a fourth.

In recognition of this, Zuckerkandl in fact devised a sytem of simply discussing tones ordered in the scale when discussing musical compositions (1956, p. 34; c.f., Handel, 1989, pp. 334-336). Arnheim is none too far from this when he says that "gestalt psychologists might refer to the solfeggio way of naming sounds, which asserts that the absolute pitch level of a tune doesn't matter. *Do re mi*...means conceiving of musical structure purely in terms of relations" (1989a, p. 8).

I already pointed the fifth as the perfect pivot in the diatonic scale. At the very center of Arnheim's understanding of tonality is the anisotropy of tonal space, already discussed in chapter 2. The scale is overlaid with a 'gravitational' vector. "Moving upward anywhere on the pitch scale carries the connotation of a victorious liberation from weight, whereas descent is experienced as a passive giving in to weight...A downward move toward the tonic is reinforced by the gravitational pull. An ascent toward the upper base of the octave pits the upward pull of the tonic against the downward pull of gravity" (Arnheim, 1986, p. 217).

Harmonic Motion
Harmony is based upon the simultaneous sounding of tones, chords. One can say that as melody is the movement of tones, harmony is the movement of chords. True harmony is more than polyphony, or the existence of additional voices. Harmony occurs when there is a genuine new dimension of 'vertical' structure.

Arnheim says that harmony is more than simply enrichment of a melodic line. It bespeaks a more complex image of the order of things. "The sound object endergoes modification within itself while it moves through time...Being becomes process modified by happening and action" (1989a, p. 37).

Zuckerkandl (1959; Handel, 1989, pp. 339-342) has outlined a simple theory of harmonic progression. Like the special identification of tones, chords are identified with the root tone as a *harmonic degree*. The tonic serves as the root of the chord and the chord of the first degree has the tone 1 of a seven tone order as its root, etc. It is identified as I. Chord progressions are identified by the interval between roots of successive chords (there are conventions observed here, thus fourths, sixths, sevenths are observed into other intervals and of course octaves are ignored).

"In general," Zuckerkandl (1956) writes, "the chord does not express the direction in which it points as clearly as does the tone of a melody. There is audible, in every chord, in accordance with its place in the tonal system, a particular state of tension that

belongs to it alone; yet it goes no further than a general will to pass beyond itself" (pp. 49-50). The tonic chord is the 'center of action' while the dominant seventh chord "makes audible...not only a pointing-beyond-itself but at the same time the goal of that pointing" (p. 50). The chordal succession dominant tonic is the harmonic equivalent of the melodic steps 2-1 and 7-8" (p. 50). Correspondingly, two chords are nearest each other when a fifth separates their roots.

If the fifth in harmonic motion is like the second in melodic motion, harmony is not purely symmetrical. Only V is 'above' I and has the directional quality, whereas 1 can be reached from above or from below. One cannot reach I through IV. Zuckerkandl (1959) concludes that "tonal harmony in the last analysis will always appear on the way to a dominant cadence and contained in the formula I...V - I" (p. 200). I...V is 'away from' the tonic chord but V-I is the only way 'back to' it.

The addition of harmony presents further difficulties for phenomenal identity. In the development of the melodic line, harmony can easily interfere with its phenomenal identity. It is necessary, therefore, to keep it simple. Arnheim (1974, p. 87) gives an example from Walter Piston's *Harmony* (1941).

Meter and Rhythm

While tonal proximity was suggested as the most important factor in tonal and harmonic grouping, temporal proximity is the domain of meter and rhythm. Both are, like melody, important formative elements in music.

Meter refers to (1) the regular time divisions of the beat and (2) the groups into which these beats are organized. More mundanely, music is notated and understood as structured after a meter. We say this piece is in two-four time, three-four time, six-eight time, etc., meaning it has two beats per measure in quarter notes.

The beat arose with polyphony and the need to coordinate multiple voices in time. Arnheim (1974) compares the measured beat to the implicit coordinates of the vertical and horizontal in painting, not literally present but always implicitly so. The deviation of a syncopated tone, in fact, can induce the regular beat in the same way that an off-center element can strengthen the frame in a visual composition. Just as in measured poetry hardly ever is the strict beat adhered to.

While the beat has existed in Western music for a long time, measured music arose later. Measure is a formalization of the spontaneous organization of sounds into simple groups of two or three. An older view regarded such groups as subjective impositions of the subject (there are traces of this view in Kurt Koffka's (1909) early work on rhythm). The view persists today in the concept of

'chunking,' which despite similarities to gestalt organization is not spontaneous and a dynamic property of the stimulus itself.

The work of the Gestalt psychologist Paul Fraisse (a student of Albert Michotte) has been seminal for metrics. His (1975) reproduction experiments proved "there is a systematic deformation of the sequences of durations towards a good form; the interdependence of the intervals is such that the modification of one of them causes a reorganization of all the others" (p. 231).

Zuckerkandl (1956) stresses the periodicity of the bar or measure. It has a quality of going away and coming back; it is a cycle. He thus defines a measure as "a whole made up, not of equal fractions of time, but of differently directed and mutually complementary cyclical phases" (p. 168).

What then is rhythm? Rhythm in measured music is time pattern related to a beat. "The wave is the meter; rhythm arises from the different arrangements of the tones on the waves" (p. 172). Following upon his definition of melody as motion in the dynamic field of the tones, he likewise calls rhythm "motion in the dynamic field of meter" (p. 174).

Fig. 12. A bar from Schumann's Träumerei.

Phrasal Dynamics

Arnheim (1986) gives a couple of structural analyses of melodic contours to give a hint of the complexity encountered in actual works of music. They serve to show how elementary structure directly gives rise to musical expression. His first example is the melody of Schumann's *Träumerei* (**Fig. 12**), in which he utilizes the above principles to explain its character of a *reverie*, conveying "the carefree rising to lofty heights, undertaken with a minumum of effort and risk" (p. 223).

In the piece, the tone creature, after leaping to the tonic and having an ample rest, then sinks back a half step, "as though even the stable base of the tonic could not quite check its languidness" (p. 223). The step backward, however, is the impulse for a rising to the upper tonic by means of the triad. The "disparity between the amplitude of the adventure undertaken and the smallness of the investment and risk it requires" (p. 223) gives the first phrase a playful and humorous quality. Soon afterward, the tone creature sinks back "by means of gliding steps" with "token" attempts to gain height. The downslide stops one step short of the base, "announcing a resumption of the dreamy exploit" (p. 223).

79

Arnheim next analyzes the unaccompanied viola solo at the beginning of Béla Bartók's *Sixth String Quartet* (the Figure is transposed to the treble cleff; **Fig. 13**). This solo, marked Mesto, is a melancholy, slow performance of constraint. This effect is achieved by the utilization of the smallest steps available in the scale. This is afforded by the use of the C-sharp-minor key.

The solo begins with 'cautious' half steps upward and then 'tumbles' downward in whole steps, "as though the cramp of the beginning had been momentarily dissolved" (p. 224). The tone-creature dwells at the tonic "for confirmation and recovery of energy," and then, again in half-steps, rises to the fourth and then to the tonic.

Arnheim admits that in the Schumann example, he has ignored the range of duration of the tones, their placement in the meter, as well as the chords and secondary voices. But such an extended analysis, he says, "would not alter the basic thesis I am trying to illustrate" (p. 223).

Fig. 13. A bar from Bartók's Sixth String Quartet.

Compositional Structure
The compositional structure of music has been elucidated by Arnheim following the general principles given above regarding temporal compositional structures. "In music," Arnheim (1986) writes, "repetition can have two different effects. It can be experienced either as a repetition of, or as a return to, the phrase that appeared earlier. In the former case the time sequence of the music proceeds undisturbed but offers an analogy to what was heard and remains in the past. In the latter case the listener interrupts the time sequence and returns the phrase to 'its proper place' earlier in the composition" (1986, p. 71). This latter form of composition occurs, according to Arnheim, when perceived similarity is absent in the. . .

Arnheim would probably agree with Zuckerkandl's (1956, p. 237) classification of circular and serial forms, or the forms of the 'arrow' and the 'circle' (Zuckerkandl, 1959, p. 83). The circular forms develop symmetry, equality and polarity, and manifest themselves in bipartite, tripartite structures.

/ a / b / a / b /

This is the effect of repetition. An example is the return of the minuet after the trio. "The difference in position within time sequence is acknowledged...when in music a theme is restated at a different pitch level or modified by augmentation, inversion, or similar change" (1986, p. 71).

Serial forms, on the other hand, develop increasing intensification and advance, rather than return. They are manifested in traditional forms as the rondo, passacaglia. Schematically, such a form might look like the following.

/ a / a / a / a /

The repeated phrase refuses to fit and therefore is returned to the only place where it fits. This alternative amounts to a reshuffling of the musical time sequence.

The above compositional structure is the most important determinant of the temporality of a work of music. I have already pointed out that, as for all the arts, time is not a primary aspect of musical experience. However, when a competing system, for instance, a finale, is expected, time is experienced. "A goal is established in the awareness of the listener and acts as an independent system toward which the music is striving" (1986, p. 87).

More radical examples are found in contemporary music where the melodic flow is deliberately fractured "so that even short intervals are strong enough to turn elements into self-contained, often point sized systems" (p. 87). Arnheim calls this experience "waiting for the next tone" (p. 87). The end result is that "A piano piece by Debussy is more nearly a mere succession in time than a movement of a Corelli sonata" (1986, p. 225).

This limited role of expectation rules out some of Leonard Meyer's (1956) explanations of gestalt process in music. He defines dynamic quality as a tendency created by expectation, which is set up along the lines of information theory. But we have already seen that expectation is a dynamic striving for balance rather than a result of broken redundancy (also Zuckerkandl, 1973, p. 128).

The alliance between Arnheim's larger theory and the extremely rich works of Victor Zuckerkandl creates a powerful perceptual approach to music. While western music is based on conventional facts determined by the scale, once it is adopted basic dynamic principles come into play that determine expression.

CHAPTER 8

THE DYNAMICS OF POETIC FORM

As with the case of music, Arnheim never devoted himself primarily to poetics. But as also in the case of music, the picture expands when we take into account the larger context about a gestalt linguistics and also take into account some of the work his more traditional studies of the visual arts have inspired. In fact, in his complete oeuvre there is a substantial amount from which one could construct a theory, and this is what I try to do in the present chapter.

'Gestalt linguistics' as a concept may sound unfamiliar. But one could look to the early theories of Karl Bühler (1879-1962) (and, perhaps also, his student Friedrich Kainz) for a tradition in linguistics that was gestalt oriented (Bühler, 1930/1990). The structuralism of Roman Jakobson (1896-1982) departed closely from this work (Holenstein, 1976). In spite of some contemporary interpreters of the 'Cognitive revolution,' Gestalt psychology and *Chomskyan* structuralism do not have as much in common as might be thought. Whereas Chomskyan structuralism considers grammar an autonomous non-semantic system, Jakobonian structuralism sees simply two poles of 'open' and 'closed' forms, which linguistically *structure* and give *content* to language. The former acccomplishes this through a topological-like grammar and the former through the lexicon; both, however, are semantic. Unfortunately, Arnheim has told me he never read Jakobson, nor met him, although their paths crossed in New York in the 'forties and in Cambridge, Massachusetts in the 'seventies.

While Chomsky steered structuralism in one direction, other structuralists steered the theory in the other direction. The fallacy of linguistic determinism lies in positing that naming can either genetically or logically proceed earlier than perceptual discrimination. Characteristic of this thinking is a story that Arnheim takes from Herder (1969, p. 238). According to Herder, a primitive man comes across a lamb, which he has never seen before. He is unable conceptually to represent it, until at last it bleats. The man cries – 'Ah! You are the bleating one!' – and it remains with him. Arnheim has called any theory that makes this mistake – whether it is found in Herder, Humboldt, Cassirer, Sapir or Whorf – the "myth of the bleating lamb" (1966).

Today the notion persists in Roland Barthes' and others poststructuralist notion of language. Barthes emphasizes the so-called 'coded' nature of language, which according to him makes it particularly subject to cultural variation. Arnheim (1986) writes that, "Ironically, not even a verbal message is coded, only the

means of conveying it. Words are discontinuous signs, reasonably well standardized, but the message they transmit consists in the image that induced the sender to verbalize and is resurrected by the words in the mind of the recipient...What comes across when a person hears 'Fire! Fire!' neither consists of two verbal units nor conveys a standardized image" (p. 112).

Similarly, language is for Arnheim ultimately a play of perceptual forces. In fact words are merely stand in for perceptual concepts. "Man can confidently rely on the senses to supply him with the perceptual equivalents of all theoretical notions because these notions derive from sensory experience in the first place...human thinking cannot go beyond the patterns suppliable by the human senses" (p. 233).

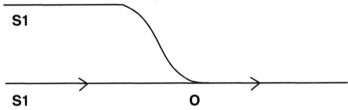

Fig. 14. A process diagram of the elementary catstrophy 'capture.'

One might ask how Arnheim's concept of center and vector is still important in this discussion of language? In fact, it bears a more than superficial relationship to the topological heuristics underlying the gestalt linguistics of Jean Petitot (1985) and Wolfgang Wildgen (1982, 1992). In this context it is worth pointing out that Petitot dedicates his work (1985) to Jakobson. With the use of the catostrophe theory of René Thom, they distinguish between catastrophic hypersurfaces and stable boundaries. One such primitive is the elementary morphology of 'capture,' in which a property or quality is transferred from one agent to another **(Fig. 14)**.

These (sixteen) surfaces may be used to model language, from phonology where the boundaries correspond to motoric articulatory roles, to the grammatical structures, to semantics where the boundaries correspond to stable entities as individuals, natural kinds, enduring states (with a lexical identity as pronouns, nouns, names), while catastrophes are events and actions (with a lexical identity as verbs and other terms with a strong relational value).

In language, it exists in the two conceptions of the *memento* and the *message*. Like an icon, the memento corresponds, for instance, to the inscription *Et in Arcadia ego*. It doesn't have much of a communicative function but instead "is discovered by us, tied to a place and inseperable from that setting" (p. 98). The memento "gives directions, prescribes behavior, facilitates orientation" (p.

99). An example might be the ornamental Koranic inscription in a mosque, or a single ideograph in a Zen temple. The message is on the other hand like a letter in the mail. "It arrives and asks for the recipient's attention. It does the talking and can be expected to deserve the time spent reading it. The letter informs and contains thought" (p. 99). The infinity of literary genres are contained in these two ontological extremes.

The link between *The Power of the Center* (1988) and gestalt linguistics lies in the level of iconic symbolism of written language. There, the topology-like aspects of Arnheim's theory of composition grade into sound, phrasal and narrative symbolism of *linguistic* topology. I shall treat of each of these separately in the following. What they all share, as in the theory of visual composition, is that perceptual dynamics are created by tensions away from centric configurations.

The semanticization of grammar brings a specifically poetic theory closer to Arnheim's general principles, and in fact there is no reason that poetry cannot be treated with his general principles of composition. Thus for Arnheim poetry simply indicates the artistic use of language, so that 'poetry' can be prosaic and prose can be poetic. Arnheim (1966) says:

> 'poetic' language is not distinguished from practical language by expressing in a deliberately unusual, ornamental manner what we say straight in everyday life, but rather by offering equally straight, adequate formulations of subjects that differ from those with which practical speech is typically concerned. The difference of form springs from a difference of content (p. 273).

We may thus look at one undifferentiated mass of 'poetry,' from which problems of genology – the theory of literary genres – become secondary.

In what way, then, does the theory of poetics make use of general principles? According to Arnheim (1966), "[the poet] has to convey the vivid experience of the forces that make a phenomena expressive" (p. 268). This is exactly what we have found in the previous chapters, where the dynamics of all art is essentially a process of metaphorization and concretezation of perceptual experience. There is no appreciable difference between the two so that the discussion of the written sign, which uses principles from the chapter "The dynamics of shape," could just as easily have been included in that section.

Arnheim holds to a form of the Interaction Theory of Metaphor (Glicksohn & Goodblatt, 1993; Glicksohn, 1994; see ch. 3). According to Arnheim, the metaphor – at whatever level it oc-

85

curs – is a modification of a signified by a signifier, for purposes of perceptual concreteness. The signifier must (in a standard sense) be more abstract as an image than the signified. Arnheim (1989a) says that, "A cloud can look like a camel but a camel is unlikely to look like a cloud...The cloud looks like all camels but no camel looks like all clouds" (p. 245).

The effect of the metaphor is caused by the modification of one image upon another, which brings about the union of two incompatable images by raising the statement to a level of abstraction that draws out their common elements. Its poetic (that is, artistic) quality arises from the structural conflict of forcing heterogenous elements of reality into a whole. Unity is only attained for this whole by a retreat to the more abstract level of common expressive qualities. Arnheim (1966) writes,

> negatively, the reality-character of the components is toned down and...positively, the physiognomic qualities common to the components are vigorously underscored in each. Thus, by their combination, the components are driven to become more abstract; but the abstracted qualities continue to draw life blood from the reality contexts in which they are presented (p. 279).

This is no less true of traditional (individual) metaphors, than it is true of sound symbolism and narrative structure. Even more generally, we can see that this is the aim of all art, so that metaphor cannot be said to be linguistic in any special sense.

Concreteness is what draws abstract language into universal perceptual experience, so it can be expected that as most views of language are formalistic, one would find Arnheim's insistence that all poetic language is concrete to be met with scepticism. It could be argued that this criterium of concreteness is rarely met in actual poetic work. Arnheim affirms, however, that it is, and asks us to consider a random example, John Donne's line "To night put on perfection, and a woman's name." Here, there seem to be no outwardly concrete images, so what makes the abstract terms poetic? "The meaning of 'perfection' carries with it sensory qualities of completeness and fulness, and 'name' also has a tangible sense of finality" (1989a, p. 53). He concludes, "Even abstractions, to be understandable, have to be concrete and, hence, can be poetic" (p. 53).

In the above line, concreteness was provided from all levels of linguistic representation, so that just as metaphor is a general concept, one cannot expect that simple clausal meaning will suffice to produce poetic concreteness. Similarly, concreteness is also provided by etymology, for if linguistic signs are arbitrary in a limited

way, old relationships have entered the realm of necessity. Language, therefore, is most meaningful to speakers proficient in the archaic form of the language they speak.

Violating concreteness leads to the opacity of language. Frequently, words are borrowed for their metaphoric superstructure. In the Latin *supercillium*, for instance, Arnheim says that one senses only the haughty expression and no longer the eyebrow (1989a, p. 102). Thus Arnheim can question whether there is no longer any need for Latin. "But how can you ignore it," he asks, "if it survives in the very language you are using? What becomes of your English if in *reveal* you no longer sense the *velum*" (p. 70)?

These connections are particularly precarious in English. In Emily Dickinson's line "the attar from the rose is not expressed by suns alone," Arnheim points out that the use of the verb *express* close to its Latin root meaing, to squeeze out, would not be caught by most (1992, p. 56). But this obscurity is still 'life-giving' in the way that metaphors are, and no writer can afford to be ignorant of such relationships. Thus Arnheim concludes that "to write English colorfully, some education helps" (p. 56).

The Dynamics of Iconic and Graphological Form

As was said earlier in the discussion of the temporal media, language lies on a continuum of orthographic transparency from pure analogue to sign. Ideographic writing is the most transparent form of language. It is no surprise that in light of Arnheim's concept of visual thinking, he might hold out such writing as a paragon of artistic communication. Arnheim (1986, 90-101) has reflected on concrete poetry (Tsur, 2000).

Since, however, language is in general a manipulation of symbols, we may say that visual expression is achieved as a *bypass* of the symbolic function. Speaking of ideography, Arnheim (1989a) explains how, "a word like the Chinese *chu*, meaning a feeling of harmony and friendship is nothing more than an identifying sound chip, but it is written as a combination of two signs, one standing for person, the other for center or middle" (p. 8). And "a modern Japanese in a thoughtful moment can still see the sun rise behind the tree when he looks at the Kanji sign for east in the word Tokyo" (1986, p. 92). The visual image renders, as Arnheim points out, the service of etymology.

When a phonetic alphabet is used, direct visual expression may furthermore be imparted by means of graphological expression, that is, the dynamics of the handwriting itself which then refers back to the grammatical content of the writing.

Graphology was a feature of Arnheim's dissertation (1928) and he returned to the subject occasionally. Perhaps as a result of

its attachment to characterology during the Nazi period, graphology has all but disappeared as a serious subject of study. Arnheim seeks to develop the real science of the expression of handwriting, but does not necessarily mean that it is a projective technique. In this sense, he takes seriously the efforts of theorists like Ludwig Klages and Max Pulver. Graphology *is* a legitimate object of study; the only question is to what extent its findings have relevance for personality.

Arnheim (1978) conceives of two perceptual attitudes at work in the act of writing (w) or reading (r) (**Fig. 15**). Attitude I refers to the normal line from the plane of the w/r surface, at whatever orientation it is found. Top is always top and bottom is always bottom. It is concerned with the vertical dimension and is dominated by vision. If one were to sit at a desk and see a w/r surface at a 45 degree angle, it would be seen as raised from the vertical. The blackboard is the prototype of attitude I. "Verticality and horizontality are determined by the confined eye/surface system" (p. 165).

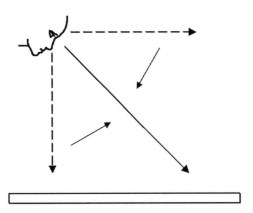

Fig. 15. Two perceptual attitudes in writing and reading.

Attitude II, on the other hand, is concerned with the w/r surface as horizontal, parallel to the person's line of sight. Placed on a table top, the w/r surface desplays its horizontality most compellingly. It interprets the dimension of top and down of the page as near and far rather than as up and down. Arnheim sums up, "The relation to the vertical is our attitude I; the relation to the horizontal is attitude II" (p. 166).

Making reference to architecture and the distinction between elevation and plan, Arnheim specifies attitude I as concerned with vision, and attitude II with motor activity. The first is like a

pictorial mode, the second like a road map or chess board. The piece of writing has a twofold nature.

Symbolically, the upward and downward movement of writing is related to the general property of all pictorial art described earlier. Upward has the quality of rising, conquering and freeing oneself, while going downward has the quality of digging in, refraining or rooting. This fact has been stressed from the very beginnings of graphology (Ludwig Klages, Max Pulver).

Arnheim offers his attitude II as the unspecified aspect of kinaesthesis spoken of by earlier theorists. "Actively it involves such behavior as hugging, squeezing, embracing, whereas passively centripetal motion results from the relaxing of an effort to attain a goal located beyond the self" (p. 168).

Iconic symbolism is not just another dimension of experience that may or may not enter into poetry. Even if of all the arts the words in the poet's mind are perhaps closest to how they appear in final form, their visual aspect is essential. In fact, Arnheim points to the worksheets of poets as a reminder of "how much of the work requires that the words be surveyable in their spatial context" (1986, p. 276). He concludes that "therefore, the work is not so much a replica of the mental *concetto* as a continuation of the shaping and inventing that began in the artist's mind" (p. 277).

The Dynamics of Tonal Form

Sound is the next level of experience from which language can profit. Following the outline of genology given above, sound-like iconism is more a property of poetry than prose. Arnheim has not written extensively on either word sounds or metre and rhythm, but in the gestalt tradition, phonology has always been of primary interest. The structural description of sounds was brought into the modern era in the research of Köhler, begun under the direction of Carl Stumpf. This resulted in the latter's classic *Die Sprachlaute* (1926). Roman Jakobson followed upon this important work (Jakobson, 1941/1968) and progressively refined them up to nearly the present day (Jakobson and Waugh, 1979).

The expressive use of sound lies in the bypassing the referential function which uses phonological features for meaning, and letting the expressive function complement the larger meaning (Jakobson). Before expression even becomes an issue, however, the sound aspect of a word must be understood as psychologically real entity. Thus Arnheim joins with certain structuralists in rejecting the Saussurean notion of the arbitrariness of the linguistic sign. Once again, the expressive use of sound is only a privileged use of an already existing form.

Dynamics of Word Phonetic Forms

Gestalt psychologists have benefitted from the conceptual framework provided for phonological form in the discussion of expressive sounds (Hornbostel, 1927; Wertheimer, 1962; Ertel, 1969; Tsur, 1992). Thus Arnheim (1989a) demonstrates that when the meaning of a word is not known, its sound and its ingredients of particular connotation may conjure up a distinct referent. For instance, Arnheim says that "*Antimacassar* is to me a mastodontic battlewagon, and the dictionary's assurance that the word designates a delicate backrest cover is not strong enough to despel the barbarous vision" (p. 96).

In the more general case when a word's meaning *is* known, then the sound can modify its usage and appropriateness. Arnheim compares the English word *delicious* with its French cognate, *délicieux.* "The squishiness of the English word assigns it to things moist and sensuous, to the material pleasures of touch and tongue. In the French word the vowels coil around the consonants with the gracefulness of a violin scroll. The English word applies to desserts; the French one, to a lovely dancer" (1989a, p. 277).

Or take the example of the words 'freedom' and 'liberty' (1989a). While the two have essentially the same meaning, "'freedom,'" Arnheim says, "is an unhampered outcry, sharpened by the squeakiness of the *ee.* 'Liberty' is a dactylic skip performed by three short vowels and made even more playful by the first and third being almost the same, so that the step taken forward returns to its base" (p. 357). As with the case of delicious, the sound symbolism can be seen to account for diverse applications of the two words.

Dynamics of Higher Order Phonetic Forms

Beyond individual words, "The expression contained by the sequences of vowels and consonants, the rhythm of stresses, the legatos, and the caesuras make it possible for him [the poet] to say in the different and more concrete medium of sound what at the same time he is saying through concepts" (1957, p. 207). In sound, unit formation determines what belongs together and what belongs apart. Rhyme and alliteration, for instance, both group according to similarity (1957, p. 149). In Jakobson's terms, this is the working of parallelism.

Rhyme can group not only words but also whole sections. The symmetry between sections gives the work structure. Such symmetry comes in different ways. In all cases, repetition and less strongly alternation are poetic devices which stress the atemporality of the work (1986, p. 94). The Heraclitic flux is overlaid.

In a poem or text, the rhyming, repetition and alternation through sound grouping, the stronger will be the tonal gestalt of the

90

work. In a similar fashion, the 'thematic' material combines the same way, and is discussed below. Even so, the identically repeated refrain of the poem is intended to be affected by in its mood and meaning by the differences between the stanzas in which it occurs" (1986, p. 71).

Toward the end of a poem or couplet, the sound pattern determines in many ways how the poem can conclude. The unfinished poem is an unbalanced structure, and the tension toward 'closure' can be attained with rhyme. If we take the example from Shakespeare,

> *The play's the thing*
> *Wherein I'll cath the conscience of the King. Exit.*

The rhyming pairs of lines end the final speech. But, says Arnheim, "When Shakespeare marks the ending of a speech by rhyming the last two lines he does more than just introduce a signal of change. He stops the waves of rhythmic alternation by repetition" (1989a, p. 17). These sound structures then interact with the meaning.

Arnheim, unlike Jakobson, has not offered much in the way of traditional line by line examinations of sound patterns. More often he simply gives an analysis embedded in a different discussion. For instance, he analyzes Denise Levertov's line, "Come back, cat; Thrash the silence with your autonomous feather tail." Here, the poet conveys the articulate dynamics of whipped quietness, the spirit of independence brought to life in animal motion, with "the urgent appeal of rhythmical 'a' sounds, brightened at the end by the radiant vowel of the 'tail'" (1966, p, 312).

Meter and Rhythm

Sound symbolism of a higher order, especially rhyme, is difficult to control without a conventionalized pattern of stressed and unstressed syllables, that is, meter. Expanding on Arnheim's work, the Israeli literary theorist Reuvan Tsur (1977) has made an important contribution to poetic meter. According to Tsur, poetic rhythm emerges as the balance between prose and metric readings of lines. The meter of a work, and nymber of feet, provide the constraint on rhythm.

Paraphrasing Arnheim, Tsur writes that "the rhythmical quality of any spoken verse-line will only be as clear-cut as the perceptual features that carry it" (p. 114). Thus, when stressed syllables occupy only and all strong positions of a line, and each line ending converges with a major syntactic juncture. Regularity is at a maximum and the line is weak.

Arnheim (1989a) recognizes this in demonstrating that different genres of poetry gain their distinctiveness through charac-

teristic sound groupings. "The 5-7-5 syllable form of the Japanese haiku poems makes the second line the center of a vertical symmetry and also produces an open, more dynamic sound structure than lines with even numbers of syllables would" (1969, p. 211).

Similarly, in European poetry there are different systems. Arnheim (1989a) gives the example of the French alexandrine verse that is broken down into two equal halves of three feet each, quoting Racine:

Toy qui connais mon coeur depuis que je respire

The structure of the line develops a symmetry that blocks the continuity of the sequence. However, in the blank verse of the German classics, where the six iambic feet are reduced to five, we find Schiller:

Lebt wohl, ihre Berge, ihr geliebten Triften!

The blank verse 'flows,' whereas the French verse 'stands heavily.'

The Dynamics of Syntactic and Semantic Forms
Arnheim has certainly made no attempts at a theory of lexical and grammatical forms, but as I have already mentioned his concepts of center and vector bear a resemblance to the Gestalt theory of 'closed' and 'open' forms of Jakobson, Petitot and Wildgen. In this system, elementary catastrophes (gestalten) represent grammatical forms while 'wells' (or centers) represent semantic entities. Stable forms like individuals, natural kinds, enduring states have a lexical identity as pronouns, nouns and names. Unstable bifurcations (vectors) represent events and actions and other terms with a strong relational value.

Purely intuitively, Arnheim in *Visual Thinking* (1969) anticipated the theory that was already being developed by Jakobson. Utilizing his concepts of 'container' and 'type' concepts, Arnheim in effect described the lexical and grammatical forms. He says,

> [Lingustic forms] either crystallize into one particular, simple and well-shaped pattern, or they cluster around this center a range of varieties covered by the concept. The first is the more comvenient for classification, identification, communication, whereas the second is needed for broad, flexible, truly productive thinking (p. 244).

As I already indicated, the former can be said to give meaning to language while the latter structures language. Arnheim gives interesting indications of the grammatical forms when he speaks of the

barrier character of 'but,' the complicated burdening of 'although,' the effectuating agency of 'because,' the victorious overcoming of 'in spite of,' the displacement of 'instead,' the stable attachment of 'with,' and the belligerency of 'against.'

The Dynamics of Lines
At the higher level of grammatical complete forms (sentences), the most traditional poetics devices are given. They arise from a variable mapping of 'open' and 'closed' forms that create expressive meaning: traditional metaphors. Arnheim has actually given numerous examples of verbal line dynamcs.

Arnheim (1992), discussing the scene of *Hamlet*, where Hamlet and Horatio listen to the gravediggers discuss the difference between drowning oneself and being drowned, brings attention to Hamlet's comment,

> *By the lord, Horatio, this three years I have took note of it,*
> *the age is grown so picked that the toe of the peasant comes*
> *so near the heal of the courtier, he galls his kibe (5.I.30).*

Hamlet's line, referring to the peasant rubbing the soles of the courtier's heel, translates Hamlet's judgement of the peasant's reasoning into proximity, and its irritation, as a physical affliction (p. 49). Here the two dynamically related images are raised to a higher level of common expression.

Arnheim gives another example of a poem by Denise Levertov, in which the author says to her reader:

> *and as you read*
> *the sea is turning its dark pages,*
> *turning*
> *its dark pages.*

The common dynamic shared by turning pages and the motion of waves are confronted, pressed for relation, and there is a "conveying of a sense of elementary nature to the pages of the book and of readability to the waves of the ocean" (p. 62). In all such cases, as was already indicated, the metaphoric quality is obtained by the juxtaposition of images that can bring out a mutual expressive property of the verbal vehicle.

Dynamics of Narrative Form
As I have already said, when a poetic work attains a particular level of accident, it becomes a 'message' (or in Jakobson's usage, more purely denotational). One can import facts and therefore accidents of accident or determinateness, but a greater level of accident

comes with a denotative, narrative structure. Arnheim stresses that there is simply of difference of degree between the memento and the message, which is in line with the Jakobson and Pomorska theory of narrative.

In narrative, the mechanims of similarity (or parallelism) are weaker, most notably in an unbound structure (without rhyme). But this is traded for more complex relations between a greater number of entities. Heider's attributional structure of apparent behavior has been applied to narrative as well (Heider, 1967), and I will use it as an implicit background for Arnheim's theory. Arnheim (1989a) writes that:

> A supremely constructed plot like that of Hugo's *Notre Dame de Paris* is a choreography of puppets, which move wih an almost methematical perfection. Labeled with their defining properties – evil, virtue, ugliness, lust, innocence, beauty – the puppets combine systematically in duets and occasional trios, and the theme deriving from the clashes of their properties supply the action. The end comes by necessity when all combinations are exhausted. The balance of it all seems so lucid that one would expect it to display its perfection if the pattern of its themes were translated into the kind of molecular model used by chemists (p. 196).

Heider at least made a start at such a theory. The grouping of objcts and motives in a narrative follows a complex attributional logic" P like Person O, P likes Thing X, etc. Heider has shown that despite variability of judgement about single characters in stories, the overall structure is remarkably stable. This in certain respects recalls Frederic Bartlett's famous story schema which has inspired so many contemporary narrative theories. But there is a crucial difference.

In this Gestalt view, the long term recall of a story does not simplify only toward a conventional schema but reorganizes in the direction of self-consistency. This fact was demonstrated by Wolfgang Wildgen and Michael Stadler (1987) in a test of serially reproduced narratives (also, Wildgen, 1993).

Different elements of a narrative are centric in different ways. The number of agents may be centric, or the spatial milieu may be centric. Discussing the former, Arnheim (1969) says that "In the fairy tales in which the youngest son succeeds there are always three brothers, because the repeated behavior of the two older ones is the minimum number needed to present the average way of behaving, overcome by the exceptional young hero. Four brothers would be redundant. Two would make for a closed symmetrical group" (1969, p. 211). He similarly says that King Lear must have three daughters, no more, no less.

Arnheim (1970/1986) singles out Dante's *Divina Commedia* as a common example of a work with a highly symbolic spatial structure. Based on the simple geographic form of a pair of cones, the progress down the paths of Inferno are accompanied by a spatial constriction that corresponds to sin.

These factors are strongly related to the visual representation of lingustic forms in memory. Arnheim has given some particularly pertinent examples from literature. He (1989a) mentions, for instance, the Book of Daniel, in which the coming of the four successive kingdoms is prophesied when Nebuchadnezzar dreams of a statue with a golden head, arms and breast of silver, belly and thighs of brass, and legs of iron with feet of iron and clay" (p. 150).

Another example given by Arnheim (1992) is from Thomas Mann's *Die Geschichten Jaakobs* (1933, prelude). When Mann tells the story of the Hebrew forefathers, he "compares the sequence of generations from Abraham through Jakob to Joseph with that of promontories appearing along the coast" (p. 38). Both the dream image and the beach are intrinsically spatial images, from which the vectors of time are read off.

Of all the arts, poetry might seem the most resistant to an Arnheimian or getalt analysis. Words are conventional signs that are combined according to cultural codes of meaning. While this is certainly true, Arnheim also shows the ways in which even signs and codes have to be enlivened by mental images that combine in predictable ways. New research in dynamic linguistic primitives (catastrophy theory), new interest in the Interaction theory of metaphor and the sheer visuality of poetry and the written word all suggest a gestalt analysis will continue to bear fruit.

CHAPTER 9

ART IN COMPARATIVE PERSPECTIVE: CHILDREN, ADULTS, CULTURES

A neglected aspect of Arnheim's theory is its contribution to genetic problems in the psychology of art. In aesthetics this has led to the one-sided view of Arnheim as a theorist who is unable to deal with relativistic aspects of perception. Arnheim, however, has written extensively on many developmental problems, including creativity, individual artistic development and art historical development, all of which complement his more canonical – 'ahistorical' – work and provide solutions to problems of relativism in criticism.

The ahistorical judgment of Arnheim is all the more surprising in light of the radically relativistic, or as we shall see, relational, nature of spatial and temporal gestalt perception that I have been describing. Development is just another relational frame of reference, and there is no reason that relativism ought to begin with it only. It exists in all aspects of experience and just as it has been rigorously studied in regard to visual and aural percepts, it can and as we shall see *has* been rigorously studied in the arts.

In the same way that visual and aural percepts are 'relationally determined' by the prevailing conditions, so too are developmental percepts. They logically determine the variable perceptual learning that is imposed upon a perceiving subject. Thus every person has in Arnheim's words a 'visual history.' Similarly, Gestalt psychologists speak of the complementarity of the 'trace field' (*Spurenfeld*) to the perceptual field. Following Arnheim, I argue that many, many aspects of 'relativistic' perception can be explained with the principles of perceptual learning.

Psychogenesis

Just as biologists look to universal laws of development, Gestalt-oriented psychologists hold out the hope for universal laws of psychological development. More narrowly, perceptual learning is explained as the process of perceptual differentiation and integration. This process of development has a long history of description in Gestalt psychology, and was given its fullest exposition in the work of Kurt Koffka (1925/1931), Kurt Lewin (1951) and also in the closely related work of Heinz Werner (1948, 1978; c.f., Duhm, 1959). A general orthogenetic principle that could apply to all psychological development was perhaps stated most clearly by Werner, who formulated that, "wherever development occurs, it proceeds from a state of relative globality and lack of differentiation to a state of increasing differentiation, articulation, and hierarchic integration" (1978, p. 109).

A general orthogenetic principle is intended to mean that the simplest adaptation to a light source, the solving of a problem, life-span development, *all* proceed by a common developmental pattern. If we wish to determine general categories of experience according to the duration of their development, we may determine orthogenesis, applied to (1) perception and (2) thought, (3) child and life-span development, and (4) ethnogenesis, or cultural development. All are said to develop according to the orthogenetic principle and represent the primary frames of reference that interact in developmental competence and creation.

Naturally, this smacks of nineteenth century grand speculation, and we must wonder to what extent Arnheim believes in its literal truth. However, like a general orthogenetic theory, Arnheim's theory is intended to be quite general, and the basis of a *comparative* psychology of artistic development. In fact, it is useful to consider Arnheim's writings on development against the backdrop of Werner's (1948) major work, the influential *Comparative Psychology of Mental Development*. So that where Werner provides a general account of all kinds of development based on a few simple principles, Arnheim provides a general account of the art work of people at all levels of development based on a few simple principles.

Werner (1955/1978) has responded to many misconceptions about what is meant by a comparative theory. Most importantly, in such a theory the 'primitive' is used as a designative and not as an evaluative concept, and simply identifies a lack of differentiation in any developmental process. Also, development is considered formally, and has nothing to say about the time of emergence. Finally, formal cross-categorical identities of development do not imply actual *material* identities. More recently a student of Werner, Jonas Langer (1988) has also pointed to no correlation between rate and extent of development in comparative development. When Arnheim sees formal similarities between, say, children's art and primitive art, it refers merely to formal similarities. Such an approach, in his (1988) words, "gives prominence to the psychological phenomenon as such rather than the particular place and time of its appearance" (p. 48). But still we may ask, is this enough? Isn't the fact of the pattern already too speculative?

It would be convenient to consistently situate Arnheim's writings on development among the works of Werner's students, for instance, Jonas Langer (1969), Bernard Kaplan and Seymour Wapner (Wapner and Kaplan, 1983; Wapner and Demick, 1991); Herman Witkin serves as a bridge between orthodox Gestalt psychology and Werner (Witkin, 1978, and Witkin, Goodenough and Oltman, 1979). It would carry the added advantage that it evolved in tandem with that of Jean Piaget (1896-1982), and one can see in

Arnheim's writings many references to Piaget's important researches (we often fail to remember that at one time Piaget was seen to experimentally illustrate Werner's theory!).

As a first step, however, it is probably best to simply acknowledge certain differences between Werner's heirs and orthodox Gestalt psychologists. Beginning even before Werner in the work of Kurt Goldstein (1877-1965), an 'organismic' tradition has existed on the periphery of Berlin Gestalt psychology that has opposed its developmental approach to the (often caricatured) 'ahistorical' approach to the latter.

Along this line, I will insist that so-called static autonomous factors in perception do not contradict development and individual differences. The fact that this is often taken to be true points to a misunderstanding of a central point in memory. It is often forgotten that an association cannot be aroused unless the stimulus is first recognized. Upon seeing a minor acquaintance one cannot, for instance, recall their name without first recognizing the face to which the name is attached. This fact is known as the Höffding function, after the philosopher Harald Höffding who first described its importance. The Höffding function has been strongly emphasized by psychologists in the Gestalt tradition (Köhler, 1940, 1941; Wallach, 1949; Rock, 1962; Kanizsa and Luccio, 1987).

The existence of a stage of pure recognition based on phenomenal similarity suggests that what Arnheim (1986) calls an 'objective percept' does exist. In his own discussion of 'New Look' psychology, Arnheim (1969) exposes the fruitlessness of explaining away learning effects. In his words, "no shape acquired in the past can be applied to what is seen in the present unless the percept has a shape of in itself. One cannot identify a percept unless it has an identity of its own" (p. 80). For the reason that perceptual differentiation does not contradict Gestalt psychology, I object to the caricatures of Gestalt psychology.

One of the first weaknesses of Wernerian theory is that it portrays development as occuring monolithically. That is, granting it is only perceptual knowledge that changes, different capacities are said to be strongly coupled so that the development of one capacity can only go as far as that of the individual. Werner (1957) argued for the 'multiformity' of development, but when it came time to concrete discussion of children's works of art, he attributed their quality to intellectual immaturity. Piaget has been the developmental theorist who most strongly resisted variable developmental lines. He (Piaget and Inhelder, 1956) blatantly equated conceptual ability with drawing ability (Thom, 1981).

Arnheim's concerns with the arts have insured a more labile approach and his theory of 'representational development' is a built-in doctrine of singly developing capacities. For every 'per-

ceptual concept' there is a corresponding 'representational concept' depending on the medium in which it is attempted. The same goes for representational development because development must take place in some medium, and one cannot assume a one-to-one correspondence between perceptual and representational development. But still, we may ask, is this enough?

The Stages of Development

According to the developmental theories I have mentioned, including those of Werner and Piaget, there are more or less three qualitative stages of development, from a 'sensory-motor' to a 'symbolic-operational' to a 'formal-operational' (more or less following Piaget, Jerome Bruner hypothesizes three similar stages of action, imagery and language). We have already seen that Arnheim believes that development changes qualitatively. However, basing his approach on visual thinking, Arnheim has no reason to believe that the most refined thinking (verbal included) is anything but the differentiation of perception in the first place.

The belief that development deals in mutually exclusive categories in certain respects owes to the underestimation of what the first can accomplish. Reflecting a bias that goes back to the biology of Spencer, developmental psychologists have underestimated early, undifferentiated perception in a number of ways (c.f., Jahoda, 1997). Of the original generation of Gestalt psychologists, for instance, Kurt Goldstein (Goldstein, 1940, Goldstein and Scheerer, 1941) spoke of the 'concrete' attitude that was shared by children, primitives and psychopaths as inferior. This was opposed to the 'abstract' attitude, of normal adults, considered superior (Arnheim, 1969).

Werner, too, calls early perception 'syncretistic' referring to something "wide and comprehensive but obscure and inaccurate." This syncretistic bias was prominently carried on by Piaget in his studies of children. More recently, Eleanor Gibson (1969) uses information theory to characterize early percepts as 'uncertain' (cf. Gibson and Gibson, 1955). It is important to point out that Gibson's influence upon E. H. Gombrich can be shown to influence some of his negative views of the veracity of 'physiognomic' perception (chs. 2, 10, 11; c.f., Verstegen, 2004a).

The main error that Arnheim points out is that undifferentiated perception is not understood to be both general and specific *at the same time*. We can already recognize this argument from the discussion of mental images (ch. 10) in which Arnheim insisted that a generic image is cognitively useful precisely because it displays with clarity the general properties of things without the complication of details.

The argument for perception is much the same, for our first impressions of objects, or the child's way of perceiving, etc, is geared to more overall properties of things. This is not at a loss to the ability to survive, or get along in the world because general properties of objects are as genuine properties of objects as are details, they only occur at a different level of magnitude. As Arnheim (1979a) has said in a discussion of 'syncretism,' "we are not dealing here with fusion of what was apart but with a primordial globality, which can still be observed at early stages of mental functioning" (p. 207). It is indispensible as the base of departure!

Arnheim develops his argument by pointing out that the supposed contributions of later stages are actually not new contributions. Writing on Piaget's experiments on object constancy using the tunnel effect, Arnheim (1969) says "what is attained here by mental growth is not the capacity to connect percepts by some secondary operation but the condition that allows perception gradually to exercise more of its natural intelligence" (p. 86). Here, thinking always takes place within perception, but the perceiving is more differentiated in one case than in another. Arnheim (1989a) also discusses the famous conservation experiments. When a child asserts that a tall and narrow beaker contains more liquid than a squat one, the child is not necessarily immature. Rather, the children "respond to a genuine perceptual phenomenon, which happens to be in conflict with the physical facts" (p. 336). Since adults are just as subject to such illusions, it is no sense to call the child bound to any particular stage (Pennington, Wallach & Wallach, 1980). This is fine for child psychology, but doesn't address the claim for a single 'law' of development.

Artistic Orthogenesis

If Werner's theory is useful in interpreting Arnheim's comparative enterprise, it did not actually suggest it. In this regard Arnheim was particularly influenced by the art educator Gustaf Britsch (1879-1923), and his *Theorie der bildenden Kunst* (1926, 1981), which was only completed after the death of its author by his student, Egon Kornmann (for an English-language introduction see Andersen, 1962).

Britsch and his disciples suggested the beginnings of just the kind of comparative developmental theory of art that was lacking in gestalt theory. When Britsch's theory came into contact with gestalt psychology in the friendship of Arnheim and another of Britsch's disciples, Henry Schaefer-Simmern, the affinity between the two approaches was evident and, in Arnheim's words, "gestalt psychology became the second pillar of [Schaefer-Simmern's] work" (1992a).

101

Britsch, Kornmann (1962) and Schaefer-Simmern (1948, 1976) outline the ways in which actual artistic relations, like that of figure ground, are manifested in general developmental ways. All early conceptions of art and cosmology, for instance, conceive of the object as distinct from a boundless, undefined matter. They thus go beyond the general developmental theory of differentiation of perceptual functioning by speaking of objects of perception and their variable manifestations. Arnheim departs from specific ideas as these.

Arnheim (1974), however, was fully aware of the formalism of this school. Of Britsch he wrote, "Like many pioneers, in attacking the realistic approach Britsch seems to have carried his revolutionary ideas to the opposite extreme. As far as can be determined by the writings published under his name, his analysis leaves little room for the influence of the perceived object upon pictorial form. To him the development of form was a self-contained mental process, an unfolding similar to the growth of a plant" (p. 171). He (1992a) furthermore wrote of Schaefer-Simmern, "Like many artists, [S-S] preferred to talk only about what can be concretely perceived and to leave matters of meaning and expression to what is surely essential but more readily sensed than known. [His] extreme formalism in art conveyed a heightened sensitivity for visual relations...But while these virtues excel in [his] comments on relatively tangible subjects...they would not do justice to [others]. [He] referred to expression only when he rightly condemned shapeless 'self-expression' in art education; he kept silent about it where it truly matters" (p. 98).

Thus in one case referring to the autonomy of the internal process (Britsch) and in another case referring to the formalism of the content (Schaefer-Simmern), Arnheim had occasion to question some of the formulations of this school. Nevertheless, he maintained it as the basis of his comparative thinking about art and development. In *Art and Visual Perception*, he wrote that, "as I try to describe some phases of formal development as an interplay of perceptual and representational concepts, I am proceeding from the base laid by Britsch" (1974, p. 171).

In fact, Arnheim's agreement with Werner-Britsch was so strong that he tried to formulate a general developmental principle, which he called the 'law' of differentiation, which is specifically formulated for the understanding of cultural products (1974, p. 181, slightly amended). In the first place Arnheim says that:

any shape will remain as undifferentiated as the artist's conception of his goal object permits.

102

This is then combined with the gestalt principle of simplicity, to state that:

> *until a perceptual feature becomes differentiated, the total range of its possibilities will be represented by the structurally simplest between them.*

The first law refers to the direction in which representational development takes place. The second refers to the interpretation of it, that is, an interpretation can only be as differentiated as the level of differentiation of the developmental context in which the work appears. In both cases of creation and interpretation, the simplest percept portrays the concept best.

Following Britsch, and in tandem with Kornmann and Schaefer-Simmern, Arnheim articulated many principles of comparative artistic development, fully applicable within Werner's comparative framework for psychology. As the other general principles mentioned earlier, these artistic principles are comparative, formal and sequence-invariant. And while they are illuminating in Arnheim's practice, he never has questioned the basic soundness of a general law of development, whether it be Werner's, Britsch's, or his own. In my opinion, however, such a general law is ultimately incoherent, and there are actually precedents in gestalt theory that Arnheim could have followed to build a better theory.

Reconstruction
Theorists departing from organic metaphors usually base their admittedly speculative social or cultural scheme on the seemingly well established understanding of such schemes in biology. There is a philosophical tradition, however, that holds that such schemes are not even viable in developmental biology, a tradition that Arnheim knew. Kurt Lewin, already mentioned, wrote a fundamental book on the philosophy of development, *Der Begriff der Genese in Physik, Biologie und Entwicklungsgeschichte. Eine Untersuchung zur vergleichenden Wissenschaftslehre* (1926). While, to my knowledge, Arnheim has never cited this work, it goes far in answering some of the methodological problems of such a psychological theory.

Lewin's most important philosophical contribution is of making any development lawful by conceiving it as a multiplicity of successive events. Understood thus, successive states can be considered existentially 'being-such-as-to-have-come-forth-from' (cf., Smith and Mulligan, 1982, § 6.2). Lewin does not ultimately allow for a 'law,' or 'pattern' in development. The best we can do, he concludes, is define states as products of immediately preceding states; there is no pattern. In the same years, Hans Driesch's biologi-

103

cal *entelichie* was popular, and Kurt Lewin's colleague in Berlin, Wolfgang Köhler, contributed an article to the biologist's Festschrift which denied its reality. Köhler argued (in a manner to be picked up later by scientists like Waddington and Thom) that the only thing guiding organismic development is minima of energy. No entelichie is necessary, just basic physics.

The greatest methodological example, however, would have been the philosopher Maurice Mandelbaum, Arnheim's contemporary and heir, in many ways, to Köhler. In works too numerous to list, Mandelbaum challenged not only social evolution, progress, etc., but also 'laws of directional change' in physics or biology. Mandelbaum (1971) concluded that one could not formulate such a directional law in physics because one would always have to report the initial and boundary conditions of the development and amend infinite *ceteris peribus* clauses. In comparative history, significantly, he concluded that one could not support an evolutionary (identical development), nor genetic (homologous development) history, only an analogical history based on phenomenological and analytic similarities (Mandelbaum, 1984, pp. 131-144).

In this context we can formalize the objections noted above regarding developmental psychology. In spite of an affinity with Wernerian and Piagetian psychology, and Britsch's theory of art, a true Gestalt theory would deny the absolute succession of stages (c.f., McGuinness, Pribram & Pirnazar, 1990).

If Arnheim's theory is viewed in such a way, its structure changes radically. One is no longer allowed to view simply 'development,' with its varying manifestations (usually based on duration). Instead, one is forced to treat the phenomena (children's drawing, the artist's old-age style, different cultures, pathological art) on their own terms. Fortunately, once Arnheim takes a problem in hand, he does just that. However, in laying out the broad scheme of his theory, I doubt that his 'orthogenetic' principle is viable.

Even granting that developing systems are not closed systems and the same laws with the same degree of rigor cannot be stated for them does not mean that a comparative theory of psychological development is not a powerful tool for understanding qualititative changes in perception. Using the non-valuative principle of differentiation and integration we find that these overall global qualities precisely lie in the degree of articulation. In all cases, however, we are still essentially dealing with principles of perception and perceptual intelligence. Therefore, these concepts can and should be used to explore and understand the various development aspects of perceiving and making art, to which we now turn.

CHAPTER 10

THE DYNAMICS OF MICROGENETIC ARTISTIC DEVEL-OPMENT

Microgenesis refers to the shortest duration of psychological proc-ess that is observable and its qualitative changes as it develops to-ward completion. The concept 'microgenesis' is the translation given by Werner (1948) to the German name of *Aktualgenese*. Following Werner and his students (Flavell and Draguns, 1957; Rosenthal, 2002), I subsume under this concept both short duration processes of perception and thinking from Arnheim's writings.

Perceptual Microgenesis
By perceptual microgenesis I shall mean genetic processes of a short duration that are so brief as to be more or less involuntary. Most often, the qualitative changes of such a process may be ob-served by variably interrupting the process, as for instance with tachistoscopic presentation of visual images for a very short dura-tion.

In a section of *Visual Thinking* (1969) called "Perception takes time" Arnheim describes the stages: At first, the perception is of an undifferentiated whole. Next, the figure gains some differen-tiaton but the inner contents remain vague and amorphous. Finally, the figure becomes complete (cf. Graumann, 1959). In the Gestalt tradition, the accuracy of the stages has been upheld against charges that perception is merely a built-up image of parts (Ceraso, 1985).

Gamma movement, already mentioned, is an example of the earlier stages of development, when the lines of force are most ac-tive as the figure is on its way to the final percept (Newman, 1934; Kanizsa, 1979). Refering to the underlying physiological process, Köhler (1971) says that gamma movement is "the initial growth of an object by self-satiation" (pp. 285-6). Arnheim (1974), we recall, pointed to gamma movement as evidence of perceptual dynamics. Allow me to quote again his description of this process: "Perception reflects an invasion of the organism by external forces, which upset the balance of the nervous system. A hole is torn in a resistant tis-sue. A struggle must result as the invading forces try to maintain themselves against the physiological forces, which endeavor to eliminate the intruder or at least to reduce it to the simplest possible pattern" (p. 438).

It is interesting to note that when there is a slight discre-pency between the perceptual field and the behavioral field even in a microgenetic process, intracerebral dynamics, that is, motivational phenomena, are given rise to. In the simple case of gamma move-

ment the two are aligned but in a building, for instance, where the demand of a given path is translated directly into a proper response we are speaking of motivation.

It is this give and take between intra- and extra-cerebral dynamics that accounts for the *active* quality of the experience of art. In Arnheim's words, "true aesthetic experience is not limited to to the passive reception of the art object arriving from afar, but involves an active interplay between the artists' work and the viewer's, listener's, or reader's response. The exploration of a painted or musical composition is experienced as an active shaping of the perceptual object, and the object, in turn, imposes its shapes as constraints upon the freedom of the explorer: 'This I will let you do, but not that!'" (1986, p. 75).

As Koffka (1935, pp. 373 ff.) and Heider (1960, p. 149 ff.) have pointed out, the relationship between the balanced perceptual field and the balanced behavioral field can be found at the most elementary level in eye movements. Arnheim (1969) explains the relation between eye movements and action in the following way. "An act of fixation can be described as a move from tension to tension reduction. The stimulus enters the visual field eccentrically and thereby opposes the field's own center with a new and alien one. This conflict between the intruding outer world and the order of the inner world creates a tension, which is eliminated when a movement of the eyeball makes the two centers coincide, thus adapting the inner order to the outer. The relevant item of the outer order is now centrally placed in the inner" (p. 24).

Until the action is performed, a tension remains in the behavioral field. The tension is communicated to the executive system, which then matches the alignment between the outer world and inner world, and reports this back to the behavioral field, and the tension disappears. This example can serve as the prototype of a general theory of motivation that follows Koffka's formulation that "the total field...sets up the stresses in the ego which determine behavior according to the behavior of the whole field" (1935, p. 663).

Objective Set

Gamma movement, as Köhler has observed, is so common as to rarely come to anyone's attention. In any case, it is so brief that its effect has no contribution to artistic expression except to serve as a demonstration of it. Another involuntary genetic process of slightly longer duration occurs as well. In Wertheimer's original paper on the laws of perceptual organization (Wertheimer, 1923/1939), the problem of *objektive Einstellung* or 'objective set' was introduced. It did not refer to set per se but to the objective influence of a microgenetic frame of reference upon perception.

Wertheimer discussed the case where a particular organization depends strongly on the sequence in which it appears, so that if one takes the dots in a pair and progressively lengthens the distance between them, they continue to appear as 'pairs,' until quite suddenly they become paired with the other, much closer dots. The persistence of this organization owes solely to the order of presentation. Seen out of order, the dots of the later sequence would not have been seen as pairs.

Wertheimer calls this factor objective because the effect occurs soley upon the order of presentation. Gestalt theorists like Usnadze (1966), Abraham Luchins (1959) and Dorothy Dinnerstein (1971) have stressed that this is not a demonstration of past experience upon perception but a demonstration of organization persisting in time. In a dynamic systems perspective (synergetics, catastrophy theory) we can see them as examples of *hysterisis* (Stadler and Kruse, 1990). Such examples of objective set are important for the arts in showing that the expression developed in short periods of time is a result of sequence but not past experience.

Problem Solving

Beyond simple microgenesis, the next step in duration of a developmental process lies in goal directed behavior. Here the processes of most interest are in the domain of problem-solving. Gestalt psychology has, of course, made classic contributions to the study of problem solving (Duncker, 1935, 1945; Köhler, 1917, 1927; Luchins, 1942; Maier, 1970; Scheerer, 1963; Wertheimer, 1959). Arnheim's *Visual Thinking* (1969) is an important addition to this literature (cf. Arnheim, 1996, pp. 174-178). While the dominant trends in problem solving research have displaced Gestalt psychology with computer and imformation processing models, a current of interest can still be discerned, especially in Italy (Kanizsa, Legrenzi, and Meazzini, 1975; Legrenzi, 1975). Furthermore, as noted earlier, Johnson-Laird's (1998) theory of mental models is highly amenable to gestalt theorizing.

Problem solving may be called an inherently genetic, and motivational phenomena, in which a short-term developmental sequence has as its aim the arrival upon a goal situation. The mechanism of problem solving is perceptual restructuring and the process of problem solving is a continuous transformation of the problem. Unlike in perception, the development of a problem solution proceeds less loosely according to genetic stages. Each contribution to the problem is a reformulation, or restructing, of the problem. In broad outline, this can occur by subdivision from the whole to the parts. But problem solvers proceed also by grouping from the parts

107

to the whole on the way to their solution. Progress can, and must, trade with regress to try a new path.

The two poles of problem-solving are 'fixation' or 'mechanization' and 'satiation.' In the first place, a particular problem solution imposes itself and through use, new solutions do not present themselves. In order to overcome this, the problem solver must satiate the solution so that a new solution can arise. In synergetic terms, fixedness can be understood as the deepening of a potential well, and satiation the flattening of the well so that the particle can fall into a new well, corresponding to a new solution (Stadler and Kruse, 1990) (**Fig. 16**).

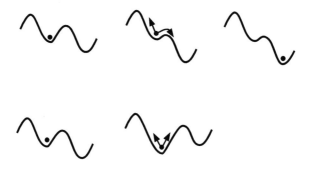

Fig. 16. Self-satiation of a particle in a potential landscape.

Most gestalt research has focused on geometrical problem solving or the use of simple tools. Arnheim's research points to the application of such principles to art. What all such problem solving situations share is a guiding mental image. Arnheim (1993b, p. 17) approvingly refers to Ernst Mach's notion of the "dark image of the persistently constant" (*das dunkle Bild des Beständigen*) as that which guides the artist (Mach, 1985). Assuming the artist is not working from a model, the mental image more often than not are more generalized and simplified. The first artistic images will share this quality.

Arnheim, in "The images of thought," devotes a chapter to the nature of the mental image (1969, pp. 97-115). This important chapter was originally published in 1965 as part of Gyorgy Kepes' volume *Education of Vision* and deserves to be seen as a pioneering work. Arnheim's most important observation is that images (contra Berkeley) are both generic and specific. "Any abstraction, no matter at what level, needs precision in order to be usable. A tree seen out of focus by a myope is of little help; only when seen sharply can a tree at a distance serve as an abstraction for trees seen nearby. The distance makes details drop out but replaces them with the

correspondingly greater prominence of the larger structure (p. 271; c.f. Mandelbaum, 1971).

One cannot compare the image to reality, and thereby determine its shortcoming. "Either the incomplete image is experienced or it is not, and if it is, the challenge to Berkeley's contention is fully with us" (p. 107). Of course following the publication of Arnheim's *Visual Thinking*, there has been a veritable explosion of research on mental images and his insights have been brilliantly corroborated by the work of psychologists like Roger Shepard, Alan Paivio and Stephen Kosslyn. Some of these psychologists tend, however, to study simple chronometric phenomena (distance or angular rotation related to time). These sacrifice the generic quality of the image, by stressing functional equivalence ("second order isomorphism"). As Arnheim says, "reports by artists and scientists indicate that visual imagination is capable of much more spectacular exploits" (1980, p. 172).

This problem of level of abstraction is common to art and interpretation. Especially when one reports the level of abstraction of an image in reading a work, it becomes an essentially interpretative problem. Arnheim's view of imagery follows his law of differentiation, which when applied to imagery means that in reading, for instance, an image must be kept as abstract as possible. He reports, for instance, that "there is a similarity between the music I derive from looking at a score and the images formed in my mind when I read a story. I get to hear little of the sound of music, but I sense the voices climbing and falling rhythmically in their interaction. The actors of a story do not appear to me as pictures, but I see them behave gently or harshly and loom large or sneak along meekly as disembodied hubs of action that play their parts without being fully understood" (p. 299).

Here the generality is highly useful. It can stand for a range of possibilities without being tangibly committed to any one of them. The guiding image is so general because like all perceptual concepts, its actualization is highly dependent on the propeties of the medium in which it is attempted. Because of an immediate feed back from the medium, the artist is able to see new possibilities in the first artistic image that was not possible even with the mental image. This first step cannot be underestimated. It "supplies the mental image with the assistance of an optical image" and makes it "tangibly concrete" (1993b, p. 17).

What also cannot be underestimated is the contribution of the medium. According to Arnheim (1989a), even acquaintance with the medium is a genetic process. "My experience with wood carving," he says, "makes me suspect that, at least in the work of an amateur, the stages of formal development repeat themselves to some extent in the genesis of each work. Not that a mature artist

109

will start each time at the very bottom of the ladder of complexity. Yet I find in my own case that I keep producing flat, shieldlike faces, simple outlines, undifferentiated rims of eyes and mouths, and right-angular corners before I proceed these simple shapes intoubtler ones" (p. 45). Here, then, is a case of orthogenesis in the simple habituation to a material, in this case carved wood. It is in this sense that Arnheim (1962) can say that "when, in the end, the artist was willing to rest his case on what his eyes and hands had arrived at, he had become able to see what he meant" (p. 135).

As in regular problem solving, the overrall pattern of artistic problem solving is not genetically rigid. Arnheim (1962) writes that "The combination of growth and execution in the process leads...to a procedure that cannot be described as the successive elaboration of fragments or sections but which works out partial entities, acting upon each other dialectically. An interplay of inter-ferences, modifications, restrictions, and compensations leads gradually to the unity and complexity of the total composition. Therefore the work of art cannot unfold straightforwardly from its seed, like an organism, but must grow in what looks like erratic leaps, forward and backward, from the whole to the parts and vice versa (pp. 131-2). Even so, when we look from the earliest drafts of a work, in whatever artistic medium, we should discern a differen-tiation from the initial concept.

Arnheim has provided some complementary discussions of the problems of fixation and satiation in artistic problem solving. In his essay "Contemplation and creativity" (1966), he first argues that satiation does not falsify the work but is actually necessary for the discovery of new artistic solutions. As visual figures restructure with prolonged inspection the percept changes and can be under-stood in a different way. In the same way, Michael Wertheimer (Wertheimer & Gillie, 1958) demonstrated the satiation of meaning of words, pointing to the potential ubiquity of such restructuring in poetics as well.

Such effects may be called examples of subjective set. This set represents the perceptual learning that is involuntarily put upon a person when they may or may not be perceiving a work of art, that is short term and equivalent in temporal duration to that of a brief creative task. It only differs from objective set in that objective set is induced by the temporal ordering of the work itself and sub-jective set is induced by temporal ordering of extraneous events. Both, however, are perfectly 'objective.'

Closely related are events of a slightly greater effect, when individual works themselves and not just parts of works become satiated. Thus Wolfgang Köhler (1947) speaks of the overture to Wagner's *Tristan and Isolde* and how for many years he used to be greatly impresses by it but now "Frankly, I am tired of it" (p.

194). By hearing the work too many times, perhaps, it no longer has the same attraction that it once did. The phenomena of 'psychical satiation' was extensively studied by Kurt Lewin and Anitra Karsten (1928, 1976) by giving subjects the same sequence of sounds hundreds of times a day and was related to Köhler's problem of satiation in perception. Here, the work actually changes in organization. But as far as interpretation is concerned, this is unimportant because it is now a different work. As Köhler (1947) explains, "As soon as, with the same stimuli, the experienced material changes, we can no longer expect the same responses to appear as natural and adequate" (p. 194).

In spite of these facts, Arnheim (1986) insists that good works of art resist such satiation. Good works, after all, are not reversible figures. Similarly, Michael Wertheimer (Wertheimer and Gillie, 1958) found in his studies of word satiation that words with onomatapoetic (gestalt) qualities resisted a loss of meaning. In the end, serial ordering of events extrinsic to the work of art can provide difficulties to understanding the work, but most resist it. In any case it is absolutely necessary for artistic problem solving.

Case Studies

Arnheim has treated of these genetic aspects of creative work with the record of the creation of actual works of art. He for instance studied poets' drafts, and demonstrated the process of arriving at a satisfactory poem (Arnheim, 1948). He has commented on the documentation of Le Corbusier's *Carpenter Center for the Visual Arts*, the building in which he worked for several years (Arnheim, 1978). Most impressive, however, is his unprecendted study of the sketches leading up to the completion of Picasso's *Guernica*, which resulted in his seminal work *Picasso's Guernica: Genesis of a Painting* (1962a). Highly complementary to Arnheim's studies of creativity is Victor Zuckerkandl's study of the musical drafts of Chopin, Schubert and Beethoven, in *Vom Musikalischen Denken* (1964).

In all these cases, the specificity of the modality (which we have discussed at length) contributes to the unique solution of each individual problem. A radical transition of a whole took place in Le Corbusier's design of the Carpenter Center for the Visual Arts at Harvard. The architect, beset by a practical impossibility, "made a tracing on a loose sheet of the large curved studio facing Quincy street, flipped the form over on its end and tucked it alongside the main ramp facing Prescott Street."

The creative development of poetry is much the same. The poet begins with a general concept or cause and then differentiates it into suitablly expressive language. Because of the indefiniteness of words, this is quite involuntary, and the literary recording of an

111

experience at first resembles, according to Arnheim, "trapping an insect with a large net" (p. 273).

Arnheim found in his study of the draft sheets of poets the persistent systematic struggle to genetically begin with intellectual concepts and revive them in sensible perceptual concepts. For example, Keats' early line:

> Not stir of air was there,
> Not so much life on as on a summer's day
> Robs not at all the dandelion's fleece

is flattened with the botanical designation of "dandelion," and is changed into the following:

> Not stir of air was there,
> Not so much life on as on a summer's day
> Robs not one light seed from the feather'd grass

The expressive perceptual features are exchanged and now satisfactorially specify weight and movement. Similarly, Keats originally writes the third stanza of "La Belle Dame Sans Merci" in the following way:

> I see death's lilly on thy brow
> With anguish moist and fever dew
> And on thy cheeks death's fading rose
> Withereth too.

Here, as in the previous naming of an intellectual concepts, the medical diagnosis ("death") flattens the effect, and is changed to:

> I see a lilly on thy brow
> With anguish moist and fever dew
> And on thy cheeks a fading rose
> Fast withereth too.

The uninterpreted description of the pale face now "provides the shock of discovery...Paleness strikes the inner eye as the physical effect of a concrete, though unnamed power" (Arnheim, 1966, p. 269).

The study of *Guernica* was initiated by Arnheim by gaining permission from Picasso to study and publish his dated and numbered sketches. By following Picasso's daily progress is arriving at the final composition, Arnheim was able to show the slow but uneven development toward the final work. Picasso alternated between rough overall sketches and individual studies. Sometimes the stud-

ies seemed to call for a detail unecessary to the whole, but they allowed him to rethink the fundamental meaning of the symbols – the horse or bull – he had chosen. This allowed him to regulate the meaning, pessimistic or hopeful, he was trying to develop.

From what has been said, it is possible to draw some conclusions as to the nature of creativity. According to Arnheim (1962a), creativity is both common to everyone and a prerequisite for everybody's good health. But it is no instinct; rather, it is the outcome of succesful functioning. Creativity is little else but that full deployement of knowing, doing and willing (see ch. 12). Also implicit in Arnheim's discussion of creativity is the unique quality of a succesful artistic solution. This differs substantially from the approach of E. H. Gombrich, for whom tastes are preferences, and for whom there must be alternatives in order to judge creativity. Assuming, however, that the properties of the medium and the problem itself are not sufficiently clear, then no 'choice situation' exists and one is incapable of assessing the true merit of the artist's choice (Gombrich, 1960). According to Arnheim, the really creative person least of all has freedom of choice in this case. He has no option to choose at will, it is his characteristic that he has only the option to take the one course, the right one, the one required by the task, the one which solved his problem (Metzger, 1962; Verstegen, 2004a).

Cases of elementary set and other microgenetic phenomena are the basis of creative processes and must be investigated for their lawful properties. Arnheim recognized that these have much to teach us about the emergence of works of art and far from being quixotic or irrational help us understand that the making of art is the directed application of perceptual intelligence.

113

CHAPTER 11

INDIVIDUAL ARTISTIC DEVELOPMENT

Creative tasks, as I have just treated them, take place during a more or less static stage of (adult) development. But if one waited long enough, the character of the solution process and especially the product could be substantially different. This is radically true with children's art in a Western culture. The length of duration considered in this chapter concerns art creation over a life time. The object is not the relation of the process itself to art, but the process of life time development to art.

As I have already mentioned, the narrow problem of individual artistic development was given important impetus in the work of Gustaf Britsch (1926) and his students Egon Kornmann (1962) and Henry Schaefer-Simmern (1948, 1976). Arnheim in his turn gave the essential aspects of the theory in his paper "Perceptual abstraction and art" (1966) and *Visual Thinking* (1969). Some of the problems of chronology and formal development were included in the chapter "Growth" in *Art and Visual Perception* (1954, 1974). The subsequent researches of Claire Golomb (1974, 1992, 1993) and Lucia Pizzo Russo (1988) follow Arnheim's concepts, as do to a lesser extent the works of Howard Gardner (1980) and Ellen Winner (1982).

Following the emphasis upon differentiation that any gestalt theory of development must make, it is evident that individual artistic development is a problem of individual perceptual differentiation (Cf. Witkin et al., 1962). Arnheim (1986) has outlined three rough categories of life-span development (see also the subsequent chapter). In the first stage, one perceives and understands the world in broad generalities. In the second phase, there is a broad conquest of reality, a "hearty wordliness that scrutinizes the world in order to interact with it" (p. 288). Finally there is a detachment from practical application and a contemplative attitude. The three categories correspond to childhood, adulthood and old age, and the same attitudes are evidenced in art.

The dialectic between individual growth and maturation on one hand and artistic development on the other is summarized by Arnheim (1974) in the following way: "Internally, the organism matures, and as it becomes capable of more differentiated functioning, it develops an urge to apply this capacity. This development, however, is not conceivable without the external world, which offers the whole variety of directional relations" (p. 188).

These life-span perceptual 'styles' then influence how works of art are made. Just as the work of the artist changes over the life span, the artist himself may look upon art differently. Ear-

lier I mentioned Köhler's (1947) statement of his dislike for Wagner's *Tristan and Isolde*. He mentions another factor that may be responsible for his dislike: "in the meantime, *I* have changed a great deal" (p. 195). So just as in the last chapter when a problem solution changes so does one's ability to assess the same problem, here too the individual's style also alters how they may receive another style.

MOTIVATION OVER THE LIFE-SPAN

Arnheim conceives of art as a major, and perhaps the most important, way of knowing the world. Therefore, individuals are highly motivated to use art and highly motivated to order their life with it. Here, the "upward tendency of the ego" (Koffka) stands in sharp contrast to conservative theories of motivation, in particular Freud's pleasure principle (Cf. Arnheim, 1962, ch. 1; 1971, p. 44 f.; 1974, pp. 36-7). Freud models the individual as one that is only active when extraneous activity upsets its equilibrium. From our earlier discussion, this focuses the discussion on a sensory system closed originally to exogenous stimulation (anabolic force).

But just as visual percepts need something to order for there to be any order at all, the larger development of the person must be taken into account: "Only if the shaping of aesthetic objects is viewed as a part of the larger process, namely, the artist's coping with the tasks of life by means of creating his works, can the whole of artistic activity be described as an instance of self-regulation" (1971, p. 34).

Accordingly, Freudian concepts have subsequently been reinterpreted to include this aspect of striving. Daniel Winnicott's concept of the transitional object is one example. If a physical 'ground' calls for its figure, then the lack created by the absence of a transitional object must be the most powerful mental ground. "Mental images are the realm of experience over which the mind rules most completely; therefore, nowhere does the infant's illusion of omnipotence survive more effectively in the adult than in the materialization of mental models. Works of art are the adult's transitional objects par excellence" (Arnheim, 1992, p. 13).

It is only upon the consummation of motivational processes that one can speak of 'pleasure.' It is aligned to the 'a-ha' experience of succesfully creating or consuming a work of art. Because of the misdirection of hedonistic aesthetics, the concept of pleasure is greeted by Arnheim with extreme caution – and he calls pleasure an "unspecified criteria" (1966, p. 311). It exists, but has always for him a subordinate role to the purpose in mind. The gestalt psychologist Karl Duncker (1941) concurs when he says that, "we have no proof that pleasantness as such is ever singled out to be the goal, as we did have in the case of the pursuit of sensory pleas-

ure...[I]n the aesthetic field pursuit of enjoyement cannot be said to strive for the sheer pleasantness of the experience because it always strives for a better understanding of the object as well" (p. 427). In the same sense that art cannot be properly understood as if it were useless, the pleasure surrounding art works is part of a general purpose of contemplation. Arnheim thus denies that there is such a thing as "aesthetic pleasure" proper. It is only one aspect of the meaning of human life: "the full experience of its existence" (Arnheim, 1993, p. 196).

Artistic motivation is a subclass of general motivation, but Arnheim has written relatively little on the complex way an artist uses art over the life-span. His few remarks can be understood, I believe, with Howard Gruber's discussion of a 'network of enterprises' (Gruber, 1989). An enterprise is a life-span concept greater than individual efforts and their success and frustration but open to expansion with success. It is related to the *oeuvre* of the artist, discussed at the end of the chapter. Here we can add a gestalt idea to Gruber's analysis to say that the fitting to which motivation strives is no longer between a task and an outcome but rather the life-span enterprise and the *self-image* of the artist (Mandelbaum, 1987).

CHILD ART

The most important consequence of a child's percepual style is that genetically early perception is expressive. Heinz Werner (1948) was most adamant about this point in his insistence that genetically early perception is 'physiognomic.' Arnheim, too, holds that early perception is expressive. However, as I have already argued (ch. 10), it is not necessary to regard such percepts as 'fused' or 'syncretistic.'

Drawing, and so often children's drawing, is looked at in terms of representational accomplishment that the expressiveness of their drawings contributes to the misinterpretation that they are somehow confused. Instead, as Arnheim argues, the medium is primarily what must be learned and it is this that 'stands in the way' of realistic depiction. According to Arnheim, the obduricy of the medium requires one to think about the effects of *form* – which is unnatural – rather than the effects of expression which is most natural. This, he stresses, is equally true for most adults who have a most difficult time making an acceptable likeness and cannot be accused of confused thought. As a matter of fact, Arnheim insists that to the child, the drawing looks just like the object depicted.

Artistic development, therefore, must be understood in terms of *representational* development. To attribute a feature of a child's work to intellectual inadequacy is to commit the "intellectualist theory" (Arnheim, 1974, pp. 164-7; 1966, p. 29). Arnheim's critiques of the older authors is supplemented by Golomb's impor-

117

tant discussion of Piaget (Golomb, 1974, ch. 7). Instead, the natural representational development within a medium must be exhausted before other alternatives are understood. The importance of representational concepts and their development has been subsequently stressed more recently Claire Golomb (1974, 1992, 1993). Following the important requirement of speaking only of representational development, we shall be concerned with children drawing *on paper*. Arnheim (1974, pp. 208-17) has also devoted much attention to the representational development of sculpture, but for the sake of brevity, I can only refer the reader to this work (cf. also Golomb, 1974). A complementary discussion of development in writing and music is contained in Ellen Winner (1982). The following is divided into the discussion of objects and composition.

Objects

Children's art begins with "drawing as motion" (1974, p. 171) in which the child's scribbling is a motor activity of merely sensory enjoyement which has the added attraction of leaving visible traces. Drawing as an artistic activity begins with the realization that gestures have a *descriptive* quality (2-8 to 3-2 according to Golomb, 1974). Citing research by Goodnow (1972), Arnheim points out that the discovery is that the motion of making a marking can match a sound, etc, but the result may still not be "representational." The order in which the drawing is made is more important than the final product. Still, "deliberate pictorial representation probably has its motor source in descriptive movement" (1974, p. 172).

Eventually, and perhaps with some help from motor learning, the scribbles are smoothed into circles, the simplest visual pattern available. It is "the first organized shape to emerge from more or less uncrontrolled scribbles" (1974, p. 175). Because of the properties of figure and ground, a one-dimensional pencil line is transformed into a solid object. This corresponds with the discovery that the objects can *stand for* objects. The circle possesses "thingness" (1974, p. 177). Arnheim says that true representation probably occurs before verbal reports, (this spontaneous reaction is different from what Golomb calls the 'reading off' of a signifier when pressed by adults).

Since the circle is a completely undifferentiated shape, it can succesfully stand for anything, "a human figure, a house, a car, a book, even the teeth of a saw." Since the circles possess only 'thingness,' it is futile to fault the child for representing saw teeth with circles because the roundness is not intended, it does not stand for 'roundness.' Here, one cannot help thinking of the centric compositional system from Arnheim's *The Power of the Center* (1988).

118

After various circles stand for things like head, eyes and nose, Golomb (1974) gives the the further distinctions between the circle-oblong with circle features, the linear configuration and the depiction of single features (p. 14). Next, appendages are added to the circles. The figure may remain simply as such, or the circle can be extended and object lines can be ambiguously added to suggest both object and appendage. This may be an intermediate stage at which the body eventually 'descends,' and real figural differentiation begins.

Traditionally, it was believed that the circle was a "head," and that arms were attached to it directly. This illusionistic bias is indicated by the use of the term 'tadpole' to describe such figures (1974, p. 197). Arnheim argues, however, that there is no reason to suppose that the circle does not refer to the whole body. Gustaf Britsch would call this a case of *Überstimmung*, or in Arnheim's words the misplacing of concreteness of a represented object. It is another example of the axiom of realism.

Gradually, the circle shrinks and the appendage arms lengthen. It is only now that the circle truly becomes the head. But even now the figure is no more a tadpole than before because the body has 'descended' somewhat ambiguously between the vertical lines of the legs. The leg lines are both this and the body's outline. The 'open' trunk eventually differentiates into a determinate shape. Similarly, other features are individualized. Interestingly circles, which are still the commonest shapes, retain their general quality. Only with the appearance of other shapes can the circle be considered truly an alternative to another shape. A true line can now differentiate the waist, as a neck and clothes may be added.

In a certain sense, children increasingly differentiate figures by turning aggregates of simple parts into a complex whole. Arnheim (1974) compares two drawings of fish done by the same child. The earlier drawing "is constructed from geometrically simple elements in vertical-horizontal relations" (p. 192). Only the fin shows evidence of a complex form. The later fish is given in a single, bold outline. This particular drawing, however, is probably too complex of an image than the child can properly control and looses some of the directness of the earlier drawing.

From such differentiation the child develops visual depth in its drawings. In his paper on "Inverted perspective" (1986) Arnheim has provided some aspects of the comparative development of depth drawing. Roughly speaking, the child draws 1) orthographic, 2) divergent, 3) isometric and finally 4) projective perspective (cf. Golomb, 1993).

Composition

Concurrent with the differentiaton of objects is the development and differentiation of composition. At first, objects are placed randomly on the page. "An internally well-organized figure may float in space, totally unrelated to other figures or the figure plane" 1974, p. 185). Then proximity is utilized. Then objects are composed with partial alignment to the paper itself. But Golomb (1992) calls this the most elementary sense of composition, refusing to call a work symmetrically arranged that does not make deliberate use of similarity of figures. It is not until similarity and contrast are improved that finally vertical and horizontal coordinates are developed.

As Arnheim points out, the straight line is actually a quite complex action, which may account for its late development above. Nevertheless, following the law of differentiation, the original 'spatial trellis' in which figures are drawn is of the vertical and horizontal coordinates. As Arnheim (1968) says, "For a child who has not yet gone beyond the level of vertical-horizontal relations, it is logical and correct to represent a diagonal by a horizontal" (p. 204).

Next, and only after the development of the vertical and and horizontal coordinates are developed, comes obliqueness. Obliqueness enlivens the child's conception with directionality, and suggests the real world. Arnheim (1974, p. 189) gives an example of two drawings of a giraffe, the one substantially more animated out of the strict up and down coordinates. These are all directional tendencies with a somewhat indirect effect on composition. But from the beginning centric strategies are utilized.

This occurs when occasionally a figure is centrally placed at the very beginning. Beyond this, some children spontaneously enclose some of their figures within a circle to second-handedly unify them. A more complex version of this occurs when the child instead 'frames' some figures creating new rectilinear boundaries for them.

With four year olds, true centric strategies emerge, and by the age of five and six children make deliberate use of symmetry. This is the kind indicated above as that where similarity of figures shows the self-conscious balance of the two figures. This strict symmetry gives way to what Golomb (1992) calls a "dynamic" symmetry, in which the balanced placement of *weight* rather than the strict identity of the figures is used to achieve the symmetry.

Golomb (1992) has noted the kinship between her twin compositional aspects of 'alignment' and 'centering' and Arnheim's two spatial systems of the 'eccentric' and the 'centric' given in his *The Power of the Center* (1982/1988). This is not at all sur-

120

prising to Arnheim who has long noted such antithetical principles in different kinds of world art.

MATURE ART

Regardless of the amount of differentiation a culture allows its arts to develop, all artists eventually gain a mature style (as we shall see, this explains why small-scale cultures do not have works which correspond to the earliest 'aligning' or 'eccentric' art of children). But Arnheim insists that there is no great distance between the child and adult artist. He has said, "it doesn't make sense in principle to distinguish that which the child and artist does, except that the artist does it more intensely, more wisely, more maturely" (Pizzo Russo, 1983, p. 33, my translation). Similarly, Golomb (1992) writes "the structuring tendencies of young children are quite similar to those of adults, even though their compositions are remote from the visual intelligence and aesthetic sensibility of the adult artist" (p. 76).

The principle difference lies in what Golomb has called 'dynamic balance.' We have already seen that young children possess a "dynamic" symmetry in their works, but this is unlike the balance of adult artists. Only adults are able in a composition to employ principles of dynamic balance that yields a dynamic equilibrium. This means that all the principles discussed in part I of this book, and in the next chapter, composition and expression, qualitatively only occur in adult development.

LATE ART

A so-called late style is only possible in a culture in which it is possible to go beyond a particular complexity in the first place. So the discussion of the late style has a limited application, and only with the personalities of artists of the last several centuries in the West has it become possible to document. In his essay, "On the late style" (1986), Arnheim concerns himself with the rare case of the artist who seems to reach an unusual state of maturation in their work embodying "a particular style, the expression of an attitude that is found often, but neither necessarily nor exclusively, in the end products of long careers" (p. 287). Arnheim counts Goethe, Cézanne, Feinenger, Beethoven, Monet, Rembrandt and Titian as outstanding examples of artists who developed a late style.

Characteristic of this work is the shift from hierarchy to coordination. "The various objects and parts of objects lose their distinctive textures, which once defined them as individual characters in the picture story...subjects have become creatures of the same kind, characterized by the community of their fate and mission" (p. 289). There is a lack of interest in causal relations. Agents and targets lose their distinctive character and elements are fused and assimilated, resemblances outweigh differences.

121

"The dynamics moving the various characters is not of their own making. Rather they are subjected to a power that affects them all equally" (p. 290). Initiative no longer animates the individual characters, but a fate pervades the work's entire world. "The living and the dead, the corpse of Christ and his mourning mother, they are all now beings in the same state, equally active and inactive, aware and unaware, enduring and resisting" (ibid.). Physically, there is a "loosening of the fabric, a diffuse-looking kind of order creating an illusion of the various components' floating in a medium of high entropy with interchangeable spatial locations" (p. 289). In the terms of *The Power of the Center*, we can notice here a multiciplity of centers, such that they all compete and the balancing center of the composition, while virtually present, tends to be unsupported compositionally. Particularly revealing are those cases in which a traditional theme or subject matter are treated at the beginning and at the end of an artistic career. Rembrandt, for instance, painted the theme of the return of the prodigal son several times. Arnheim compares one done when Rembrandt was thirty-four with another from the last year of his life (St. Petersburg, Hermitage).

Arnheim points out that in certain other cases, the late style may be observed in young individual artists that seem to age faster. This 'young-late' style can be seen in the work of Wolfgang Amadeus Mozart, for instance his *Requiem*, and Vincent Van Gogh, in the *Crows over a Wheatfield* (1890, Amsterdam, Van Gogh Museum). The artists who develop a young-late style are outstanding examples of the invariance of stage sequence in artistic development and the variance of temporal manifestation of these stages.

THE ARTIST'S LIFE-TIME OUEVRE

The artist's *oeuvre* is a special problem of life span development. We have already discussed the problem of expression in regards to individual works. The next level of judgment lies in discussing how expressive judgments of an artist's work is affected with a knowledge of it. Arnheim (1986) has said that it is "not unexpected that a given work will reveal a different style when seen as a part of an artist's entire oeuvre. Changes in range often change the appropriate way of viewing a given structure" (p. 267).

I tried to show how Arnheim would dissent to Gombrich's limitation of individual expressive judgments based upon a merely metric scale of judgment. Gombrich holds a similar view with regard to the artist's oeuvre or, as he calls it, the artist's repertoire which is merely the sum of works completed by an artist (1960, ch. XI). How, then, do we come to an expressive understanding? With Richard Wollheim, Arnheim rejects the mechanical notion of repertoire as a set of all items known to have been produced by an artist. Instead the notion of *style* is more important. It is an intuitive

problem, relating to the amount of freeplay a given stylistic concept can admit of. Just as we might discuss an ideal "Renaissance" or 'Baroque' style, there is an individual style, a 'Picasso' style which more or less perfectly embodies the style of Picasso.

Accepting this fact means relaxing the insistence that an 'original' must be the artist's own handiwork. Arnheim (1989a) points out that since a building need not be put together by the architect's own hand, why should any other work of art require it? To "the purist's claim that a Mondrian redone by someone with a ruler and primary pigments would lack that decisive something," Arnheim asks, "would it?" (p. 273).

The test of our concept of oeuvre is the individually forged work. Arnheim (1986) discusses forgeries with the example of *Supper at Emmaus*, by Han Van Meegeren, the famous Vermeer forger. The work, he says, was so succesful "not only because it was a good painting, but because it fitted the context of Vermeer's known work perfectly" (p. 283). Arnheim's stress that the contextuality of a forgery makes it as much a legitimate work of art as a genuine work, implies a relativism of identity, suggesting Max Liebermann's remark that "the function of the art historians is to pronounce our weaker works unauthentic." But he points out that as necessary as is the procedure of context fitting, the question of its trustworthiness is another matter. Even though the judgment of genuine works is endless, it is not to say that the truth does not exist at all. Once a genuine work is discovered, no violation to the canon denies its validity.

Art serves development as a way to understand the world, instituting its own built-in motivational structure. The task of representing evolves through perceptual differentiation mediated through representational concepts, and so too must interpretation. 'Early' (undifferentiated) solutions possess the full specificity of thingness and slowly gain in concreteness. If we fail to remember this we will misunderstand these items.

123

CHAPTER 12

THE DYNAMICS OF DIFFERENTIAL AND PSYCHO-PATHOLOGICAL ARTISTIC FORM

The previous three chapters have described frames of reference within which artistic development may occur. Cultural 'development' (chapter 13) 'slaves' individual development (chapter 11) and, ultimately, microgenetic development (chapter 10). But there is another frame of reference provided by the 'constitution' of the artist that slaves all development. It is in the case of organic pathology that this is most evident.

Organic psychoses are known to have often well known and localized occurence. For example, a stroke or piece of shrapnell, the effects of a fever affect one place. What can be said of other pathologies? To quote Arnheim (1992), "The human nervous system is governed by a tendency to keep shapes as simple as possible, so that the stronger the formative influence of the outer world is, the more complex the shapes will become. Conversely, when the perceptual input from the outside weakens, the basic shapes will become more dominant" (p. 147).

This simple formulation serves as a heuristic in explaining the art associated with certain individual differences and pathologies. More technically, Gestalt psychologists like Michael Wertheimer (1955) with his concept of "metabolic efficiency" and more recently Peter Kruse and Michael Stadler (1990) with their concept of "strength of nervous system" have correlated the robustness and mobility of the nervous system with classical psychotic disturbances. Kruse and Stadler (1990), for instance, identify schizophrenia as a case of maximum systemic instability "where the minimum reliability for adequate functioning is no longer guarenteed and the system begins to continually shift" (p. 208).

Individual Differences and Creativity

The constitution with which I shall be concerned is a narrow understanding of cognitive style that owes nothing to the previous three frames of reference except the systemic characteristics of the individual. It deserves to be treated here because cognitive style shares in the qualitative (orthogenetic) characteristics of perceptual development in general. When in the case of pathology the style is merely a stunted version of another, it deserves to be treated under development because sequence invariance is preserved.

Arnheim makes frequent references to Ernst Kretschmer's work on character and body types but makes no pronouncement as to its ultimate theoretical value. More likely, Arnheim intends his discussion of differential artistic constitution to fit into Herman

Witkin's theory of individual differences (e.g., Witkin, 1950, 1965). Using various perceptual tests, Witkin defined poles of "field dependent" versus "field independent" according to the degree one used visual cues or ego-centered cues in spatial tasks. While the tests of Witkin and his students can register cognitive style that is the product of any number of frames of reference, I am framing Arnheim's discussion in terms of pure systemic differences.

Arnheim (1966), himself, has described characteristics of these two kinds of individuals. In a discussion of variable "movement" responses to Rorschach cards, he says there is in the first place:

> [One] who strongly feels the visual dynamics of percepts because he is passionately interested in the outside world and experiences its properties sharply and fully. The richness of his experience would account for the variety of associations available to his thinking and the lack of rigid stereotypes. He has 'imagination' in the literal sense, that is, the capacity to turn thoughts into images and hence to think concretely and colorfully in terms of perceptual symbols (p. 86).

There is in the second place:

> [One] for whom external stimulation essentially fulfills the function of pulling the trigger that sets inner activities into motion. He responds to the outside to the extent to which he rediscovers himself in it. To him, perceptual stimulation is the point of departure for speculation and the play of internally motivated associations. His imagination is in the nature of fantasies, that is, rich subjective productions, only slightly connected with the environmental experiences that gave rise to them (p. 86).

These simple perceptual styles give rise more largely to cognitive styles. In an early essay written on the teaching of psychology, Arnheim (1950) distinguished between two corresponding cognitive styles:

> At the one extreme, there are students who like to deal with children, observe animals, attend court trials, or canvass the neighborhood. They are absorbed by what can be watched and touched. They handle people with intuitive wisdom. But they become uneasy when called upon to draw general conclusions, to compare one theory with another, or to evaluate the soundness of a proof. Scientific terms, which

they handle gingerly or quite unconcernedly, acquire a strange poetical flavor. When asked to define the conditioned reflex, they may say: 'They had a dog on the table, and they made a harmless operation at the jaw, so that they could count the drops of his saliva, and they rang a bell.

At the other extreme:

There are the clever jugglers. They are in love with terminology and quick in connecting ideas which stem from disparate contexts. But their brilliant short-circuits are often purely formal and therefore unproductive. Detached from the facts to which they refer, concepts drift and combine at random. The careful presentation of evidence makes such students impatient: 'Why does he have to go through all these cases since the main idea was clear on the first page?" (p. 84, also 1969, pp. 206-7).

The implications for creative individuals were suggested by Arnheim (1966), after a suggestion by the Japanese psychologist Sakaburashi (1953). Arnheim suggested that ease of perceptual satiation could lead creative people to restructure perceptual material more easily and, therefore, to consider new relationships and meanings. Subsequent work by Klintman (1984) essentially confirms Arnheim's suggestion that there is a positive relationship between chosen profession and satiation (in this case, again, the rate of reversal of a figure). In a smiliar vein, the work of Nathan Kogan and Michael Wallach (Wallach & Kogan, 1965; Wallach, 1988) has shown that creativity cannot be judged by standardized tests but rather competence in actual artistic fields. The flow and uniqueness of ideas is a crucial determinant of success in the arts.

Psychopathology
Psychopathology is often included in discussions of development as the arrest or regression of some sequence of development. In the same way, Arnheim's discussions of psychopathological art are presented in the context of a discussion of development. As we shall see, however, he does not hold to a rigid view of the pathology in relation to development.

For Arnheim, psychopathology can only be introduced as a legitimate concept into the study of art if it is not invoked to explain any work deviating from concrete objects in the environment. We have already come across such a bias which Arnheim (1986, pp. 159-185) calls the "axiom of realism." In his essays, "Inverted perspective and the axiom of realism" and "Caricature: the rationale of deformation" (1992, pp. 101-114) Arnheim gives many

127

examples of realist judgments of works of art. El Greco's supposed astygmatism is one of the more conspicuous examples. If practitioners can resist the temptation of ascribing an unacostomed style to pathology, then we go much further into understanding the particular expression of any particular work.

This accompanies a more general understanding of pathology, itself. In the realm of therapy, Arnheim (1966) has objected to the the notion that the stimulus in a projective technique like a Rorschach test essentially has no character, and therefore is a pure indicator of mental state. He thus advised against immediately assigning an individual tendency or pathology to something that might simply be a response to a different visual dynamics. The result of this is that Arnheim is opposed to viewing pathology as qualitatively different but rather as quantitatively different. The whole dichotomy of healthy and diseased is, therefore, insufficient. "Psychotic states," says Arnheim, "are maligned caricatures of types of character or temperament found in the general population" (1992).

In the same way, Arnheim is primarily concerned with formal properties of psychotic and neurotic art. Yet in spite of this fact, I will nevertheless follow the standard divisions of pathology into organic and functional psychoses to refer to pathologies for which the subjects cannot participate in society. And I will keep this separate from the neuroses, for which therapy is a general help.

Organic Psychosis and Art

Of organic psychoses, Arnheim is well aware of brain damage studies on agnosia, aphasia, etc, especially those undertaken in the Gestalt school, by Kurt Goldstein (1878-1965), Adhemar Gelb (1878-1935), and their students (On Goldstein, see Hans-Lukas Teuber, 1966). These problems, however, are of less interest for the arts and perhaps for this reason Arnheim passes over them (more detailed discussions of the effect of organic psychoses on art are found in Gardner, 1982).

Arnheim, however, did depart from Goldstein's work on pathology and *thought* which then has implications for the arts (Goldstein, 1940, Goldstein and Scheerer, 1941). In particular, Arnheim considered Goldstein's notion that "abstract" thinking was lost in injury as a facet of the general *Grundstörung*. Arnheim's criticisms follow his understanding of abstraction, given earlier (ch. 2), and he differs from Goldstein principally in considering it a bias to call abstract the ability to name in words some principle inherent in a situation.

In his discussions of many brain-damaged patients, Goldstein discusses many tasks that the patients properly execute. Some of these operations – which Arnheim would regard as real accomplishments of productive thinking – Goldstein calls merely "pas-

sive," because they are merely responses to immediate, particular world situations. Arnheim considers this exclusion to be arbitrary. In fact, he says, the patient fails,

> because he cannot find the generic notion of distance...in that situation. He can abstract to the extent of handling the relation...within the context of his performance, but he cannot make this abstraction explicit by isolating it in the context (p. 193).

It may seem surprising that Arnheim should have so much disagreement with a gestalt psychologist like Goldstein, but it is worth pointing out that Wertheimer, himself, thought that this conception was piece-meal (Luchins & Luchins, 1978), and it is probable that Wertheimer here influenced Arnheim. With this general problem in mind, I will proceed to one organic psychosis that Arnheim has discussed in relation to art, autism.

Autism
Autism is an organic psychosis that results from early fever and seizures which cause neurological damage in a determinate area (Sacks, 1987). Some of the afflicted subjects develop preoccupations with words, numbers and most interesting for our purposes, sometimes, drawings or modeling. In this case, there is a tendency to attend, not to the formal characteristics of the design before them, but to the literal features of some model. In "The puzzle of Nadia's drawings" (1992, pp. 155-163), Arnheim considers the case of the young autistic girl, Nadia, who showed remarkable drawing skill well beyond her years. Arnheim endorses the opinion of David Pariser (1981) that Nadia's drawings are a result of an inability or refusal to conceptualize that which she drew. The lack of conceptual categories allows her to attend to accidental features.

Arnheim, furthermore, seeks to account for some of the aspects of virtuosity of such work. Here, the aforementioned fact that "deliberate pictorial representation probably has its motor source in descriptive movement" has special relevance for autist artists (1974, p. 172). And, indeed, Pariser has called the drawings of Nadia a case of "hypertrophy of the so-called scribbling stage."

Functional Psychosis and Art
By far, Arnheim's writings on psychotic art are overwhelmingly devoted to functionally psychotic patients, and in particular to schizoid or schizophrenic art. In general, the schizoid has the classic symptom of excessive sensitivity that protects itself against the provocation of the outer world by an ever more impenetrable shell. Consequently, we find in the art work a kind of incessant restruc-

129

turing, "when the person's contact with reality has been so severly weakened that only an external shell is left of its structure and meaning – a surface pattern that can be transformed at will" (1969, p. 195; 1974, pp. 147-9).

Arnheim has pointed out that like children's art, the art of many schizophrenics present representational concepts very purely and remain very close to the medium. The well known "punning" of some schizophrenics artists points to a formal closeness to the medium, as does the horror vacui also demonstrated by some visual artists. Here, a drawn detail will trigger another detail formally but not thematically related to it. This will, in turn, suggest another form; the process bears similarities to doodling.

Psychotic art has great variety, and one can only attempt to describe certain formal characteristics. At the risk schematization, therefore, the two extremes of systemic robustness and mobility call to mind the artworks of victims of both organic and functional psychosis, the twin disturbances of autism and schizophrenia. Since organic psychoses, for instance, occur at different locals, no technical parallelism is intended. The following observations are formal. In the two examples of schizophrenic and autist art, we see tragic caracatures of the two pictorial attitudes of decoration and illustration. In both cases, Arnheim speaks of the haunting effect of such work attained, however, at a high price.

Neurosis and Art
According to the standard definitions, organic and functional psychotics like schizophrenics and autists cannot be helped much in standard therapy, and thus their art work is usually not a part of a process of therapy leading to eventual health. Art therapy can best help those that traditional therapy might, in the traditional neuroses for instance.

Art as therapy, however, is something of a paradoxical subject for the picture of Arnheim's theory that I have given thus far. As the psychology of art has occupied Arnheim, what the *individual* brings to work is usually negligible. Thus, after examining the drawings made by Jackson Pollock during his psychiatric treatment, Arnheim can say, "the ability of the professional does not provide a favorable condition for art therapy...[The artist] cannot let his private impulses dominate his drawings or paintings, because he is always governed by the artist's task of depicting the human condition in general. If he could overcome this deep-seated obligation, it would perhaps help his analyst, but it would be his undoing as an artists" (1989a, p. 141).

Arnheim is here recognizing the crucial distinction between an art that has its emphasis upon "the benefit of the person and not on the creation of the work" (McNiff, 1975, p. 201). I have al-

130

ready pointed out that the two are related as regards the intentionality of the object in the way that "intracerebral expression" differs from "extracerebral dynamics" as seen in works of art (ch. 11). In the case of art therapy, the patient must "express himself" while the artist normally makes works of art "expressive of" some content. But of course the socializing gesture of going out to a content is the ultimate goal, so it is only as a means to an end. "The natural way of making the self function is to treat it as a means to an end" (Arnheim, 1977b, p. 12).

Discussion of psychotherapy of course begins with Freud and, not surprisingly, many prominent art therapeutic approaches like that of Margaret Naumberg, have been psychoanalytically based (see Arnheim, 1984). Like psychoanalysis, Gestalt psychology bases its therapy upon dynamic principles (Brown, 1937; Lewin, 1937). And Arnheim, himself, has remarked many times on the significance of Freud's deterministic views of neurosis as a lawful product of certain initial conditions.

But in general the drives postulated by Freud are taken to be rationalistic entities of only a broad empirical foundation. For Arnheim, 'the' unconscious does not exist and is not a noun but an attribute (1966, p. 287; c.f. Koffka, 1927). According to Arnheim (McNiff, 1975), the Freudian unconscious has been reinterpreted in moral terms that obscure the struggle between id and ego. Arnheim prefers, however, to view the struggle as one between intuition and intellect.

In spite of important differences between pschoanalysis and Gestalt psychology, in no case does Arnheim identify with so-called gestalt therapy, and he has personally chastized this movement for using the same name (Arnheim, 1974, b). In fact, Gestalt psychologists in general have gone to pains to point out that the two schools have no relationship (Henle, 1986). It is safe to say that whatever Arnheim had to say about therapy was intended without any reference to the works of this school. The early works of gestalt therapy were based on the quixotic writings of Fritz Perls and a new generation has emerged with more respect to the orthodox gestalt writings and an interest in integrating rigorously a therapy to its principles. This leaves the hope of an eventual reconciliation in which even Arnheim's thought might find an amplification.

In his essay, "Art as therapy" (1986, pp. 252-257) Arnheim develops his ideas on therapy most consistently, showing how the patient must orient his art toward "reality," and how the patient can increasingly thereby "express himself" less and less. This approach seems very much indebted to Wertheimer. It is not well known, but under the name of a friend, Heinrich Schulte (1924/1986), Wertheimer authored a theory of paranoia, based on the concept of "centering" (*Zentrierung*). Centering is the generic

concession to the structural requirements of a given situation, and in neurosis it is the acceptance of objectively given relations. As we shall see, Arnheim's "reality" is not unlike Wertheimer's "we" concept. The clearest continuation of these ideas are found in the writings of Erwin Levy, J. F. Brown, Molly Harrower, and Abraham Luchins.

Arnheim (1988) has written that, "the interaction of the two tendencies [of centricity and eccentricity] represents a fundamental task of life. The proper ratio between the two must be found for existence in general as well as for every particular encounter between the inner and the outer centers" (p. 2). The theory of artistic composition can serve as a guide to succesful social "composition." Arnheim stresses that reality is understood as a mental content. "We should go farther," he says, "and realize that when we try to orient a person toward the so-called reality principle, we are not drawing him away from 'mere' mental reality to the facts of physical reality but we make him adapt his mental images to conditions likely to be confirmed by what future experience has in store for him" (1992, p. 249).

If we take the case of a patient suffering from neurosis, their artwork or affinity for certain kinds of work, will reflect a wish or delusion. We find that neurotic art is exactly of the kind prescribed by psychoanalytic theory. It is for this reason that Arnheim reminds us that Freud's famous "Creative Writers and Day-Dreaming" (1908/1985) was directed at popular art, and aimed in Freud's words, "not to those writers who are most highly esteemed by the critics. [But] to the less pretentious writers of romances, novels and stories."

But this is once again not to say that Freud's theory of neurosis is correct if circumscribed within its domain. Arnheim departs from Freud when he insists that quality is required to attain such reality. He goes on to point out that Freud "thought of good form as a mere sugar coating, intended to make the receiver accept the fulfillment of instinctual needs, which is supplied by the content of the work" (p. 249). This is entirely unconcinving to Arnheim. He says that his demand for quality "does not derive from a dogmatic demand for high aesthetic achievement as a value for its own sake but rather from the well supported conviction that a person's best achievement bears therepeutic fruit, not obtainable from a lesser effort" and further "quality is directly related to the reality value of art."

Arnheim says that "I suspect that the repulsiveness of amateur fantasy…is aroused not so much because desires and fears are revealed in their nakedness, but because preconceived ideas and hackneyed imagery are permitted to interfere with the truthfulness of the statement. These products of the mind are cognitively un-

clean" (1969, p. 150). Elsewhere, he says, "I find that we have no aversion to wish fulfillment as such. We are perfectly willing to accept the ideal hero, the victory of virtue and the defeat of evil when they are offered in good works of art.

> We do so not because we are bribed by pretty shape and easy harmony to accept wish dreams but because the good artist succeeds in proving that those desirable happenings can be quite true. Under circumstances that show the human condition 'in the pure,' virtue is in fact rewarded and evil punished, for the reason that virtue is nothing else but what enhances well being and evil is what disturbs it. Mediocre works are rejected when they obtain wish fulfillment at the price of distorting the truth. When the good are cheaply virtuous and improbably succesful, when the evilness of the villain is unrelieved and the seductiveness of the love object a mere figment of lustful phantasy, we object because we cannot afford to have reality betrayed (1992, p. 249).

Arnheim's approach to art therapy has been developed by a student, Shaun McNiff. In a review of McNiff's standard work (McNiff, 1981), Arnheim (1982b) agrees to his kind of "expressive art therapy." McNiff not only utilizes standard drawing and modeling, but extends his therapy into dance and psychodrama. This matches up with the Laban inspired system of dance therapy of Bartinieff's students, which Arnheim has also approvingly reviewed (Arnheim, 1984).

In the case of the neuroses, the question is left open to what extent these constitute true illnesses. Wertheimer's immanentism almost suggests a theory like that of Thomas Szazs in which drug therapy, for instance, would have no place. Arnheim has called the view of the 'myth of mental illness' "quixotic" but potentially useful. In any case, Arnheim is certain that drug therapy has no relation to the arousal of creativity, something of a weakening of the 'regression' hypothesis. He has, in various places, refuted the view that a drug like mescaline can induce creativity (Arnheim, 1971, 1972) saying, "you only get what you deserve...if you are not perceptually alive already – the drugs won't really help" (p. 94). According to Arnheim, this view was shared by Aldous Huxley himself.

The important contribution of the Gestalt view of individual differences is the conception of such differences as systemic. In either case we are dealing with a perceptual system more open or closed to external stimulation, which then has consequences for the creation of art. Similarly, pathologies then become exaggerations

133

of these already existent differences. While the two examples discussed above, autism and psychosis, do not have opposite etiologies it is useful to see the product of their malfunctioning as in some ways opposite, the one opening the subject to irrelevant and hence, realistic, detail in the world, and the other closing the subject from this detail.

CHAPTER 13

THE DYNAMICS OF CULTURAL-PERCEPTUAL ARTISTIC FORM

According to a strict Wernerian perspective, we would be justified in speaking of 'Cultural Development,' to mirror individual development (ch. 11) and microgenetic development (ch. 10). This would be part of a larger system of developmental concepts – orthogenesis – that was sympathetically critiqued in Chapter 9. Indeed, Arnheim often speaks of so-called primitive people and their display of qualitatively 'early' behavior and art. However, as I argued, although Arnheim is sympathetic to such theorizing, his theory does not and need not use it as a foundation.

Gestalt theory is not so much about rigid lines of development, which find qualitative parallels in different domains, as a theory of psychological differentiation. That is, different domains, the cultural, the individual and the task-oriented, allow and develop to a particular level of differentiation. As I showed in chapter 9, cultures do not develop. Technically, any 'open' system does not develop either, for the scientist and philosopher must insert additional *ceteribus paribus* clauses to make the pattern fit into any pregiven pattern.

What is more important in this situation, and what marks the value of Arnheim's gestalt approach, is the naturalistic search after dynamic principles that operate on known conditions. This raises again (see ch. 1) the curious status of Gestalt psychology as a theory of innate faculties. I have argued that Gestaltism should not be allied to ethology (Lorenz), Cartesian linguistics (Chomsky) or other such theories. Gestalt theorists never argued that nativism was correct. They have indeed used this argument when defending their theory as what I would call a short-hand (Pastore, 1956, 1960; Wertheimer, 1951, 1961; Zuckerman and Rock, 1957; c.f. Epstein, 1964). But in using this shorthand they have done more damage than good, because nativism destroys the naturalistic foundations under-girding Gestalt theory.

Culture and Perception

Gestalt psychology once again is about using dynamic principles in concert with known initial conditions to theorize general principles of perception. Without such a conception, culture becomes antithetical to psychology. What the study of art needs, and what Arnheim tried to give it, was a set of working tools that could be put to use productively for this kind of theory. In this sense, psychology is merely one science among many that is required to explain art. A-cultural Nativism or its reverse that is currently instituted in much

135

of academia, a-nativistic Culturism, are equally damaging in their exclusivity. What is needed is a science of psychology that can contribute to other sciences, much the way that biology helps to explain organic chemistry, while maintaining its own identity.

'Cross cultural psychology,' then, is not a misnomer or an oxymoron. As Dan Sperber (1982/1985) rightly wrote, it "is not generally relativist." Instead, it seeks to show the intersection points of general psychology – behavioral principles all people share – and the environmental forces that shape variations of that behavior. Sperber himself has given us an exemplary model of psycho-cultural interaction in his theory of linguistic relevance, whereby speakers and listeners have an inborn searching-after-meaning that accompanies formal linguistic structures of under-standing (Sperber & Wilson, 1986/1995).

The anthro-social domain of culture consists of social facts, rules and representations that are not common to all people but instead only to distinct communities. These representations are reciprocally based on, and emerge from, real-world practices. With these practices, psychological abilities are deployed. As noted, cultures do not develop according to any observable pattern, but there are broad qualitative traits of psychological differentiation that may be characterized. That is, taking a cross-section of practices, especially those based on technologies and ecological embedding in a way of life, we come up with representational complexes that often share fundamental properties and can be compared to others. These properties are a result of dynamic interactions and not the simplistically conceived associationistic conditioning of the 'carpentered world hypothesis' and the like (Segall, Campbell & Herskovitz, 1966).

The result can be called a 'cognitive style' based on a degree of psychological differentiation, or relative field dependence/independence. Psychological differentiation theory proposes that cognitive-perceptual style might be assessed on a continuum from an articulated to a global style. An articulated style is one in which the individual separates and joins contextual information. Its opposite, a global style, is one in which the individual acts on contextual information as an undifferentiated whole. Therefore, one end of the continuum is characterised by a more differentiated, articulated, field independent cognitive-perceptual style. Individuals whose style is more differentiated are able to dis-embed stimuli from their surrounding cognitive-perceptual field, experience parts of the field separately from other parts of it, and have a well differentiated body concept. Conversely, individuals whose cognitive perceptual style is less differentiated have difficulty dis-embedding stimuli from their field, are dominated perceptually by the field, and have an undifferentiated, impressionistic body concept.

The most up to date model of this ecological selection of psychological skills lies in the work of the cross-cultural psychologist John Berry (1987, 1993, 1996). He was a collaborator of Herman Witkin, applying the constructs of field and ego-dependence to cross-cultural material. According to his model, cognitive abilities arise from the concerted adaptation of biological and cultural factors to ecological demands: "abilities are behaviours that reach stable levels through the adaptation of cerebral structures to ecological demands...Abilities develop in response to ecological demands that themselves are modified by skill acquisition." To refer to his diagram (**Fig. 17**), he sees cognitive abilities (on the right) as a complex result of a number of factors that can be likened to Arnheim's (and Gestalt psychology's) frames of reference. It is not a question of nature or nurture but rather the lawful coordination of different relational influences together.

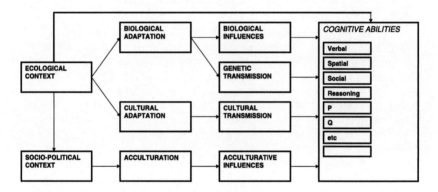

Fig. 17. The interrelation of skills and ecological learning in cross-cultural psychology, after Berry (1988)

Art and Culture
Throughout the world today, and throughout history, a myriad of beliefs and practices have given rise to a great plurality of artistic traditions. Decades ago, psychology optimistically grouped non-western are that did not emerge from the great Hindi, Islamic and Chinese traditions under the rubric of 'primitive,' presuming that it shared enough qualities of naïve construction to justify inclusion together. Using the term primitive in turn ascribed the lack of naturalism of the various arts to a lower level of intellectual achievement, based on animistic and pre-logical thought processes.

As noted in the discussion of childrens' art, Arnheim distinguishes between intellectual and representational concepts, thereby effectively distinguishing representational abilities from intellectual development. Therefore, when he affirms that 'early'

forms of representation share formal qualities, he means purely *representational* qualities of constructive relative to a medium. In fact, Arnheim makes the refreshing observation that westerners are not the yardstick for measuring the rest of the world's art production. Rather, their approach and its success over millenea should give pause to our post-Renaissance experiments in realism, which only find parallels in certain strands of the Chinese and Japanese traditions.

Instead of relying on western standards of verisimilitude, he focuses on more elementary examples of picturing, in which a more immediate approach to the pictorial idea is approached. This has been discussed by Arnheim as the 'Egyptian method,' which he sums up by saying that '[the artist] actually makes [the painting] be what it suggests it is' (Arnheim, 1974, 112). If in representing a chessboard the perceptual concept of 'squareness' calls for a simple, undistorted flat square, then this is how it is represented (c.f. Arnheim, 1986).

In terms of a formal perspective system, this means that linear perspective is not necessarily privileged. Much closer to actual picture-making is the negatively termed 'inverted perspective.' Arnheim points out that the term 'inverted perspective' is a misnomer because it is the most natural and genetically privileged perspective system. It is central perceptive that is actually 'inverted.' The main advantage of this kind of perspective lies, according to Arnheim, in its ability to render size and volume unambiguously. Size relations considered purely from the point of view of the frontal plane of the drawing or painting surface unambiguously represent hierarchies of symbolic importance. This is precisely the strategies we find in self-taught art, folk art, Medieval European art, various arts of small-scale societies (Africa, Oceania, America), and even children's art. We need not romantically conflate them all into a form of primitivism if the standard itself is derived from the material condition of the picture.

The upholder of the rational basis of perspective, especially Gombrich, often confuses perspective with the issue of scientific or historical objectivity. To deny the special status of perspective we need not deny the validity of geometry or of science, nor need we accept (with Nelson Goodman) the alternative that all picture-making strategies are mere conventions. Both scientific and historical objectivity are isolated issues. When Arnheim offers a different basis for perspective, he still assures historical objectivity; it is the objectivity of inverted perspective (Verstegen, 2004a; Zimmer, 1995).

This amounts to a reformulation of the notion of realism and again of Arnheim's notion of the special status of linear perspective. By placing the burden of standard perspective on inverted

perspective, and making linear perspective a subset of it, he retains the objectivity of a norm, but reorganizes the canon. This is an alternative that frankly has not been considered.

It is obvious that subtle distinctions must be held in mind when considering such issues. Not the least of these relates to the changing sensitivities that go with pictorial form. Critics of Arnheim should realize that there is a considerable body of gestalt work on perceptual modification. The Gestaltists in fact considered the trace field (*Spurenfeld*) to be under the same lawful relational-determinism as the spatial field; percepts can be lawfully altered in time the same way that a perceptual illusion is merely caused by the relational determination of the visual field. Herman Witkin emerged from the gestalt tradition and went on to inspire the 'period eye' of the art historian Michael Baxandall (1972). In a study of tacit knowledge surrounding the use of geometric perspective in the Renaissance, I insisted that one had to take into account an extensive store of skills necessary to unpack complex perspective images (Verstegen, 2004c).

Arnheim has tried to describe the ways in which we see images differently because of our learning, without going over into relativism. Gombrich balked at Arnheim's suggestion, first put forward in 1954, that because of the relativity of perception, "probably only a further shift of the reality level is needed to make the Picassos, the Bracques, or the Klees look exactly like the things they represent" (Arnheim, 1974, p. 93). Gombrich (1960, p. 27) called Arnheim's formulation a prime example of the old historicist doctrine that cannot dispense with value judgments and is hopelessly relativistic. What Arnheim was trying to say is that these artists and their reception worked with perceptual learning subject to rigourous relational principles.

Here we can reverse Arnheim's so-called law of differentiation to include reception. If we recall that it states that a perceptual feature must be represented by the structurally simplest of its total range of interpretations, we can chart an art historical approach to reception. As we shall see, the consequences for interpretation are enormous, for not only is a functional approach to artist's and art suggested, but also a functional approach to interpretation. When Arnheim states that the percept must be represented by the structurally simplest of its total range of interpretations, he is once again following Wölfflin who recognized that one must not interpret art as if 'formal possibilities' (*Formmöglichkeiten*) were then known to the artist (cited in Arnheim, 1974, p. 184).

Arnheim's pseudo-pattern of development is portrayed when he says that, "At first, works in a new style are rejected as being unnatural. In a second period, where the style truly conforms with its culture, the work itself looks like nature itself. Still later,

139

they lose their naturalism and are recognized as conceptions of abstraction. They turn out to be works of art" (Arnheim, 1989a, p. 255). The perceptual learning of the subject may hinder the ability to understand or properly appreciate the work of another culture. Why is it that the person "brought up on Leonardo will see Tintoretto as a mad rush hour scene" (Arnheim, 1966). Why did Impressionist paintings look like assortments of meaningless color patches to the contemporary layman who today has no trouble perceiving human figures and animals in them? Once again, the same factors that oversee the differentiation of perception govern its interpretation. As a general strategy, one must locate the perceiving subject at their degree of perceptual differentiation, and then one can begin to predict their perception.

It is not sufficient to regard the pictorial works of the world as a 'museum without walls.' Different modes of seeing can be different and seem hopelessly relativistic when the supporting real-world practices that relationally determine them are ignored. Thus Otto Pächt writes that 'If...there is no absolute norm of taste or beauty, then there can be no absolute norm of skill either. Thus it would be equally meaningless to ask whether the Master of the *Lindisfarne Gospels* (c. 700, British Library, London) could have drawn and even could have wanted to draw a natural likeness, or whether Pollaiuolo could have designed or invented one of the carpet pages of the *Book of Kells* (c. 800, Trinity College, Dublin). Either lacked the skill to do the other's work. The faculties required in each case were mutually exclusive" (Pächt, 1960, p. 103). Arnheim would heartily agree, not least about the coupling of practices with representations.

These observations insist that seeming cases of relativism of perception are actually lawfully determined cases of perceptual learning. On the other hand, Arnheim always stresses that the task of artistic creation is so fundamental that artists usually retain a core of intelligibility in their designs. In this Arnheim's position finds support from contemporary studies of communications and cognitive science that sees limits to the reception of different messages (Messaris, 1994). Of course, Arnheim and Gestaltists would always resist framing this in the language of nativism vs. learning, for it disguises the lawful nature of learning.

CHAPTER 14

OBJECTIVE PERCEPTS, OBJECTIVE VALUES

"Objective Percepts, Objective Values" is borrowed from one of Arnheim's (1986) more provacative essays, and it will serve as a proper conclusion to this book. In a sense, art only makes a difference when it can be enjoyed and has a claim to our view of reality. However, there a many obstacles to the proper understanding of art. What has not been appreciated with Arnheim's theory is the extent to which these can be accomodated to a relational determinst frameword of the very kind Gestalt psychology espouses.

As I have pointed out, the field of contemporaneously acting perceptual forces is complemented with the so-called memory field of accumulating and interacting memory traces. These all interact in a determinate way. In fact these very factors can be brought to bear on both the problem of the objectivity of expressive percepts and values more generally. In this way, Arnheim's contribution can be better appreciated with more contemporary approaches.

The Objectivity of Expressive Judgements

A major area of psychological research concerns the agreement upon expressive adjectives, that is, expressive judgments. By far the most important name in this research is Irvin Child (Child, 1962). We ask, what is the degree of agreement on aesthetic terms? Does it obtain across cultures?

As we can see, this is in large part a debate over the confines of psychology and sociology (ch. 1). To argue that subjects can agree about judgments is simply to argue that it is 'psychological' which by definition defines (or should define) the cross-cultural aspects of human behavior. Therefore, it is best simply to admit directly that when one finds agreement, one is making a philosophical claim that aesthetic properties exist. The use of 'psychological' methods, is really deciding a philosophical problem.

The tradition represented in this book argues for the large agreement on expressive judgments and argues that cases of lack of judgment are special cases in which experimental design was unclear, directing the subjects to disagreement. Characteristic of our approach is the so-called 'physiognomic' game developed by Max Wertheimer (Heider, 1983). Wertheimer always had a piano in his class and would improvise with the personality of one of the seminar students in mind. When asked to identify the student, there was always above chance agreement.

Subsequent to Wertheimer, various psychologists investigated the agreement on expressive judgments. Carroll Pratt's (1956)

later work moved into statistics but was somewhat limited. Interesting is the fact that psychologists in the Gestalt tradition, like Suitbert Ertel and Giovanni Flores-D'Arcais, collaborated with Charles Osgood in what is probably the most sophisticated investigation of the objectivity of affective meaning in recent times (Osgood, May and Miron, 1975).

Osgood represented a neo-Behaviorist viewpoint but anyone must be impressed with the breadth and genuine cooperation that went into his international study. Perhaps there are surprising commonalities that have yet to be uncovered. If such work took for granted multidimensional scaling that separated descriptive and evaluative factors, more important results might be obtained (ch. 2; Peabody & Goldberg, 1989).

Relativity vs. Disparity

It is one thing to affirm that expressive judgements are objective, but it is quite another to affirm that value judgements of works of art are objective. This question has received little recent attention in psychology (however, see Arnheim, 1986), but during the 'thirties, there was an amazing amount of work on the social psychological effects of social influence on evaluation. The Gestalt approach to aesthetic value judgement must be seen in this context.

One of the most important works was Muzafer Sherif's *The Psychology of Social Norms* (1936), which was based superficially on Gestalt psychology. Sherif, however, concluded that evaluation was the effect of prestige, suggestion, or sociological determinism, and his conclusions should not be taken to be those of Gestalt psychology. His 'aesthetic skepticism' was the major conclusion of most contemporary studies (summarized in Thorndike, 1935).

Led primarily by Wertheimer, the Gestalt school responded with numerous works to demonstrate that such effects were not the results of blind prestige or imitation, but the structural conditions in which the evaluated objects were presented (Asch, 1952; Luchins and Luchins, 1978; Pratt, 1931). They furthermore showed how misapprehensions of value could take place.

In a typical aesthetic evaluation task, subjects are asked to rank artists, be they musicians, composers, painters, etc., according to greatness of samples of their work. The names of the artists and the samples are scrambled and the effect of the prestigiousness of the name is shown. Thus Sherif (1935) concluded that, "authors rated high tended to push up the ratings of the passages attributed to them. Conversely, authors rated low tended to pull down the ratings of passages attributed to them...Not the intrinsic merits of the passages but the familiar or unfamiliar frame of reference explained the findings" (p. 122).

The gestalt concept of the 'frame of reference' is used by Sherif improperly. He sees the prestigiousness of the name as the frame of reference. But the true frame of reference is the very lack of a frame of reference. The quality of the passages is similar, their length is short, and in short there is no basis upon which to make a judgement. Thus Wertheimer concluded that Sherif's subjects' judgements were the results of the 'narrowing of the mental field' (Luchins & Luchins, 1978).

Wertheimer, Asch and others constructed new tests in which the criteria of judgement were more clear-cut. In one important study (Asch, 1952), it was explicitly shown that the determinants of aesthetic value were the structural characteristics of the work of art itself and not the determinants of status or prestige. This brings us to the surprising conclusion that Gestaltists do not deny determinism in a form of Gombrichian 'aesthetic libertarianism.' They are happy to admit that aesthetic judgement is determined, *but insist that it is determined by what we see and hear* (c.f., Mandelbaum, 1960).

But aesthetic absolutism is immediately ruled out because we can accept the truth of what we may call *descriptive* relativism. Just as in ethics, the fact that descriptively such judgements do not correspond does not necessarily imply true relativism. We can often distinguish true relativism from merely descriptively relative judgements that are a result of differing or disparate perspectives. This we may call relationism, or what the philosopher Monroe Beardsley (1956) called 'particularism.'

To take an example, we know that two periods or two people judge nineteenth century Gothic revival with different levels of value. The question we must seek to answer is the degree to which aesthetic descriptive judgements that disagree are truly relative and which are merely relational or disparate. In order to answer this, we must treat of the various factors that may influence the judging process. One could here look to gestalt work on ethical value for some clarification.

It was Kurt Koffka (1935) who made some important observations on this problem, especially with reference to works of art, when he discussed the 'proper quality' of a work of art in his *The Principles of Gestalt Psychology*. He introduces the constructs of the picture, P, and the 'critics' A and B and specifies that "every behavioral object depends upon the external and internal conditions to the case of art-appreciation" and provides the following formula (p. 348):

$$Pn = f (P, N)$$

Koffka adds to the equation, s, the important fact that the picture is a developmental schema level. The work of art may be variably perceived not as P or even Pn, but as P non-s. Arnheim (1986; 1977, pp. 5-6) seems to follow Koffka and gives the interpretational state of affairs in the following diagram (**Fig. 18**). Arnheim calls T the target of the cognitive processes and A, B, C, and D the respondants or groups of respondants.

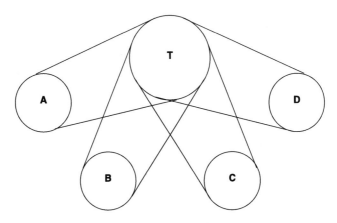

Fig. 18, The objective percept (T) and its changes due to perceptual learning (A, B, C, D), after Arnheim (1986)

Each of the responses is a "gestalt context constituted by T and the particular observer's intrinsic determinants" (1986, p. 314). Presumably, spatial and temporal relativity would contribute to the modification of T while developmental relativity would contribute to the responses. To reiterate what was said in the introduction to the chapter, the relations described here are just as absolute as those discussed concerning the physical material of the object of perception and the autonomous processes of the organism.

Part and Whole in Aesthetic Disagreements
Perhaps the simplest explanation of disparity lies in the variability of the part-whole relation. Using as an example Gottschaldt's famous figures, Carroll Pratt (1956) argued that a phenomenal work of art might be geometrically embedded in another context thereby making it unrecognizable. If such was the case, the phenomenal experience would not be the same and no aesthetic disagreement would exist. Pratt provided examples from music as well. Asch (1952), discussing the "structural understanding of assertions," made points highly relevant to particularism in literary evaluation. He, indeed, specifically spoke of the part-whole relation, and the

effect of context upon understanding the proper meaning of any individual literary fragment.

More specifically, we can treat the problem of when a part is treated as a whole. Arnheim's (1928) dissertation demonstrated that a part of a profile, a nose or a chin, could change radically in a new face. Arnheim (1974) says that, "no portion of a work of art is ever quite self-sufficient" (p. 78). Therefore, the breaking of a work into parts is always falsifying to the nature of the whole.

If we try to respect necessary versus arbitrary parts, however, the part-quality of a work of art is predictable in its behavior. Arnheim gives the example of the statue with its head broken off, and remarks how it looks 'disappointingly empty.' This is because if it had been detailed to the degree that it might serve as portraiture, it would not have fit into the structure of the whole. According to Arnheim (1974),

> good fragments are neither surprisingly complete nor distressingly incomplete; they have the particular charm of revealing unexpected merits of parts while at the same time pointing to a lost entity beyond themselves (p. 78).

It follows from this that only strong wholes will have parts that will be able to reflect this quality. But strong shapes always resist falsification. Edwin Rausch (1964, 1966) has gone on to identify these "isolation properties" (*Einzelgegenstänlichkeit*). The importance of this concept cannot be underestimated for aesthetics.

Probably more common is the admission of the work of art into a context alien to its original design. This is actually a quite common problem that arises most often with simple problems of the illumination of works of (usually portable) art. Arnheim (1974, p. 345) points to Wolfgang Schöne's important admonitions against the standard lighting of contemporary museums. Even if we try to limit white backgrounds to modern works (as advised by Schöne), there are more idiosyncratic problems.

For instance, the mere proximity of two paintings can change their character (Koffka, 1935, p. 346). A student of Arnheim, Ann Gaelen Brooke, studied this problem by observing how the meaning of the same work of art changed in different contexts (Arnheim, 1969). She asked for descriptions of paintings paired in novel ways. For instance, Rembrandt's painting of the Polish rider was placed next to Jean Dubuffet's *Landscape with a Partridge*. The similarity of the:

> two large, brown areas gave the background of Rembrandt's painting a new and unsuitable importance. At the same time, this very relation increased the depth between

145

the foreground figure and the horseback rider and the backdrop, which looked too far away in contrast with its counterpart in the Debuffet, where the textured mass filled the frontal plane flatly (1969, p. 61).

Next replacing the Debuffet with Klee's painting of a large running chicken, "there was a sudden emphasis on the movement of the trotting horse in the Rembrandt and a corresponding fading out of the backdrop" (p. 61). Arnheim gives further examples.

Other Factors in Aesthetic Disagreements
Our discussion of comparative development contains in its positive exploration of processes of varying length – problem solving, life-span development – also a negative explanation of distorting effects upon perceiving. Something similar was developed by Mandelbaum (1969), in his study of the distorting effects on moral judgments. According to Mandelbaum, there are three principal sources of disagreement in ethical judgements, and these are (1) emotions, (2) sentiments, and (3) personality factors. Since I have found that Mandelbaum's writings are fully compatible with gestalt theory (Verstegen, 2000b), I choose to use his work as an example for resolving the problem for aesthetic evaluation.

Attitudes
Mandelbaum discussed first attitudes, which could correspond to the micorgenetic effects of 'set' (ch. 10). It is usually meant to refer to someone's semi-permanent biases that inhere in their per-sonalities. Mandelbaum says, "we shall on the contrary use the term to designate whatever, at a given time, may be the 'set' of a person toward the objects of his experience. Thus in our usage, we would not speak of 'radicalism' or 'conservatism' as attitudes, but we would speak of attitudes of anticipation, boredom, disgust, hatred, anxiety, admiration, disapproval, and the like" (p. 118).

Affect
Just as our discussion was led loosely by duration, 'emotion' can be introduced as a quality inhering that is more permanent than an attitude but less so than a personality trait (ch. 2, 10). We have mentioned emotions above as 'affects,' and these could be likened to the changing feelings we have toward an object as we proceed through the problem-solving of creating art.

Sentiments
Sentiments, as they are used here, generally relate to "love" and 'hate.' In Köhler's (1958/1971) words, "it has the characteristics of an enduring disposition which tends to give a person's thoughts,

146

feekings, and actions a particular orientation" (p. 406). In Mandelbaum's (1955/1969) words, "it is an enduring thing, havind its own laws of growth, of transformation, and of extinction...once it has been formed, a sentiment will in large measure control what emotions we feel and what responses we make when a passing situation contains the object of our sentiment, or contains anything connected with this object" (p. 218; c.f., Asch, 1952, p. 569). We have not discussed sentiments but they would fall under the discussion of chapters 10 & 11.

Personality

And we discussed personality, which relates to 'differential' psychology. In other words, there will be a personality make-up that might lead one toward a tendency to perceive objects in one manner over another. What is important to understand in all these cases is the systematic nature of each contributing factor, and the analyzability of the various factors.

Without discussing each of these potentially falsifying factors in depth, we can see that each has a deterministic genesis and effect, which can be charted. Falsification – leading ultimately to neurosis and even psychosis – is a real thing. But that should not lead us to give up hope for obtaining the objective percept. Gestalt psychologists have consistently shown that the patient attending to the design of the experiment and the careful isolation of judgment of the relevant elements leads to intersubjective agreement (Henle, 1955; Prentice, 1956)

The Primacy of the Facts in the Resolution of Aesthetic Disagreements

We have seen ways in which spatial and temporal gestalt processes do not so much distort as alter the character of our percepts of works of art. These characters are of various durations and permanence, and our adaptive search to understand the world around us insures that we seek to improve the reliability of the cues we receive. One of the worries of opponents of such perceptual relativism (like Gombrich) is that it seems to state that people are victims of their present cognitive-perceptual adaptation and are barred from understanding each other and their cultural products (works of art).

Everything about Gestalt psychology, however, suggests that adaptation and the search after meaning is constant. Especially in the way that perception is coupled with action and mental representations are bound to real world practices means we can variously adapt to any circumstances. The chaos of interactive media has made westerners quite sensitive to the briefest of iconic information that we interpolate without problem. But spending time in a rela-

tively 'deprived' environment resensitizes us to simpler traditions, which we can recover.

Even so, there are principles that we may fall back upon, principles that were investigated by Mandelbaum but are more or less common sense. And they state that before we throw up our hands and invoke relativism, we have to make sure that the conditions under which a judgment about a work of art is made and the affirmation it makes are universalizable across instances. For instance, if one viewer says that Picasso is a great artist, and another says he is not, we have only begun at the very earliest stages of meaningful dialogue. It is here that Arnheim's (1986) dismisses the blank apellation 'good.' 'Good for what?' he asks instead. Only be being extremely specific can we hope to make sense of aesthetic disagreement. Once 'good for what?' has been specified we can see where potentially falsifying factors lie.

As sketched at the beginning of this book, psychology is the universal science of behavior. That is, it seeks to uncover principles and laws that pertain to the behavior of all individuals. If this is true, then there *must* be a psychology of art. We can disagree on its exact configuration and theoretical commitments, but some science of the perception of works of art must exist, and must be compatible with our further understanding of anthropology and sociology. In this endeavor, Arnheim has provided a unique model for the potential interlocking of psychological with sociological knowledge.

148

CONCLUSION

Art is in need of psychological investigation. One of the most promising investigations in this manner is the life's work of Rudolf Arnheim. His unique theories based on Gestalt psychology are unusual in being based on principles that are rich enough to make art more than an instinct, foible or merely reflection of non-cognitive factors. Therefore, this book has undertaken the dual purpose of both illustrating the unity of Arnheims' theory but also presenting it as a species of Gestalt psychology that is subject to contemporary defense.

Arnheim's theories can be explained by common principles that ultimately derive from Gestalt psychology. This is good for both those who support and do not support an Arnheimian interpretation of art, for it makes what is praiseworthy or blameworthy easier to identify within Arnheim's theory. However, resources may be brought to the understanding of Arnheim above and beyond the recent interest by Cognitive Psychology in Gestalt Theory. In particular, European (especially Italian and German) research on various aspects of perception and cognition give us good reason to suppose that the model of mental functioning proposed by Arnheim has much merit and should be taken seriously.

To begin with, Gestalt Theory has a compelling theory of perception which includes in its purview expression. Rather than an addition to quotidian perception, expression is an aspect of perception itself, revealing cognitive relationships between objects. The rich phenomenology of expression demands an equally complex model to represent its axes and parts. The ability of the visual system to abstract makes the secondary expression of works of art arise naturally, as a direct result of the interaction of diverse percepts together. Furthermore, the ability to then manipulate objects to think productively makes art a cognitive achievement. A fundamental theory of perception can underlie the various arts and base itself on a simple theory of perception objects and their dynamics. Far from being outdated, new research in brain functioning gives us reason to think again about the 'notorious gestalt brain model.'

Gestalt Theory explains perception on the model of simplicity. This explains perception but also expression in pictorial, sculptural and architectural form (the 'visual arts'), the pantomimic arts (film, dance, theater), musical form and poetic form. But the Gestalt Theory of perception must be adopted in all its completeness to include percepts developing in time. This raised methodolical issues that had to be addressed, but when the organicism was exercised from Arnheim's Gestalt Theory, it remained a powerful framework for understanding art and development. Using the loose model of developmental duration, we investigated microgenetic

149

development, individual artistic development, differential and psy-chopathological 'development,' and cultural-perceptual 'development.' Putting both the spatial and temporal insights of Gestal Theory together, Arnheim's theory provided a powerful way to portray the perception of art in all its ramifications. It shows art in its variety, but also in its objective aspect.

APPENDIX

THE LIFE OF A PSYCHOLOGIST OF ART[*]

Rudolf Arnheim is surely one of the great psychologists of the century. In a career reaching over seventy years, he has made seminal contributions to the psychology of art, aesthetics, art education, and media studies. His achievement touches so many aspects of twentieth-century thought that it is hard to estimate his importance. Even so, besides a few articles (Kennedy, 1980, 1985), no major study of his thinking has appeared.

Technically, Arnheim was trained as a psychologist, and he always considered himself to be a psychologist. But with the exception of his dissertation (Arnheim, 1928) and one or two other writings, he never published an experiment. He was, as he admitted, the epitome of the amateur. Like Trimalchio of the Satyricon, Arnheim says he is like the crab. "To stand on many legs, as I have done in my own professional interests for a lifetime, is rewarding but tricky" and, furthermore, to walk side-ways creates an 'obvious' traffic problem" (cited in Henle, 1976, p. xiii).

Arnheim's great works are of course *Art and Visual Perception*, an instant classic when first published in 1954, and expanded to 500 pages in 1974, and *The Power of the Center* (1982/1988). His great contribution, and that of these particular works, is of balancing the scientific rationale of psychology with the reality of art. Arnheim (1982) once wrote,

> When psychologists investigate the arts, two prerequisites, more than any others, are indispensable for success. The explorers need the delicate hands of good surgeons, who can penetrate a body without destroying the order and functioning of the organs; and they need respect for what Rudolf Otto, speaking of religion, called the *mysterium tremendum* – that is, the awe-inspiring secret. If they lack the delicacy of touch, they will noisily handle their data without caring enough about what they are doing to the phenomena they want to describe and explain. If they lack the respect, they may assume that they are dealing only with the ordinary, augmented perhaps a few degrees (p. v).

The goal is of "catching the albatross while it is still flying" as he is fond of saying. In the introduction to *Art and Visual Perception* he in fact writes of the difficulty of mastering both art theory and psychology, and his ability to do both is his particular gift and leg-

[*] Reprinted by kind permission of Heldref publications.

acy. But this is not all. His work had to appeal to the artist, and the theory put forward had to have "the stain of authenticity." It is an art theory/psychology recognizable to artists.

What does Arnheim try to do? Simply put, he tries to explain the way we perceive, think about, and create art. More narrowly, he tries to understand the work of art as a preliminary science. The painting or sculpture must reveal itself as a work of art before other extensions into its understanding can be undertaken. This approach can coexist with others, if it is recognized as the preliminary science that it is. If it is denied that a first science exists – then Arnheim parts company anyway.

Arnheim is one of the truly intelligent lookers we have had, in the line of Alois Riegl and Heinrich Wölfflin. He secondly was extremely fortunate in his almost accidental affiliation with Berlin Gestalt psychology, which provided him with most intelligent tools with which to sharpen his looking. Third, he was an orthodox Berlin gestalt psychologist which accrues to him any of the philosophical sophistication (or lack of it) of his teachers. Perhaps lastly he has had the gift of a long life, which gave him the opportunity to write more in the twenty years after his retirement than he had in the several decades before it.

Arnheim looks at art as a scientist and, indeed, throughout his entire academic career, he has identified with, and represented, the scientific school of gestalt theory. As a scientist, his concepts are not engraved in stone, but are offered as the best rational explanations of the phenomena he presently observes. Arnheim strongly believes that science can bridge the gap between itself and hermeneutic interpretation, and always looks to more adequate tools from mathematics and physics to address this. In this sense, his theory is open ended, and it is only this fact that allowed him to completely rewrite his *Art and Visual Perception* twenty years after its original publication.

Berlin to 1932

Arnheim was born in Berlin, 15 July 1904. His father, Georg Arnheim (1878-1943), was a manufacturer of pianos. Arnheim entered the University of Berlin in 1923. According to Arnheim (Glasscock, 1989), he made a deal with his father to "spend half the week at the piano factory and half the week at the University of Berlin" (p. 10). But his studies soon consumed him and it was clear that he would devote all his attention to academics. Arnheim's natural interests were in art, literature and music, and while he "minored" in art and music history, most important was his eventual training and adherence to Gestalt psychology.

After the revolution of 1918, the Imperial Palace had been abandoned, and there in a part of it the Psychological Institute was

given occupancy (c.f., Ash, 1995). There the Gestalt psychologists had their headquarters. The school only had developed an identity in the 'teens, and when Arnheim entered the University the journal which published the Gestalt research, *Psychologische Forschung*, had just been founded and Wolfgang Köhler (1887-1967) had just been awarded Carl Stumpf's prestigious chair in philosophy and directorship of the Psychological Institute.

Max Wertheimer (1880-1943), another professor at the Institute, would come to be Arnheim's most important teacher, advising his dissertation. But Arnheim not only took courses from Wertheimer and Köhler, but also Johannes von Allesch (1890-?), Erich M. von Hornbostel (1877-1935) and Kurt Lewin (1890-1947). It is well known that Köhler and Wertheimer were musical (and Köhler, like Stumpf before him, was an expert on sound perception) but it is important to point out many of the faculty were recognized figures in aesthetics. Allesch published on art and aesthetics, and Hornbostel was the world authority on ethnomusicology. One cannot imagine a more fruitful training.

I need not go into detail about the brilliance of the Gestalt school in the years of the 'twenties, which has been described many times (c.f., Heider, 1983). Besides the brilliance of his teachers, one need only point out that many of Arnheim's contemporaries went on to brilliant careers in psychology, themselves, including Karl Duncker (1903-1941), Richard Meili (1901-1989), Wolfgang Metzger (1899-1979) and Hans Wallach (1904-). Almost throughout Arnheim's career, some contemporary of his was continuing to make seminal contributions to general psychology.

Arnheim's (1928) dissertation was devoted to the problem of expression (*Ausdruckspsychologie*). Matching experiments were devised by Wertheimer to test his claim that the different aspects of one person, their handwriting, their artistic work, etc. shared a "radix" and could be matched with success. The experiments also showed the effect context has on the expressive quality of any part of a configuration. The same chin, for instance, embedded in another face, can take on a completely different dynamic. The matching experiments were completed with above chance success. The study remains a classic in expression theory, and in the writings of Maurice Merleau-Ponty it is often referred to, and often anonymously, along with the experiments of Arnheim's classmate, Werner Wolff (1904-1957), as a demonstration of the epistemological reality of expressive properties.

Concurrent with his studies, Arnheim became a contributor of film reviews to Berlin weeklies (at first, *Das Stachelschwein*), publishing his first review at 21 (Diederichs, 1977). As he says, "I was twenty one when Eisenstein's *Battleship Potempkin* first sailed" (Peterson, 1972). Arnheim says he "would compose reviews in his

head as he walked home from the latest films" (Glasscock, 1989, p. 10). From 1925 to 1928 Arnheim both studied psychology and wrote for the weeklies. At twenty four, with the completion of the dissertation, he hired on as a junior editor of *Die Weltbühne*, edited by the social critics Carl von Ossietzky (1889-1938) and Kurt Tucholsky (1890-1941).

It is interesting to point out that because Arnheim's locus operandi was in journalism at this time, he was challenged much more than his fellow students by more ideological doctrines, most importantly Marxism and psychoanalysis. The hegemony of Marxism can be judged by the names of the great film and radio theorists and writers of the time, Bela Balazs, Walter Benjamin, Bertold Brecht, etc.

Arnheim did not react to this situation as an outsider but transformed it as an insider, by remaining sensitive to ideology but affirming the precedence of form. In a precocious and highly independent statement, Arnheim addressed reactions to his criticisms of the director Rene Clair. Arnheim humorously says that "the reader must now picture me as a bald dotard sitting at his desk with dreadfully thick spectacles on his nose. But after all, what are aesthetic laws if not laws of concrete effect?" (Diederichs, 1977, p. 254). Arnheim always affirmed that ideological analysis must always precede adequate formal analysis.

Arnheim's journalistic efforts culminated in his *Film als Kunst (Film as Art)*, first published in 1932, with a book cover by the artist Georgy Kepes. As the title indicates, a major part of the book was an attempt to acclimatize the public to the differences between film and reality that allowed it to be used successfully as an artistic medium. More importantly, it was one of the most rigorous attempts to see how meaning can arise from cinematographic techniques. Needless to say, the work remains a classic in film theory, and especially of the so-called era of "formalist film criticism" (Arnheim would reject the designation of formalist). While subsequent developments in film theory tended almost exclusively to the ideological side, formal analysis is once again a serious topic of research.

Soon, the Nazi threat made itself felt. An insight into Arnheim's life can be seen in the fact that in December 1930, at the premiere of the film version of Remarque's *All Quiet on the Western Front*, Nazi sympathizers let loose rats in the theaters and terrorized anyone attempting to see the anti-war film. Ossietzy responded in no uncertain terms. Immediately afterward, he wrote,

> This affair is not political and not touched by aesthetic categories. It is completely irrelevant whether the film, and the book on which it is based, are works of art. The sole

question is whether a deliberately moderate pacific way of thinking...should be continued to be permitted or not (cited in Gay, 1968).

This view supplemented Arnheim's, for within the bounds of the picture frame, we can suppose, Arnheim's imperative held (as it did, for instance, in his criticism of Chaplin's *The Great Dictator*). A work of Nazi propaganda would have to be analyzed for its formal elements, and then criticized. But outside of the frame, in the interacting world of citizens, another imperative arises.

Soon afterward, Hitler was elected chancellor and *Die Welt-bühne* was quickly put out of publication. In 1933 the racial laws were openly adapted and since many of the Gestalt psychologists were Jews, including Arnheim, they were forced with varying degrees of urgency, to consider emigration. The German Gestalt school began to fragment. Only Köhler and some students remained in Germany until the National Socialist party began to dictate the affairs of the psychological institute, and he too left. Ossietzky was eventually interred in a concentration camp and released, but because of mistreatment in the camp contracted tuberculosis and had to accept his Nobel Peace Prize in absentia and died in 1938.

Wolfgang Köhler demonstrated heroic behavior during the Nazi period (he was one of the first academics to publish an open protest against Nazi policies, and one of the few non-Jewish academics to protest at all (Henle, 1978). Nevertheless, Arnheim (1992) called von Ossietzky "the only real hero I have ever known because his heroism did not emanate from vital exuberance but was a power of the spirit in spite of a personal frailty and shyness that were quite evident at first meeting" (p. 239). Arnheim was one of the few to leave immediately. Perhaps because of his humanist training and probable mastery of Italian, he left for Rome in 1933. As he says, not yet thirty, "I left the country that had shaped my mind" (p. 240).

Rome, 1932-1939
According to Arnheim (1988), he took a home in the Alban hills outside of Rome. He became associated with the League of Nations and the International Institute for Educational Film. His friends were primarily humanists, like Guido Aristarco, Fedele d'Amico and Paolo Milano. Since at this time Arnheim's teachers were still towering figures in psychology, he must have shared in the impression that things were being left in very good hands (in 1935 Kurt Koffka published his monumental *Principles of Gestalt Psychology*). While the only Gestalt-like work in psychology was going on in the north of Italy, and in Padua more precisely, Arnheim seems to have

followed these developments at a distance, although it seems certain that he knew of the publications of Cesare Musatti (1899-1989), the premier student of Vittorio Benussi, the Graz Gestalt psychologist.

According to Mary Arnheim's bibliography deposited at the Fine Arts Library, University of Michigan, *Film als Kunst* was partially translated into Italian by Umberto Barbaro (1902-1959). Several sources refer to the fact that Barbaro and Luigi Chiarini (1900-1975) distributed Italian versions of the classic theoretical works of Balázs, Eisenstein and Pudovkin to their students at the Centro Sperimentale Cinematografico; to this list Arnheim's name must be added. The theorists of the Istituto, including Arnheim, lectured at the Centro Sperimentale Cinematografico. Arnheim (1957), in a new preface to *Film as Art* refers to these students being "hamstrung with fascism" and studying the classic silent films like "cloistered monks" (p. 23). With usual modesty he fails to note that some of these students would be the leaders of neorealismo.

Arnheim's career in Italy paralleled his career in Germany in that he devoted himself to a central book. While amidst the movie reviewing he wrote Film als Kunst, in Italy amidst his encyclopedia article writing, he wrote a parallel work on radio, titled in manuscript Rundfunk als Hörkunst. When it was finished in 1935, it was impossible to publish it in Germany, where Arnheim had since only published a few articles, sometimes under a pseudoname. Instead, the manuscript was delivered to England and translated by Herbert Read as *Radio: An Art of Sound* (1936). The original German was not published until 1979, two years after a reprint of the book on film.

In 1937, the to-be-famous movie production center, *Cinecittà*, was dedicated by Mussolini, and the journal *Bianco e Nero* was launched. The following year Arnheim (1938/1957) contributed one of his most important works, "Nuovo Laocoonte" [New Laocoon] in which he developed a lengthy argument about the rules according to which composite works of art can be made, and thereby invalidated the talking film as a "hybrid form".

In 1938 the *Enciclopedia del Cinema*, including many entries by Arnheim, was in page proofs when Mussolini withdrew from the League of Nations. This meant that the Encliclopedia would never be published (In the 'fifties some articles were translated by Arnheim and published in English, and then in the 'seventies with the aid of Helmut Diederichs some were published in the original German). At this time Mussolini also finally adopted the racial laws of Germany; thus Arnheim would be forced to leave. From this time, Arnheim (1988) recalls a meeting with the art historian Horst Janson, who had then come to Rome. Arnheim expressed his misgivings about the inevitable move to America (misgivings which he would later recognize in the diaries of the painter Max

Beckmann). Arnheim does not know whether or not he would have stayed in Italy without Mussolini's action, though he admits "The intensely intellectual provincialism of a Mediterranean setting limited to a minor, though magnificently endowed language would have exerted its influence" (p, 241).

Arnheim did not visit Italy again until 1947. At that time, according to his friend Fedele d'Amico (Garau, 1989a), a private screening of the film, *Ladri di biciclette*, by the former student of the Centro Sperimentale Cinematografico, de Sica, was arranged. Arnheim admired the film, and said so to de Sica. Afterwards, de Sica took d'Amico aside and said, "Ma questo Arnheim, chi'è?" ("Who is this man Arnheim?"). Even though Arnheim lectured the students, he does not seem to have known them personally.

Thereafter, Arnheim occasionally contributed to Italian film journals and the Italian film specialists received with interest his book, *Art and Visual Perception* (1954) (and especially the chapter on "Movement") which was translated by the Trieste philosopher Gillo Dorfles. Arnheim did begin to recognize, however, that much of the most important research done in perception was being done in Italy in relative obscurity. Arnheim, with his perfect Italian, eventually began to correspond with these scientists, most importantly Gaetano Kanizsa (1913-1993) (to whom he became especially close) and Fabio Metelli (1907-1987), and made use of their work when it was almost unknown in America (this is approvingly noted by Dorfles in his Italian preface to the second edition of *Art and Visual Perception*).

Perhaps with their broader, humanist training the Italians seemed particularly receptive to Arnheim. If one compares Arnheim's Italian and American *Festschriften*, one can see this fact (Garau, 1989b; Henle, 1976). The American contributions are of a wide variety and made by contemporaries and friends, while the Italian contributions are made almost exclusively by psychologists and some by the younger generation who may not have known Arnheim at all. At the honorary meeting organized by the painter Augusto Garau (the papers of which became the Italian Festschrift), Arnheim for the first time assembled with Kanizsa and Metelli. As he said, being in Italy was like his "casa propria" (own home).

London, 1939-1940

Arnheim, apparently, tried to go first to America but because of immigration quotas went to London for the interim. Herbert Read sponsored his coming to England. Upon arriving in England, Arnheim also received aid from his sister, Leni, and her husband the art historian Kurt Badt, both of whom had already fled Germany. Another sister, Mary Arnheim, was also in England and married to the photographer John Gay.

Arnheim recalls that at this time he became a translator for the Overseas Broadcasting Company, London, providing live written translations from English into German for the radio announcers (Arnheim, 1988). He says, "Our biggest challenge was translating Winston Churchill because the better the writer, the harder the translation" (Glasscock, 1989).

In conversation, Arnheim has indicated that with his brother-in-law, Kurt Badt, he worked on a German translation of Dante's *Divina Commedia (Divine Comedy)*. Years later Arnheim (1970/1986) contributed an essay on Dante to Badt's Festschrift with the inscription, "In dankbarer Erinnerung an gemeinsame Dantestudien während des Krieges in London" (p. 56). The two no doubt also visited the great museums in London. When, in an essay on the theory of art history, Arnheim (1992) says, "I owe the late Dr. Badt many of my most decisive experiences of art," we can imagine these visits (p. 234).

New York, 1940-1969

In 1940, with the procurement of the proper visa, "Arnheim traveled from England to New York on a passenger ship blacked out to escape detection by Nazi submarines and planes" (Glasscock, 1989). In New York, he was able to rejoin his teacher, Wertheimer, who had come to New York in 1934 after fleeing from Prague. Wertheimer established a home in New Rochelle which was known as a haven for regufees.

Wertheimer was then professor of psychology on the Graduate Faculty at the newly created New School for Social Research, or "University in Exile," and Arnheim was invited to join the faculty as well. In Italy, Arnheim shifted from journalism to a more academic lifestyle. Now, in America, it seemed the transformation was complete. Recall that Arnheim had never bothered to become habilitiert, and complete a second dissertation that would have enabled him to teach in German universities. But Arnheim's dissertation, as well as two recognized books and volume of essays, already made him an established figure in psychology, and he began the life of an American academic.

Almost immediately (1941), Arnheim received a Rockefeller Fellowship to work for the Office of Radio Research at Columbia University, which it funded. In consultation with its director, the Vienna-trained sociologist, Paul Lazarsfeld, he decided to work on an analysis of the radio "soap opera," and he proceeded by analyzing the content of plots, producing a classic work (Arnheim, 1944). It is interesting to note that the philosopher Theodor Adorno (1903-1969) had just left when the funding for the music project had run out in Spring 1939, and he went to California to rejoin Horkheimer. Neither Adorno nor Arnheim ever addressed the

158

other's work, but Arnheim shared Adorno's (1969) view that "[Walter] Benjamin [took] an all too positive attitude toward cultural industry, due to its technological potentialities" (p. 342). It is also interesting to note that Lazarsfeld had been generally disappointed with Adorno's contributions, but was very pleased with Arnheim's (Lazarsfeld, 1969).

The radio project concluded, in a way, the phase of Arnheim's life that had begun in 1925 with his first film reviews. He had by then spent almost two decades on problems of new media and, aside from the dissertation, had scarcely touched in publications more traditional questions of psychology and art. I already mentioned that while in Italy, the affairs of Gestalt psychology were "in good hands," and it is reasonable to say that this had at least reflection on the general psychology of art. Wertheimer, we must recall, was still lecturing on the subject at the New School and while Koffka had suddenly died at the age of 55 (in 1941) he had contributed an application of Gestalt psychology, "Problems in the psychology of art," that was on the cutting edge of psychological aesthetics (Koffka, 1940). It was only with Wertheimer's death two years later (in 1943) that Arnheim took up the subject full time. At that time, Arnheim (1989b) delivered a memorial address for Wertheimer, and recalls Wertheimer's friend of many years, Albert Einstein, sitting in the first row.

Now Arnheim planned in earnest to produce a work on the implications of Gestalt psychology for art. Toward this, he was awarded a two-year fellowship from the Guggenheim foundation. The first indication of this was in a work entitled "Gestalt and art," published in the newly founded *Journal of Aesthetics and Art Criticism* in 1943. As Arnheim (1954/1974) later wrote in the "Introduction" to *Art and Visual Perception*:

> In the course of my work I was driven to the conclusion that the tools then available in the psychology of perception were inadequate for dealing with some of the more important visual problems in the arts. Instead of writing the book I had planned, I therefore undertook a number of specific studies, mainly in the areas of space, expression and movement, designed to fill some of the gaps (p. 9).

These 'studies' became the professional papers, "Perceptual abstraction and art," "The gestalt theory of expression" and "Perceptual and aesthetic aspects of the movement response" (Arnheim, 1966). The kind of book Arnheim perhaps could have written earlier is easily seen in Georgy Kepes' *Language of Vision* (1944), which was a straightforward application of Gestalt principles to art.

159

(One may also look to some of the papers of Ivy Campbell, who applied Gestalt psychology to art). But he waited.

It is perhaps at this point that something should be said of Arnheim's meeting with the philosopher Ananda Coomaraswamy, which also may have contributed to the unity of his views. One of the authors Arnheim came upon by accident in America was Coomaraswamy, who was then curator at the Boston Museum of Art. Coomaraswamy's traditional or "normal" view of art seemed to provide a historical and philosophical complement to the psychological theory he was then constructing. Arnheim then traveled to Boston to meet Coomaraswamy and speak to him. The meeting seemed to cement Arnheim's confidence in what he was undertaking and it is the present author's conviction that this is what led Gestalt psychology (at least in Arnheim's mind) back to a philosophical basis that had been severed with psychology's emancipation from philosophy.

In 1943 Arnheim also became a faculty member of Sarah Lawrence College in Bronxville, New York; an undergraduate institution, it complemented his position at the New School. He would remain at Sarah Lawrence until 1968. At this time, Sarah Lawrence was an exciting place. Bessie Schoenberg taught dance, and Arnheim's perfect contemporary, Joseph Campell (1904-1987) taught mythology. With Campbell, Arnheim was able to probe deeper into questions of Ananda Coomaraswamy's traditional philosophy of art, with which he had been recently acquainted.

In 1950 Arnheim made another attempt at a Gestalt psychology of art with the award of a Rockefeller Fellowship. Of course, by this time the "preliminary studies" already mentioned had been completed so Arnheim finally began the work, which he says he wrote essentially in one long sitting. According to Arnheim (1954/1974), this manuscript of what was to become Art and Visual Perception was read completely by the art educator Henry Schaefer-Simmern (1896-197?), the art historian Meyer Schapiro, and the psychologist Hans Wallach. This provided perspectives of art education, art history and psychology by three world class experts. Arnheim published pieces of the manuscript as essays in aesthetic journals and then the work finally appeared in 1954, with the subtitle, *A Psychology for the Creative Eye*.

In 1959, Arnheim was awarded a Fulbright Fellowship to teach in Japan for the academic year. He recounts (Arnheim, 1994) that he "wanted to live for a while in a place where the arts were not confined to museums and galleries but were still needed to shape the style of daily living and objects of practical use" (p. 29). Arnheim met the leader of the folkcraft movement in Japan, Soetsu Yanagi, and must have seen Coomaraswamian principles at work. This influenced Arnheim, upon returning to the United States, to

160

formulate a 'traditional' view of art making that did not distinguish between the functional and the aesthetic (Arnheim, 1964/1966).

Even larger questions began to be developed. These centered on Arnheim's conviction of the 'intelligence of the senses,' already mentioned in his essay "Gestalt and art" (Arnheim, 1943). Now, Arnheim's ideas about the conceptual element in perception, developed in "Perceptual abstraction and art" (1966), emerged as a central problem. Arnheim wrote essays on mental imagery ("Image and thought"), constancy of form as a cognitive problem ("Constancy and abstraction") and the role of language in cognition ("What do the eyes contribute") and developed these thoughts into the manuscript of *Visual Thinking*, to be published in 1969.

The basic thesis of *Visual Thinking* is that spatially perceivable relations provide the analogies of productive thinking. The idea is already present in Wertheimer's discussions of sensible relations in *Productive Thinking* (1945). As a matter of fact, in a note included in the second edition of the work, Wertheimer (1959) writes that he hoped that his book could be supplemented by another on general thinking and another on logic. It occured to the present author that perhaps Arnheim regarded his work as a realization of Wertheimer's project. But upon Arnheim's recollection at that time (ca. 1992) he did not remember the idea of general thinking but only the logic. So it seems that Visual Thinking grew from organic concerns.

In a sense, *Visual Thinking* was the culmination of the New York years, for upon its publication Arnheim was called to Harvard University to become the first professor of the psychology of art, for which it created a title (never since refilled after his retirement). There, at age sixty five Arnheim enjoyed and continued what he had created, a psychology of art based upon general cognition and applicable to all the arts.

Cambridge, 1969-1974
In Cambridge, Arnheim's office was located in the Carpenter Center for the Arts, designed by Le Corbusier. The department was that of Visual and Environmental Studies. This indicates a drift from psychology and while Arnheim was Professor of psychology at Sarah Lawrence, he never again held a position, visiting or otherwise, in a psychology department. But he was relieved to devote himself at last completely to the psychology of art, and not general psychology.

During the appointment at Harvard, Arnheim continued to work on mental images and thinking. Recall that his essay, "Image and thought" was one of the first to seriously discuss the problems of mental images for decades, and preceded the explosion of work on such images in the early 'seventies (by Roger Shepard, etc.).

161

Another project in Cambridge was the writing of the new version of Art and Visual Perception. As Arnheim (1954/1974) writes in the preface to the book, it "ha[d] been completely rewritten" and "most of the text is new" (p. ix, x). He further said that he was not perfectly happy with the organization of the earlier edition, and that, in fact, his understanding of the problems he treated had become even clearer in the meantime.

Ann Arbor, 1974-Present

Upon retirement from Harvard, Arnheim moved to Ann Arbor, Michigan, the home town of his wife Mary. He became Walgreen visiting professor at the college of Language, Sciences and Arts at the University of Michigan and taught a large course in the Fall and a seminar on the comparative psychology of art, in the Spring. Arnheim says that many of the students who had taken the Fall course vied for places in the Winter course, for which there were only thirty openings (Glasscock, 1989).

Arnheim has spoken of his shift of approach of these years. Early he had begun with a perceptual mechanism and proceeded to illustrate it with works of art. Now with his theoretical position completed, he began with the works themselves, and proceeded to muster whatever psychological tools he could. This was a prime example of Arnheim's own 'late' style, which he at this time was elaborating with examples of painters (Arnheim, 1986).

Immediately after leaving Harvard, Arnheim was invited to deliver the Mary Duke Biddle lectures at the Cooper Union School in New York. He chose to take the opportunity to present a substantial contribution on the theory of architecture, to match the earlier books on visual art, film and radio. *Art and Visual Perception*, however, did not serve as the absolute model of what was to become *The Dynamics of Architectural Form* (1977). As he said, "the present book is less technical, less systematic. Be it because I was reluctant to recapitulate earlier explanations, or because the broader experiential range of architecture invited a different treatment, the present book is more an explorer's report on high spots of the man-made environment than the outcome of a professional analysis" (p. 7).

More importantly, it was some time earlier when Arnheim had rediscovered Theodor Lipps' *Raumästhetik* (1897). In 1966 Arnheim had written a long article on "The dynamics of shape" which signalled a new orientation. This was brought over to the study of architecture. Arnheim (1977) writes that "I have come increasingly to believe that the dynamics of shape, color, and movement is the decisive, although the least explored, factor of sensory perception, and for this reason the word 'dynamics' figures in the title of this book" (p. 7). A few years later, Arnheim

(1984/1986) would write "The dynamics of musical expression", perhaps as a further unifying gesture. As he viewed his work synoptically at this time, it is tempting to think that he did not think of perception and the arts, but rather dynamics constituting each of the individual arts (shape, architecture, music).

It is for this reason that it is not at all surprising that Arnheim's last major book, *The Power of the Center* (1982/1988), was devoted to general principles of artistic composition. While he subtitles the work, *A Study of Composition in the Visual Arts*, he claimed that its principles were quite universal, and in fact when we examine some of the papers just cited, we can see the use of the same principles. Even so, the book does introduce a new terminology of "centers" and "vectors" which, while present, is not foundational in previous writings. Thus, Arnheim called the genesis of this book a "discovery," and not merely a gradual extension of the Lippsian ideas first occurring in the 'sixties and culminating in the book on architecture.

When *The Power of the Center* was published, some critics saw it as an attack on post-structuralist aesthetics because of its provocative title and seemingly intentional neglect of the metaphysical aspects as "center" or "presence." It would be interesting to know what Arnheim must have thought of some of his structuralist colleagues (Barthes, Foucault) who, before 1968, were more or less closely allied with Gestalt theory and then went on to develop such seemingly strange theories. But it seems clear that if one really wanted to, one could use the analysis of the book to support post-structuralist theses, by showing the compositional "loss of the center" which is accompanied by the metaphysical "loss of the center" (a la Derrida). As a matter of fact, this is none too far from Hans Sedlmayr's *Die Verlust der Mitte* (1948), a famous critique of modern art by an historian to which Arnheim was sympathetic (although less so in this particular work).

Like *Art and Visual Perception*, *The Power of the Center* was issued in a New Version (1988), so that as suggested earlier in this paper, the two really do form a complementary pair. While Arnheim once intimated to a colleague that he "did not have another book in him," the Ann Arbor period was the most productive in his life. After 1988 he has published three more books, and dozens of articles.

Arnheimian Theory

While Arnheim has been widely hailed for his achievement, when one looks to the subsequent generation and, in particular, to the students whom he taught in New York and in Cambridge, Massachusetts, one sees no intact continuation of his program. With respect to these psychologists, some students, some not, like Howard

163

Gardner, John Kennedy, David Pariser, Ellen Winner, I think it can be safely said that none would call themselves "Arnheimians."

Perhaps closest has been the work of Claire Golomb who, under Marianne Simmel at Brandeis University, extended Arnheim's observations on children's art with empirical demonstrations. The fact that Golomb was not directly a student points to the possibility that perhaps psychologists of art do not beget psychologists of art but rather are dependent upon generalists from whom they expand. This would seem to be the case because the two theorists of art whose work does bear most directly on Arnheim's work were mentored by his generalist contemporaries. These are the artist Augusto Garau, a disciple of Gaetano Kanizsa (1913-1993) and author of *Color Harmonies* (1984/1993) and Max Kobbert, student of Wolfgang Metzger (1899-1979) and author of *Kunstpsychologie* (1986).

The fact that Garau and Kobbert are Europeans then points to the possibility that Arnheim's ideas, like Gestalt ideas in general, have suffered in cultural transmission from their original European context (Ash, 1992). I have already pointed to some of the differences in reception suggested by the very structure of the *Festschriften* dedicated to Arnheim. Whatever the reason, for the continuation of the idea of a "Gestalt theory of art," continued foundational work is going to have to be done to lay bare the ideas to which Arnheim has pointed, and the direction he has tried to take them.

REFERENCES

Adorno, T. (1969). Scientific experiments of a European scholar in America. In Fleming, D. & Bailyn, B. (Eds.), *The Intellectual Migration.* Cambridge: Belknap Press.

Andersen, W. (1962). A Neglected Theory of Art History. *Journal of Aesthetics and Art Criticism, 20,* pp. 389-404.

Argenton, A. (1996). *Arte e cognizione. Introduzione alla psicologia dell'arte.* Milano: Raffaello Cortina Editore.

Aristarco, G. (1951). I sistematori: Balázs e Pudovkin; Eisenstein e Arnheim. *Storia delle teoriche del film,* (Torino: Einaudi, 1951), 43-108.

Arnheim, R. (1928). Experimentell-psychologische Untersuchungen zum Ausdrucksproblem. *Psychologische Forschung, 11,* 2-132.

Arnheim, R. (1932/1957). *Film as Art.* Berkeley and Los Angeles: University of California Press.

Arnheim, R. (1936). *Radio.* London: Faber and Faber.

Arnheim, R. (1938/1957). Nuovo laocoonte. *Bianco e nero, 2,* 3-33; *Film as Art.* Berkeley and Los Angeles: University of California Press.

Arnheim, R. (1943). Gestalt and art. *Journal of Aesthetics and Art Criticism, 2,* 71-5.

Arnheim, R. (1944). The world of the daytime serial. In Lazarsfeld, P. & Stanton, F. N. (Eds.), *Radio Research 1942-43.* New York: Duell, Sloan and Pearce.

Arnheim, R. (1947). Foreward. In Alfred Mendel, *Personality in Handwriting* (pp. 11-15). New York: Stephen Daye Press.

Arnheim, R. (1948). Psychological notes on the poetical process," in Charles D. Abbott (ed.), *Poets at Work* (pp. 138-159). New York: Harcourt, Brace and World.

Arnheim, R. (1948). review of Renato May, *Il Languaggio del Film, Journal of Aesthetics and Art Criticism, 7,* pp. 158-160.

Arnheim, R. (1950). Second thoughts of a psychologist. In Taylor, H. (Ed.). *Essays in Teaching* (pp. 77-95), New York: Harper.

Arnheim, R. (1952). review of James J. Gibson. *The Perception of the Visual World, Journal of Aesthetics and Art Criticism, 11,* 172-3.

Arnheim, R. (1962a). *Picasso's Guernica: Genesis of a Painting.* Berkeley and Los Angeles: University of California Press.

Arnheim, R. (1962b). What do the eyes contribute? *Audio-Visual Communication Review, 10,* 10-21.

Arnheim, R. (1965). Image and thought. In Kepes, G. (Ed.), *Sign, Image, Symbol.* (pp. 62-77). New York: Braziller.

165

Arnheim, R. (1966). *Toward a Psychology of Art*. Berkeley and Los Angeles: University of California Press.

Arnheim, R. (1966a). Art today and the film. *Art Journal, 25*, 242-244.

Arnheim, R. (1966b). Inside and outside of architecture: a symposium. *Journal of Aesthetics and Art Criticism, 25*, 3-15.

Arnheim, R. (1966c). The dynamics of shape. *Design Quarterly, 42*, 1-32.

Arnheim, R. (1968). Comments and discussion on a symposium: from perceiving to performing, an aspect of cognitive growth," *Ontario Journal of Educational Research* 10 (1968): 203-207.

Arnheim, R. (1969). *Visual Thinking*, Berkeley and Los Angeles: University of California Press.

Arnheim, R. (1970/1986). Notes on the imagery of Dante's Purgatorio. *New Essays on the Psychology of Art*. Berkeley and Los Angeles: University of California Press.

Arnheim, R. (1970). review of Rhoda Khellogg, *Analyzing Children's Art, Harvard Educational Review, 20*, 135-7.

Arnheim, R. (1970). review of Richard Wollheim, *Art and its Objects*, in *The Art Bulletin*, 471-3.

Arnheim, R. (1971). *Entropy and Art: an Essay on Disorder and Order*. Berkeley and Los Angeles: University of California Press.

Arnheim, R. (1971a). Introduction. *Film as Art*. Berkeley and Las Angeles: University of California Press.

Arnheim, R. (1971b). Review of R. A. Durr, *Poetic Vision and the Psychadelic Experience*, in *Contemporary Psychology, 16*, p. 461.

Arnheim, R. (1974). *Art and Visual Perception: A Psychology of the Creative Eye*, New Version. Berkeley and Los Angeles: University of California Press.

Arnheim, R. (1974a). 'Gestalt' misapplied. *Contemporary Psychology, 19*, 570.

Arnheim, R. (1974b). Introduction. In Claire Golomb, *Young Children's Sculpture and Drawing: A Study in Representational Development* (pp. xvii-xiv). Cambridge, Mass.: Harvard University Press.

Arnheim, R. (1974c). Snippets and seeds. *Salmagundi*, no. 25, 77-80.

Arnheim, R. (1975). Anwedungen gestalttheoretischer Prinzipien auf die Kunst. In Ertel, S.; Kemmler, L. & Stadler, M. (Eds.). *Gestalttheorie in der modernen Psychologie* (pp. 278-84). Darmstadt: Steinkopf.

Arnheim, R. (1975a). From Contrast to Assimilation: in Art and in the Eye. *Leonardo, 8*, 270-1.

Arnheim, R. (1976). Visual aspects of concrete poetry. In Strelka, J. (ed.), *Yearbook of Comparative Criticism* (pp. 91-109). Philadelphia: Pennsylvania State University Press, shortened and slightly altered as "Language, image, and concrete poetry," in Arnheim (1986).

Arnheim, R. (1977). *The Dynamics of Architectural Form*, (Berkeley and Los Angeles: University of California Press.

Arnheim, R. (1977a). The art of psychotics. *Art Psychotherapy, 4*, 113-20.

Arnheim, R. (1977b). Musings of a reader. *Art Psychotherapy, 4*, 11-14.

Arnheim, R. (1977c). Perception of perspective space from different viewing points. *Leonardo, 10*, 283-288.

Arnheim, R. (1977d). Thoughts on durability: architecture as an affirmation of confidence, *American Institute of Architecture Journal*, 1977, b, *66*, 48-50.

Arnheim, R. (1978). Notes on creative invention. In Sekler, E. & Curtis, W. (Eds.). *Le Corbusier at Work: The Genesis of the Carpenter Center for the Visual Arts* (pp. 261-66). Cambridge: Harvard University Press.

Arnheim, R. (1978). Spatial aspects of graphological expression. *Visible Language, 12*, 163-9.

Arnheim, R. (1979/1972). *Rundfunk als Hörkunst*. Carl Hanser Verlag; translated by Herbert Read as *Radio: An Art of Sound*. New York: Da Capo.

Arnheim, R. (1979a). Art, poetry, and retardation. *Art Psychotherapy, 6*, pp. 205-211.

Arnheim, R. (1979b). Some comments on J. J. Gibson's approach to picture perception. *Leonardo, 12*, 121-122.

Arnheim, R. (1980). review of Francis Pockman Hawkins, *The Logic of Action: Young Children at Work, Canadian Journal of Art Educational Research, 6*, 183-4.

Arnheim, R. (1981). Review of Irmgard Bartenieff and Dori Lewis, *Body Movement: Coping with the Environment*, in *The Arts in Psychotherapy, 8*, 245-8.

Arnheim, R. (1982a). Foreword. In Winner, E. *Invented Worlds: The Psychology of the Arts* (pp. v-vii). Cambridge, Mass.: Harvard University Press.

Arnheim, R. (1982b). Review of Shawn McNiff, *The Arts and Psychotherapy*, in *The Arts is Psychotherapy, 9*, 297-8.

Arnheim, R. (1984). For Margaret Naumberg, *The Arts in Psychotherapy, 11*, pp. 9-12.

Arnheim. R. (1984). Gestalt psychology. In Corsini, R. (Ed.). *Encyclopedia of Psychology* (pp. 58-60). New York: John Wiley & Sons.

Arnheim, R. (1984/1994). Prefazione. In Garau, A. *Le Armonie del Colore*. Milano: Feltrinelli; Eng. trans., Preface. In Garau, A. *Color Harmonies*. Chicago: University of Chicago Press.

Arnheim, R. (1986). *New Essays on the Psychology of Art*. Berkeley and Los Angeles: University of California Press.

Arnheim, R. (1986a). A stricture on space and time. In *New Essays on the Psychology of Art*, Berkeley and Los Angeles: University of California Press.

Arnheim, R. (1986b). Prägnanz and its discontents. *Gestalt Theory*, 9, 102-107.

Arnheim, R. (1986c). The trouble with wholes and parts. *New Ideas in Psychology*, 4, 281-284.

Arnheim, R. (1987). Progress in color composition. *Leonardo*, 20, 165-168 (review of Augusto Garau, *Le Armonie del Colore*).

Arnheim, R. (1987a). The state of the art in perception. *Leonardo*, 20, 305-307 (review of Peter Dodwell & Terry Caelli (eds.), *Figural Synthesis*).

Arnheim, R. (1988). *The Power of the Center: A Study of Composition in the Visual Arts*. new version. Berkeley and Los Angeles: University of California Press.

Arnheim, R. (1988a). Confessions of a Maverick. *Salmagundi*, no. 78-9, 44-53.

Arnheim, R. (1988b). Visual Dynamics. *American Scientist* 76 (1988): 585-592.

Arnheim, R. (1989a). *Parables of Sunlight*. Berkeley and Los Angeles: University of California Press.

Arnheim, R. (1989b). Max Wertheimer. *Psychological Research*, 51, 45-46.

Arnheim, R. (1991). The dynamics of problem solving. *Gestalt Theory*, 13, 215-9.

Arnheim, R. (1992). *To the Rescue of Art: Twenty-Six Essays*. Berkeley and Los Angeles: University of California Press.

Arnheim, R. (1992a). Review of Seymour Sarason, *The Challenge of Art to Psychology*, (New Haven: Yale University Press, 1991), *Leonardo*, 25, 98-9.

Arnheim, R. (21 November 1992b). Letter to the author.

Arnheim, R. (1993). From pleasure to contemplation, *Journal of Aesthetics and Art Criticism*, 52, 195-7.

Arnheim, R. (1993b). Sketching and the psychology of design, *Design Issues*, 9, 15-19.

Arnheim, R. (1994). The way of the crafts, *Design Issues*, 10, 29-35.

Arnheim, R. (1996). *The Split and the Structure: Twenty-Eight Essays*. Berkeley and Los Angeles: University of California Press.

168

Arnheim, R. (1997). *Film Essays and Criticism*. Madison: University of Wisconsin Press.

Arnheim, R. (1998). Wolfgang Köhler and Gestalt Theory: An English Translation of Köhler's Introduction to *Die physischen Gestalten* for Philosophers and Biologists. *History of Psychology, 1*, 21-26.

Asch, S. (1952). *Social Psychology*. Englewood Cliffs: Prentice-Hall.

Ash, M. (1992). Cultural contexts and scientific change in psychology: Kurt Lewin in Iowa. *American Psychologist, 47*, 198-207.

Ash, M. (1995). *Gestalt Psychology in German Culture, 1890-1967: Holism and the Quest for Objectivity*. New York: Cambridge University Press.

Baumgartner, G. (1990). Where do visual signals become a perception? In Eccles, J. C. & Creutfeldt, Eds. *The Principles of Design and Operation of the Brain* (pp. 99-114). Berlin: Springer.

Baxandall, M. (1972). *Painting and Experience in Fifteenth Century Italy*. Oxford: Clarendon.

Beardsley, B. (1979). The role of psychological explanation in aesthetics. In Fisher, J. (ed.), *Perceiving Artworks* (185-212). Philadelphia: Temple University Press.

Beghi, L., Vicario, G. & Zanforlin, M. (1982). The perceptual centre of visual configurations. *Atti e Memorie dell'Accademia Patavina di Scienze, Lettere ed arti* 95, 133-48.

Berry, J.W. (1987). The comparative study of cognitive abilities. In Irvine, S.H. & Newstead, S. (eds.), *Intelligence and Cognition: Contemporary Frames of Reference*, (pp. 393-420). Dordrecht: Nijhoff.

Berry, J. W. (1993). An ecological approach to understanding cognition across cultures. In Altarriba, J. *Cognition and culture: A cross-cultural approach to cognitive psychology* (pp. 361-375). Amsterdam, Netherlands: North-Holland/Elsevier Science Publishers.

Berry, J. W. (1996). A cultural ecology of cognition. In Dennis, I. & Tapsfield, P. *Human abilities: Their nature and measurement*, (pp. 19-37). Mahwah: Erlbaum.

Bischof, N. (1966). Erkenntnistheorie Grundlagenprobleme der Wahrnehmungspsychologie. In Metzger, W., Ed. *Handbuch der Psychologie*, vol. I, *Wahrnehmung und Bewusstsein* (pp. 21-71). Göttingen: C. J. Hogrefe.

Bonauito, P., Bartoli, G. & A. Giannini (Eds.). (1994). *Contributi di psicologia dell'arte e dell'esperienza estetica*. Roma: Psicologia.

169

Bordwell, D. (1989). *Making Meaning: Inference and Rhetoric in the Interpretation of Cinema*. Cambridge: Harvard University Press.

Bozzi, P. (1990). *Fisica Ingenua*. Bologna: Mulino.

Bozzi, P. & Vicario, P. (1960). Due fattori di unificazione fra note musicali: la vicinanza temporale e la vicinanza tonale. *Rivista di Psicologia, 54*, 235-58.

Britsch, G. (1926). *Theorie der bildenden Kunst*, edited by Egon Kornmann. Munich: F. Bruckmann.

Britsch, G. (1981). *Schriften*, edited by Wilhelm Menning and Karina Türr. Berlin: Gebr. Mann Verlag.

Brown, J. F. (1936). *Psychology and the Social Order: An Introduction to the Dynamic Study of Social Fields*. New York: McGraw-Hill.

Brown, J. F. (1937). Psychoanalysis, topological psychology and experimental psychopathology. *Psychoanalytic Quarterly, 6*, 227-37.

Brown, J. F. (1940). *The Psychodynamics of Abnormal Behavior*. New York: McGraw-Hill.

Bruner, J. (1973). The Course of Cognitive Growth. In Anglin, J. (Ed.). *Beyond the Information Given* (pp. 325-51). New York, Wiley.

Bühler, K. (1930/1990). *Sprachtheorie: Die Darstellungsfunktion der Sprache*, (Jena, 1930) translated as *Theory of Language: The Representational Function of Language*, (Amsterdam: J. Benjamins, 1990).

Bulgakowa, O. (1992). Kurt Lewin und Sergeij Eisenstein. In Schönpflug, W. (Ed.). *Kurt Lewin: Person, Werk, Umfeld*. New York: Peter Lang.

Carroll, N. (1988). *Philosophical Problems with Classical Film Theories*. New York: Columbia University Press.

Ceraso, J. (1985). Unit formation in perception and memory. In Bower, G. (Ed.). *The Psychology of Learning and Memory* (pp. 179-210). New York: Academic Press.

Ceraso, J.& Provitera, A. (1971). Sources of error in syllogistic reasoning. Cognitive Psychology, 2,

Cesa-Bianchi, M. (1989). Approcio fenomenologia e psicologia dell'ambiente: aspetti teoretici e di ricerca. In Garau, A. (Ed.). *Pensiero e Visione in Rudolf Arnheim* (pp. 55-68). Milano: Angeli.

Child, I. (1962). *A Study of Esthetic Judgment*. New Haven: Yale.

Clark, H. & Clark, E. (1977). *Psychology and Language: An Introduction to Psycholinguistics*. New York: Harcourt Brace Jovanovich, 1977.

Croft, D., & Thagard, P. (2002). Dynamic imagery: A computational model of motion and visual analogy. In L. Magnani

and N. Nersessian (Eds.), Model-based reasoning: Science, technology, values. New York: Kluwer/Plenum, 259-274.

Crozier, W. R., & Greenhalgh, P. (1992). The Empathy Principle: Towards a Model for the Psychology of Art. *Journal for the Theory of Social Behaviour* 22 (1992): 63-79.

Cutting, J. (1986). *Perception with an Eye for Motion.* Cambridge: MIT Press.

Davi, M. (1989). Il centro percettivo di figure piane. *Giornale Italiano di Psicologia* 16, 45-60.

De Rivera, J. (1977). A Structural Theory of the Emotions. *Psychological Issues, 10,* 1-178.

De Rivera, J. & Grinkis, C. (1986). Emotions as Social Relationships. *Motivation and Emotion, 19,* 351-69.

Desimone, R. (1991). Face-selective cells in the temporal cortex of monkeys. *Journal of Cognitive Neuroscience, 3,*1-7.

Diederichs, H. (Ed). (1977). *Kritiken und Aufstze zum Film.* Munich: Carl Hanser Verlag.

Dinnerstein, D. (1971). Adaptation level and structural interaction. In Appley, M. H. (Ed.). *Adaptation Level Theory* (pp. 81-93). New York: Academic Press.

Dodwell, P. & Caelli, T. (1984). *Figural Synthesis.* Hillsdale: Erlbaum.

Dreyfus, H. (1972). *What Computers Can't Do: A Critique of Artificial Reason.* New York: Harper & Row.

_____. (1992). *What Computers Still Can't Do: A Critique of Artifiicial Reason.* Cambridge: MIT Press.

Dudley, A. (1978). Rudolf Arnheim, *The Major Film Theories: An Introduction* (pp. 27-41). London: Oxford University Press.

Duhm, E. (1959). Entwicklung und Differenzierung. In Thomae, H. (ed.), *Handbuch der Psychologie,* vol. 3, *Entwicklungspsychologie* (pp. 220-39), Göttingen: C. J. Hogrefe.

Duncker, K. (1935/1972). *Zum Psychologie des produktiven Denkens.* Berlin: Springer; Eng. trans., *On Problem-Solving.* Westport, Ct.: Greenwood Press.

Duncker, K. (1941). On pleasure, emotion and striving, *Philosophy and Phenomenological Research,* 1941, *1,* pp. 391-430.

Epstein, W. (1964). Experimental investigations of the genesis of visual space perception. *Psychological Bulletin, 61,* 115-28.

Epstein, W. (1977). What are the prospects of a higher-order stimulus theory of perception? *Scandinavian Journal of Psychology, 18,* 164-171.

Epstein, W. (1982). Percept-percept couplings, *Perception, 11,* 75-83.

Epstein, W. (1988). Has the time come to rehabilitate gestalt theory? *Psychological Research, 50*, 69-74.

Epstein, W. (1993). The representational stance in perceptual theory. *Perception and Psychophysics, 52.*

Epstein, W. (1995). 'Why do things look as they do?' What Koffka might have said to Gibson, Marr, and Rock. In R. Casati (Ed.), *Gestalt Psychology: Its Origins, Foundations, and Influence*. Florence: Olschky.

Epstein, W. & Hatfield, G. (1994): Gestalt Psychology and the Philosophy of Mind. *Philosophical Psychology, 7*, 163-181.

Epstein, W., & Park, J. (1964). Examination of Gibson's psychophysical hypothesis. *Psychological Bulletin, 62*, 180-96.

Eriksson, E. S. (1970). A field theory of visual illusions. *British Journal of Psychology, 61*, 451-66.

Ertel, S. (1964). "Die emotionale Natur des "semantischen" Raumes. *Psychologische Forschung* 28: 1-32.

Ertel, S. (1969). *Psychophonetik: Untersuchungen über Lautsymbolik und Motivation*. Göttingen, C. J. Hogrefe.

Flavell, J. & Draguns, J. (1957). A microgenetic approach to perception and thought. *Psychological Bulletin, 54*, 197-217.

Fraisse, P. (1975). Is rhythm a gestalt? In S. Ertel, L. Kemmler & M. Stadler (Eds). *Gestalttheorie in der modernen Psychologie* (pp. 227-80). Darmstadt: Wissenschaftliche Buchgesellschaft.

Friend, R, Rafferty, Y. & Bramel, D. (1990). A puzzling misinterpretation of the Asch 'conformity' study. *European Journal of Social Psychology, 20*, 29-44.

Freud, S. (1908/1985). Creative Writers and Day-Dreaming. *Art and Literature* (pp. 129-141), Volume 14, *The Penguin Freud Library*. Harmondsworth: Penguin Books.

Garau, A. (1984/1994). *Le Armonie del Colore*. Milano: Feltrinelli; Eng. trans., *Color Harmonies*. Chicago: University of Chicago Press.

Garau, A. (1989a). Intervista di Augusto Garau a Fedele D'Amico. In Garau, A. (Ed.), *Pensiero e Visione in Rudolf Arnheim* (pp. 69-75). Milano: Franco Angeli.

Garau, A. (Ed.). (1989b), *Pensiero e Visione in Rudolf Arnheim*. Milano: Franco Angeli.

Gardner, H. (1980). *Artful Scribbles: The Significance of Children's Drawings*. New York: Basic Books.

Gay, P. (1968). *Weimar Culture: The Outsider as Insider*. New York: Harper.

Georgopoulos, A., Lorito, J., Petrides, M., Schwartz, A. & Massey, J. (1989). Mental rotation of the neuronal population vector. *Science, 243*, 234-236.

Gerbino, W. (1983). *La Percezione*. Bologna: Il Mulino.

Gibson, E. (1969). *Principles of Perceptual Learning and Development*. New York: Appleton-Century-Crofts.

Gibson, J. J. & Gibson, E. (1955). Perceptual Learning: Differentiation or Enrichment? *Psychological Review, 62*, 32-41.

Gibson, J. J., (1979). *The Ecological Approach to Visual Perception*. New York: Houghton-Mifflin.

Gilchrist, A. (1990). Developments in the Gestalt Theory of Lightness Perception. In Rock, I. (Ed.). *The Legacy of Solomon Asch*. Hillsdale: Erlbaum.

Glasscock, C. S. (1989, February). Rudolf Arnheim. *Michigan Today*, 8-10.

Glicksohn, J. (1994). Putting interaction theory to the empirical test: Some promising results. *Pragmatics & Cognition, 2*, 223-235.

Glicksohn, J. & Goodblatt, C. (1993). Metaphor and Gestalt: Interaction Theory Revisited. *Poetics Today, 14*, 83-97.

Glicksohn, J. & Yafe, T. (1998). Physiognomic perception and metaphoric thinking in young children. *Metaphor and Symbol*, 13, 179-204.

Goldmeier, E. (1982). *The Memory Trace: Its Transformations and Its Fate*. Hillsdale: Erlbaum.

Goldstein, K. & Scheerer, M. (1941). Abstract and concrete behavior. *Psychological Monographs, 53*, no. 239.

Goldstein, K. (1940). *Human Nature*. Cambridge, Ma.: Harvard University Press.

Golomb, C. (1974). *Young Children's Sculpture and Drawing: A Study in Representational Development*. Cambridge, Mass.: Harvard University Press.

Golomb, C. (1992). *The Child's Creation of a Pictorial World*. Berkeley and Los Angeles: University of California Press.

Golomb, C. (1993). Rudolf Arnheim and the psychology of child art. *Journal of Aesthetic Education, 27*, 11-29.

Gombrich, E. H. (1960). *Art and Illusion*. New York: Pantheon.

Goodnow, J. (1972). Rules and repertoires, rituals and tricks of the trade. In Farnham-Diggery, S. (Ed.). *Information Processing in Children*. New York: Wiley.

Graumann, C. F. (1959). Aktualgenese. *Zeitschrift für experimentelle und angewandte Psychologie, 6*.

Grodal, T. (1997). *Moving Pictures: A New Theory of Film Genres, Feelings and Cognition*, Oxford: Clarendon.

Gruber, H. (1989). The evolving systems approach to creativity. In Wallace, D. & Gruber, H. (Eds.). *Creative People at Work* (pp. 3-24). New York: Oxford University Press.

Handel, S. (1989). *Listening: An Introduction to the Perception of Auditory Events*. Cambridge: MIT Press.

173

Hatfield, G. & Epstein, W. (1985). The status of the minimal principle in the theoretical analysis of visual perception. *Psychological Bulletin, 97*, 155-186.

Heider, F. & Simmel, M. (1944). A study of apparent behavior. *American Journal of Psychology, 57*, 243-59.

Heider, F. (1958/1982). *The Psychology of Interpersonal Relations.* Hillsdale: Erlbaum.

Heider, F. (1967). On social cognition. *American Psychologist, 22*, 25-31.

Heider, F. (1960). The gestalt theory of motivation. In Marshall Jones, M (Ed.). *Nebraska Symposium on Motivation* (145-71). Lincoln: University of Nebraska Press.

Heider, F. (1983). *The Life of a Psychologist.* Lawrence: University of Kansas Press.

Henle, M. (1955). Some Effects of Motivational Processes on Cognition. *Psychological Review, 62*, 423-32.

Henle, M. (1978, October). One man against the Nazis – Wolfgang Köhler. *American Psychologist*, 939-44.

Henle, M. (1984). Isomorphism: setting the record straight. *Psychological Research, 46*, 317-327.

Henle, M. (1986). Gestalt psychology and gestalt therapy. In *1879 and All That.* New York: Columbia University Press.

Henle, M. (1990). Some neo-gestalt psychologies and their relation to gestalt psychology. In Rock, I. (Ed.). *The Legacy of Solomon Asch* (pp. 279-91). Hillsdale: Erlbaum.

Henle, M. (Ed.) (1961). *Documents of Gestalt Psychology.* Berkeley and Los Angeles: University of California Press.

Henle, M. (Ed.). (1976). *Vision and Artefact.* New York: Springer.

Herrnstein Smith, B. (1968). *Poetic Closure: A Study of How Poems End.* Chicago: University of Chicago Press.

Hochberg, J. (1981). Levels of perceptual organization. In Kubovy, M. & Pomerantz, J. R. (Eds.). *Perceptual Organization.* Hillsdale: Erlbaum.

Holenstein, R. (1976). *Roman Jakobson's Approach to Language: Phenomenological Structuralism.* Bloomington: Indiana University Press.

Hornbostel, E. M. von. (1926). Das räumliche Hören. Bethe, A. (ed.). *Handbuch der normalen und pathologischen Physiologie* (pp. 602-18). Berlin: Springer.

Hornbostel, E. M. von. (1927). Laut und Sinn. In *Festschrift Meinhof:Sprachwissenschaft und andere Studien* (pp. 239-48). Hamburg: Kommisionsverlag von L. Friederichsen.

Hornbostel, E. M. von. (1939). The Unity of the Senses. In Ellis, W. D. (ed.). *A Source Book of Gestalt Psychology.* London: Kegan Paul, Trench, Trubner.

174

Hornbostel, E. M. von, (1975). *Hornbostel Opera Omnia.* Wachsmann, K. P. Christensen, D. & Reinecke, H. P. (eds.). The Hague: Mouton.

Huber, K. (1923). *Der Ausdruck musikalischer Elementarmotive: Eine experimentelle-psychologische Untersuchung.* Leipzig: J. A. Barth.

Huttenlocher, J. (1968). Constructing spatial images: a strategy in reasoning. Psychological Review, 75, 550-560.

Ingarden, R. (1931/1973). *Das literarische Kunstwerk: Eine Untersuchung aus dem Grenzgebiet der Ontologie, Logik und Literaturwissenschaft.* Halle: Max Niemeyer; translated by George Grabowicz as *The Literary Work of Art.* Evanston: Northwestern University Press.

Jacobs, D. (1984). Interview with Rudolf Arnheim. *Exposure, 23,* 15-19.

Jaffe, J. S. (1954). The expressive meaning of a dance. *Journal of Aesthetics and Art Criticism, 12,* 518-21.

Jahoda, G. (1997). *Images of Savages: Ancient Roots of Modern Prejudice in Modern Culture.* London: Routledge.

Jakobson, R. & Waugh, L. (1979). *The Sound Shape of Language.* Cambridge, Mass.: Harvard University Press.

Jakobson, R. (1941/1968). *Child Language, Aphasia and Phonologial Universals.* The Hague: Mouton.

Jakobson, R. (1981). *Selected Writings,* vol. III, *Poetry of Grammar and Grammar of Poetry.* The Hague: Mouton.

Jameson, D. (1989). Color in the Hands of the Artist and Eyes of the Beholder. *Color Research and Application, 14,* 284-92.

Jameson, D. & Hurvich, L. (1975). From Contrast to Assimilation: in Art and in the Eye. *Leonardo, 8,* 125-131.

Johansson, G. (1975). Visual motion perception. *Scientific American, 232,* 76-88.

Jansson, G. Bergström, S.S., & Epstein, W. (1994). (Eds.). *Perceiving Events and Objects.* Hillsdale: Erlbaum.

Johnson-Laird, P. N. (1998). Imagery, Visualization, and Thinking. In Hochberg, J. (Ed.). *Perception and Cognition at Century's End* (pp. 441-467). San Diego: Academic Press.

Kanizsa, G., Legrenzi, P., & Meazzini, P. (1975). *I processi cognitivi.* Bologna: Il Mulino.

Kanizsa, G. (1979). The polarization of gamma movement. In *Organization in Vision* (pp. 113-34). New York: Praeger.

Kanizsa, G. (1984). Vedere e pensare. *Ricerche di Psicologia, 8,* pp. 7-42.

Kanizsa, G. & Luccio, R. (1987). Höffding's Often Forgotten but Never Refuted Argument. *Gestalt Theory.*

Kanizsa, G., Vicario, G. Eds. (1968). *Ricerche sperimentale sulla percezione,* (Trieste: Universitá degli Studi.

175

Karsten, A. & Lewin, K. (1928/1976). Psychische Sättigung. *Psychologische Forschung*, *10*, 142-254; Eng. trans., Mental satiation. In De Rivera, J. (Ed.). *Field Theory as Human Science* (pp. 151-207). New York: Gardner Press.

Kennedy, J. M. (1980). A Commentary on Rudolf Arnheim's Approach to Art and Visual Perception. *Leonardo*, *13*, 117-22.

Kennedy, J. M. (1985). Arnheim, Gestalt Theory and Pictures. *Visual Arts Research, 11*, 23-44.

Kennedy, J.M. (1990). Metaphor: Its intellectual basis. *Metaphor and Symbolic Activity*, 5, 115-123.

Kepes, G. (1944). *Language of Vision*. Chicago: Theobald.

Klintman, H. (1984). Original thinking and ambiguous figure reversal rates. *Bulletin of the Psychonomic Society, 22*, 129-31.

Knauff, M. & Johnson-Laird, P. N. (2000). Visual and spatial representations in spatial reasoning. In *Proceedings of the Twenty-second Annual Conference of the Cognitive Science Society* (759-765). Mahwah, NJ: Lawrence Erlbaum Associates.

Kobbert, M. (1986). *Kunstpsychologie – Kunstwerk, Künstler und Betrachter*. Darmstadt: Wissenschaftliche Buchgesellschaft.

Koffka, K. (1909). *Experimental-Untersuchungen zur Lehre von Rhythmus*. Leipzig.

Koffka, K. (1925/1931). *Die Grundlagen der psychischen Entwicklung*. Osterwieck; Eng. trans., *The Growth of the Mind*. New York: Harcourt Brace and Company.

Koffka, K. (1927). On the structure of the unconscious. In Dummer, E. S. (ed.). *The Unconscious: A Symposium* (pp. 43-68). New York: Alfred A. Knopf.

Koffka, K. (1935). *The Principles of Gestalt Psychology*. New York: Harcourt, Brace and Company.

Koffka, K. (1940). Problems in the Psychology of Art. In Bernheimer, R., et al. (Eds.). *Art: a Bryn Mawr symposium* (pp. 180-273). Bryn Mawr: Bryn Mawr College.

Koffka, K. (1942). The art of the actor as a psychological problem. *American Scholar, 11*, 315-26.

Kogan, N., Connor, K., Gross, A., Fava, D. (1980). Understanding visual metaphor; developmental and individual differences. *Monographs of the Society for Research in Child Development, 45*,1 Serial n.183.

Köhler, W. (1915). Akustische Untersuchungen. *Zeitschrift für Psychologie, 72*, 1-192.

Köhler, W. (1920). *Die physischen Gestalten in Ruhe und im stationären Zustand*. Braunschweig: Friedr. Viewig & Sohn.

Köhler, W. (1923). Tonpsychologie. In Alexander, G. & Marburg, O. (eds.), *Handbuch der Neurologie und des Ohres* (pp. 419-64), vol. I, Berlin and Vienna: Urban and Schwarzenberg.

Köhler, W. (1927). *Intelligenzprüfungen an Menschenaffen*, Eng. trans., *The Mentality of Apes*. London: Routledge and Kegan Paul.

Köhler, W. (1938). *The Place of Value in a World of Facts*. New York: Liveright.

Köhler, W. (1940). *Dynamics in Psychology*. New York: Liveright.

Köhler, W. (1941). On the nature of associations. *Proceedings of the American Philosophical Society, 84*, 489-502.

Köhler, W. (1947). *Gestalt Psychology*. New York: Liveright.

Köhler, W. (1950). Psychology and Evolution. *Acta Psychologica, 7*, 288-97.

Köhler, W. (1958). The present situation in brain physiology. *American Psychologist, 13*, 150-154.

Köhler, W. (1959). Gestalt psychology today. *American Psychologist, 14*, 727-734.

Köhler, W. (1967). Gestalt psychology. *Psychologische Forschung, 31*, xviii-xxx.

Köhler, W. (1971). Unsolved problems in the study of figural after-effects. In Henle, M. (ed.), *Selected Papers of Wolfgang Köhler* (pp. 274-302). New York: Liveright.

Köhler, W. & Wallach, H. (1944). Figural After-Effects: An Investigation of Visual Processes. *Proceedings of the American Philosophical Society, 88*, 269-357.

Kornmann, E. (1931). *Die Theorie von Gustaf Britsch als Grundlage der Kunstlerziehung*. Düsseldorf.

Kornmann, E. (1962). *Grundprinzipien bildnerischer Gestaltung*. Ratingen: Henn.

Kosslyn, S. (1994). *Image and Brain: The Resolution of the Imagery Debate*. Cambridge: MIT Press.

Kosslyn, S. (1995). Mental imagery. In Kosslyn, S. & Osherson, D. Eds. *Visual Cognition: An Invitation to Cognitive Science*, vol. II (pp. 267-296). Cambridge: MIT Press.

Kruse, P. & Stadler, M. (1990). Stability and instability in cognitive systems: multistability, suggestion, and psychomatic interaction. In Haken, H. & Stadler, M. (eds.). *Synergetics of Cognition* (pp. 201-15). Berlin and Heidelberg: Springer.

Kubovy, M. (1986). *The Psychology of Perspective and Renaissance Art*. Cambridge: Cambridge University Press.

Kubovy, M. & Van Valkenburg, D. (2001). Auditory and visual objects. *Cognition, 80*, 97-126.

La Meri, (1964). *The Gesture Language of the Hindu Dance*. New York: Blom.

Langer, J. (1969). *Theories of Development*. New York: Holt, Rinehart and Winston.

Langer, J. (1988). A Note on the Comparative Psychology of Mental Development. In Strauss, S. (Ed.). *Ontogeny, Phylogeny, and Historical Development*. Norwood, N.J.: Ablex Publishing.

Langfeld, H. (1920). *The Aesthetic Attitude*. New York, Harcourt, Brace and Howe.

Larson, S. (1993). On Rudolf Arnheim's contribtion to music theory, *Journal of Aesthetic Education, 27*, 97-104.

Lashley, K., Chow, K. & Semmes, J. (1951). An Examination of the Electric Field Theory of Cerebral Integration. *Psychological Review, 58*, 123-136.

Lazarsfeld, P. (1969). An episode in the history of social research: a memoir. In Fleming, D. & Bailyn, B. (Eds.), *The Intellectual Migration* (pp. 270-337). Cambridge: Belknap Press.

Legrenzi, P. (1975). *Forma e contenuto dei processi cognitivi*. Bologna: Il Mulino.

Lehar, S. (1999). Computational Implications of Gestalt Theory II: A Directed Diffusion to Model Collinear Illusory Contour Formation. http://cns-alumni.bu.edu/pub/slehar/webstuff/orivar/

Lehar, S. (2003). Gestalt isomorphism and the primacy of subjective conscious experience: A Gestalt bubble model. *Behavioral and Brain Sciences, 26*, 375-444.

Lehrdal, F. & Jackendoff, R. (1983). *A Generative Theory of Tonal Music*. Cambridge: MIT Press.

Lewin, K. (1926). *Der Begriff der Genese in Physik, Biologie und Entwicklungsgeschichte. Eine Untersuchung zur vergleichenden Wissenschaftslehre*. Berlin: J. Springer.

Lewin, K. (1937). Psychoanalysis and topological psychology. *Bulletin of the Menninger Clinic, 1*, 202-11.

Lewin, K. (1951). Regression, Retrogression and Development. In Cartwright, D. (Ed.). *Field Theory in Human Science*. New York: Harper.

Leyton, M. (1992). *Symmetry, Causality, Mind*. Cambridge: MIT Press.

Lipps, T. (1897). *Raumästhetik und geometrisch-optische Tuschungen*. Leipzig: Barth.

Luchins, A. (1942). Mechanization in problem solving: the effect of 'Einstellung.' *Psychological Monographs, 54*, no. 248.

Luchins, A. (1951). An evaluation of current criticism of gestalt psychological work on perception, *Psychological Review, 58*, 69-95.

Luchins, A. (1959). *Rigidity of Behavior: A Variational Approach to the Effect of Einstellung*. Eugene: University of Oregon Press.

Luchins, A. & Luchins, E. (1978). *Revisiting Wertheimer's Seminars, vol. II, Problems of Social Psychology*. Lewisburg: Bucknell University Press.

Luterotti, S. W. (1968). Analisi sperimentale di alcuni fattori di organizzazione percettiva. In Kanizsa, G. and Vicario, G. (eds.). *Ricerche sperimentale sulla percezione* (pp. 299-327), Trieste: Università degli Studi.

Lynch, K. (1954). The form of cities. *Scientific American, 190*, 54-63.

Lynch, K. (1960). *The Image of the City*. Cambridge: M.I.T. Press.

Mach, E. (1985). *Die Analyse der Empfindungen und das Verhältnis des Physischen zum Psychoschen*. Darmstadt: Wiss. Buchgesellschaft.

Maier, N. R. F., (1970). *Problem Solving and Creativity in Individuals and Groups*. Belmont: Brooks.

Mandelbaum, M. (1960). Determinism and Moral Responsibility. *Ethics, 70*, 204-219.

Mandelbaum, M. (1969). *The Phenomenology of Moral Experience*. Baltimore: Johns Hopkins University Press.

Mandelbaum, M. (1971). *History, Man and Reason: A Study in Nineteenth Century Thought*. Baltimore: Johns Hopkins University Press.

Mandelbaum, M. (1984). *Philosophy, History and the Sciences: Selected Critical Essays*. Baltimore: Johns Hopkins University Press.

Mandelbaum, M. (1987). *Purpose and Necessity in Social Theory*. Baltimore: Johns Hopkins University Press.

Marks, L. (1978). *The Unity of the Senses*. New York: Academic.

Massironi, M. (2002). *The Psychology of Graphic Images: Seeing, Drawing, Communicating* (Mahwah: Lawrence Erlbaum Associates.

May, R. (1947). *Il Languaggio del Film*. Milano: Poligono Società Editrice.

McGuinness, D., Pribram, K. H., & Pirnazar, M. (1990). Upstaging the stage model. In C. N. Alexander & E. J. Langer (ed.). *Higher Stages of Human Development* (pp. 97-113). New York: Oxford.

McNiff, S. (1975). On art therapy: a conversation with Rudolf Arnheim. *Art Psychotherapy, 2*, 195-202.

McNiff, S. (1981). *The Arts and Psychotherapy*. Springfield, Ill.: Charles C. Thomas.

Messaris, P. (1994). *Visual Literacy: Image, Mind, & Reality*. Boulder: Westview Press.

Metzger, W. (1941). *Psychologie*. Darmstadt: Dietrich Steinkopff.

Metzger, W. (1953). Sehen, Hören und Tasten in der Lehre von der Gestalt. *Schweizerische Zeitschrift für Psychologie, 13*, 188-98.

Metzger, W. (1960). Ist die Gestalttheorie überholt? Fortsetzung eines Gespräches mit P. R. Hofstätter. In Weinhandl, F. (ed.), *Gestalthaftes Sehen* (pp. 279-91). Darmstadt: Wissenschaftliche Buchgesellschaft.

Metzger, W. (1962). *Schöpferische Freiheit*. Frankfurt: Kramer.

Metzger, W. (1975). *Gesetze des Sehens*. Frankfurt am Main, Kramer.

Meyer, L. (1956). *Emotion and Meaning in Music*. Chicago: University of Chicago Press.

Michotte, A. (1963). *The Perception of Causality*. New York: Basic Books.

Mitchell. W. J. T., (1980). Spatial form in literature. In W. J. T. Mitchell (ed.), *The Language of Images* (pp. 271-99). Chicago: University of Chicago Press.

Mulligan, K. (1988). On structure: Bühler's linguistic and psychological examples. In Achem Eschbach (ed.), *Karl Bühler's Theory of Language* (pp. 203-25). Amsterdam: John Benjamins.

Murray, David. (1995). *Gestalt Psychology and the Cognitive Revolution*. Wheatsheaf Books.

Musatti, C. (1931). Forma e assimilazione. *Archivio italiano di psicologia, 9*, 61-156.

Newman, E. (1934). Versuche über das Gamma-Phänomen. *Psychologische Forschung, 19*, 102-21.

Osgood, C., Suci, G. & Tannenbaum, P. (1957). *The Measurement of Meaning*. Urbana, University of Illinois Press.

Osgood, C., May, W., & Miron, M. (1975). *Cross Cultural Universals of Affective Meaning*, Urbana: University of Illinois Press.

Østergaard, S. (1996). Aestetikkens Dynamik. *Almen Semiotik* 11/12.

Pächt, O. (1960). Art Historians and Art Critics VI: Alois Riegl. *Burlington Magazine, 105*, 188-193.

Pariser, D. (1981). Nadia's drawings: theorizing about an autistic child's phenomenal ability. *Studies in Art Education, 22*, 20-31.

Pastore, N. (1956). An examination of an aspect of the thesis that perception is learned. *Psychological Review, 63*, 309-16.

_____. (1960). Perceiving as innately determined. *Journal of Genetic Psychology, 96*, 93-99.

Peabody, Dean and Goldberg, Lewis R. (1989). Some Determinants of Factor Structures from Personality Trait Descriptors.

Journal of Personality and Social Psychology, 57 (3): 552-567.

Pennington, B. Wallach, L. & Wallach, M. (1980). Nonconserver's use and understanding of number and arithmetic. *Genetic Psychology Monographs, 101,* 231-43.

Perkins, D. (1986). Gestalt is alive and well and living in information-processing land. *New Ideas in Psychology, 4,* 295-299.

Peterson, J. R. (1972, June). Eyes have they, but they see not. A conversation with Rudolf Arnheim about a generation that has lost touch with its senses. *Psychology Today,* 55-59, 92-98.

Petitot, J. (1985). *Les catastrophes de la parole.* Paris: Maloine.

Petitot, J-M., Roy, B., Pachoud and F. J. Varela, eds. (1998). *Naturalizing Phenomenology: Issues in Contemporary Phenomenology and Cognitive Science.* Palo Alto: Stanford University Press.

Piaget, J., & Inhelder, B. (1956). *The Child's Conception of Space.* New York: Harcourt, Brace.

Pizzo Russo, L. (1983). Conversazione con Rudolf Arnheim. *Aesthetica Preprint, 2,* 4-50.

Pizzo Russo, L. (1988). *Il disegno infantile. Storia, teoria, pratiche.* Palermo: Aesthetica edizioni.

_____. (2004). *Le arti e la psicologia.* Milan: Il Castoro.

Pratt, C. (1931). *The Meaning of Music: A Study in Psychological Aesthetics.* New York: McGraw Hill.

Pratt, C. (1956). The stability of aesthetic judgements. *Journal of Aesthetics and Art Criticism, 15,* 1-11.

Pratt, C. (1962). Tertiary qualities. *Psychologische Beiträge, 6,* 365-73.

Prentice, W. C. H. (1951). review of Gibson, J. J. (1950). *The Perception of the Visual World.* Boston. *American Journal of Psychology, 64,* 622-5.

Prentice, W. C. H. (1956): 'Functionalism' in Perception. *Psychological Review, 63,* 29-38.

Prentice, W. C. H. (1959). The systematic psychology of Wolfgang Köhler. In S. Koch (Ed.). Psychology: A study of a science. Volume 1. New York, McGraw-Hill.

Pribram, K. (1971). *Languages of the Brain.* Englewood Cliffs: Prentice Hall.

Pribram, K. (1984). What is iso and what is morphic in isomorphism? *Psychological Research, 46,* 329-32.

Proffitt, D. R. (1999). Perception: Ecological versus Inferential Approaches. In R. J. Sternberg (Ed.). *The concept of cognition.* Cambridge: MIT Press.

Rasmussen, S. E. (1959). *Experiencing Architecture.* Cambridge, Mass.: Harvard University Press.

181

Ratliff, F. (1992). *Paul Signac and Color in Neo-Impressionism.* New York: Rockefeller University Press.

Rausch, E. (1952). *Struktur und Metrik figural-optischer Wahrnehmung.* Frankfurt a. M.

Rausch, E. (1964). Einzelgegenstänlichkeit als phänomenale Eigenschaft. *Psycholgische Forschung, 28,* 33-45.

Rausch, E. (1966). Die Eigenschaftsproblem in der Gestalttheorie der Wahrnehmung. In Metzger, W. Ed. *Handbuch der Psychologie* (pp. 866-953). Göttingen: Hogrefe.

Rausch, E. (1982). *Bild und Wahrnehmung: Psychologische Studien ausgehend von Graphiken Volker Bussmanns.* Frankfurt: Verlag Waldemar Kramer.

Révész, G. (1937). Gibt es ein Hörraum? *Acta Psychologica, 3,* ??

Robertson, L. (1986). From gestalt to neo-gestalt. In Knapp, T. & Robertson, L. (eds.). *Approaches to Cognition: Contrasts and Controversies* (pp. 159-88). Hillsdale, N.J.: L. Erlbaum.

Rock, I. (1960). The current status of gestalt psychology. In Peatman, J. G. & Hartley, E. L. (eds.). *Festschrift for Gardner Murphy* (pp. 127-8).

Rock, I. (1962). A Neglected Problem in Recall: the Höffding Function. In Schrer, J. (ed.), *Theories of the Mind.* New York: Wiley.

Rock, I. (1973). *Orientation and Form.* New York: Academin Press.

Rock, I. (1990). Frame of reference. In Rock, I. (ed.), *The Legacy of Solomon Asch.* (pp. 243-68). Hillsdale, N.J.: L. Erlbaum.

Rogers, S. (1996). The horizon-ratio relation as information for relative size in pictures. *Perception and Psychophysics, 58,* 142-155.

Rosenthal, Victor (2002) Microgenesis, immediate experience and visual processes in reading. In Carsetti, A. Ed. *Seeing and thinking.* Kluver.

Rubin, E. (1921). *Visuell wahrgenomme Figuren.* Copenhagen: Gyldendals.

Saint-Martin, F. (1990). *Semiotics of Visual Language.* Bloomington: Indiana University Press.

Sakurabayashi, H. (1953). Studies in creation, IV: The meaning of prolonged inspection from the standpoint of creation. *Japanese Journal of Psychology, 23,* 207-16, 286-8.

Sambin, M. & Pinna, B. (1987). Costrutti ipotetici nella spiegazione del fenomeno figura-sfondo. In *Giornate di Studio in Ricordo di Fabio Metelli* (pp. 144-63). Padova: Università degli Studi di Padova.

Sambin, M. (1989a). Danza moderna, gestalt e tempo di una performance. In Garau, A. (ed.), *Pensiero e Visione in Rudolf Arnheim* (pp. 244-73). Milano: Franco Angeli.

Sambin, M. (1989b). Il fenomeno figura sfonda in architettura. In Savardi, U. (ed.), *Ricerche per una psicologia dell'arte.* Milano: Franco Angeli.

Savardi, U. (1999). La percezione di un centro. In Pedrazza, M. *La perdita del potere del centro. Trame di identità in una società senza confini.* Milano: Edizioni Unicopli.

Schaefer-Simmern, H. (1948). *The Unfolding of Artistic Activity.* Berkeley and Los Angeles: University of California Press.

Schaefer-Simmern, H. (1976). Basic structures in the earliest beginnings of artistic activity. In Henle, M. (ed.) *Art and Artifact* (pp. 87-94). New York: Springer.

Scheerer, E. (1994). Psychoneural isomorphism: historical background and current relevance. *Philosophical Psychology, 7,* 183-210.

Scheerer, M. (1963). Problem-solving. *Scientific American, 208,* 118-128.

Scheerer, M. & Lyons, J. (1957). Line Drawings and Matching Responses to Words. *Journal of Personality,* 251-73.

Sherif, M. (1936). *The Psychology of Social Norms.* New York: Harper.

Schufreider, G. (1985). Overpowering the center: three compositions by Mondrian. *Journal of Aesthetics and Art Criticism, 43,* 13-28.

Schulte, H. (1924/1986). Versuch einer Theorie der paranoischen Eigenbeziehung und Wahnbildung. *Psychologische Forschung, 5,* 1-23; E. Levy trans. An attempt at a theory of the paranoid ideas of reference and delusion formation. *Gestalt Theory, 7,* 231-48.

Schulz, T. (1973). Punktverschätzungen und intrafigurale Dynamik. Ein Beitrag zur Feldtheorie der Wahrnehmung. *Psychologische Beiträge, 15,* 249-290.

Sedlmayr, H. (1948). *Art in Crisis: The Lost Center* (B. Battershaw, Trans.). Chicago: H. Regnery Co.

Segall, M.H., Campbell, D.T. & Herskovits, M.J. (1966). *The Influence of Culture on Visual Perception* Bobbs-Merrill.

Simmel, M. (1972). Mime and reason: notes on the creation of the perceptual object. *Journal of Aesthetics and Art Criticism, 31,* 193-200.

Sloboda, J. A. (1985). *The Musical Mind: The Cognitive Psychology of Music.* Oxford: Oxford University Press.

Smith, B. (1988). Practices of Art. In Nyiri, J. C. & Smith, B. (eds.). *Practical Knowledge: Outlines of a Theory of Tradition and*

Skills (pp. 172-209). London, Sydney and New York: Croom Helm.

Solso, R. (1994). *Cognition and the Visual Arts*. Cambridge: MIT Press.

Sperber, D. (1982/1985) Apparently Irrational Beliefs, In S. Lukes & M. Hollis (eds.), *Rationality and Relativism* (Oxford, Blackwell, 1982). Revised version in D. Sperber (1985). *On Anthropological Knowledge*. Cambridge: Cambridge University Press.

Sperber, D. & Wilson, D. (1986/1995). *Relevance: Communication and cognition*. Oxford: Blackwell, 1986. *Second Edition,* Oxford: Blackwell 1995.

Sperry, R., Miner, N. & Myers, R. (1955). Visual Pattern perception following subpail slicing and tantalum wire implantations in the visual cortex. *Journal of Comparative and Physiological Psychology, 48*, 50-58.

Spillmann, L. & Ehrenstein, W. (2004). Gestalt factors in the Visual Neurosciences. In Chalupa, L. M. & Werner, J. S., Eds. *The Visual Neurosciences* (pp. 1573-1589). Cambridge: MIT Press.

Stadler, M. & Kruse, P. (1990). The self-organization perspective in cognition research. In Haken, H. & Stadler, M. (eds.). *Synergetics of Cognition* (pp. 32-52). Berlin and Heidelberg: Springer.

Stadler, M. & Wildgen, W. (1987). Ordnungsbildung beim Verstehen und bei der Reproduktion von Texten. *Siegener Periodicum zur Internationalen empirischen Literaturwissenschaft, 6*, 101-144.

Stadler, M., Richter, P., Pfaff, S. & Kruse, P. (1991). Attractors and perceptual field dynamics of homogeneous stimulus areas. *Psychological Research, 53*, 102-112.

Stadler, M., Stegnano, L., & Trombini, G. (1979). Quantitative Analyse der Rauschen Prägnanzaspekte. *Gestalt Theory, 1*, 39-51.

Stumpf, C. (1926). *Die Sprachlaute – experimentell-phonetische Untersuchungen.* Berlin: Springer.

Ternus, J. (1939). The problem of phenomenal identity. In W. D. Ellis (Ed.*), A source book of Gestalt psychology* (pp. 149–160). London: Routledge & Kegan Paul.

Thagard, P., & Nerb, J. (2002). Emotional gestalts: Appraisal, change, and emotional coherence. *Personality and Social Psychology Review*, 6: 274-282.

Thom, R. (1981). The Genesis of Representational Space According to Piaget. In Piattelli-Palmarini, M. (ed.). *Language and Learning* (pp. 361-8). Cambridge, Mass.: Harvard University Press.

184

Thorndike, E. L. (1935). *The Psychology of Wants, Interests, and Attitudes*. New York: D. Appleton-Century.

Tsur, R. (1977). *A Perception-oriented Theory of Metre*. Tel Aviv: Porter Institute for Poetics and Semiotics.

Tsur, R. (1992). *What Makes Sound Patterns Expressive: The Poetic Mode of Speech-Perception*. Durham: Duke University Press.

Tsur, R. (1999). Lakoff's roads not taken. *Pragmatics & Cognition, 7,* 339-360.

Tsur, R. (2000). Picture Poetry, Mannerism, and Sign Relationships. *Poetics Today, 21,* 751-781.

Usnadze, D. (1966). *The Psychology of Set*. New York: Consultants Bureau.

Verstegen, I. (1996). The Thought, Life, and Influence of Rudolf Arnheim. *Genetic, Social and General Psychological Monographs, 122,* 197-213.

Verstegen, I. (2000a). Gestalt Psychology in Italy. *Journal of the History of the Behavioral Sciences* 42 (2000): 31-42.

Verstegen, I. (2000b). Maurice Mandelbaum as a Gestalt Philosopher. *Gestalt Theory* 20 (2000): 46-58.

Verstegen, I. (2004a). Arnheim and Gombrich in Social Scientific Perspective. *Journal of the Theory of Social Behaviour, 34,* 91-102.

Verstegen, I. (2004b). Gestalt, Art History, and Nazism. *Gestalt Theory, 23.*

Verstegen, I. (2004c). Tacit Skills in the Perspective Treatise of the Late Renaissance. In Enenkel, K. & Neubehr, W. Eds. *Cognition and the Book (Intersections: Yearbook of Early Modern Studies)*. Leiden: Brill.

Vicario, G. (1978). Una gestaltista legge Neisser. In Kanizsa, G. and Legrenzi, P. Eds. *Psicologia della gestalt e psicologia cognitivista* (pp. 107-27). Bologna: Il Mulino.

Vicario, G. (1982). Some observations in the auditory field. In Beck, J. (Ed.), *Organization and Representation in Perception* (pp. 269-83). Hillsdale, N. J.: L. Erlbaum.

Wallach, H. (1949/1976). The Relation between Perception and Thinking. *Journal of Personality*; reprinted in Wallach, *On Perception*. New York: New York Times.

Wallach, M. (1988). Creativity and Talent. In Gronhaug, K. & Kaufmann, G. Eds. *Innovation: A Cross-Disciplinary Perspective*. Olso: Norwegian University Press.

Wallach, M. & Kogan, N. (1965). *Modes of Thinking in Young Children: A Study of the Creativity-Intelligence Distinction*. New York: Holt, Rinehart and Winston

185

Wallach, M. & Wallach, L. (1983). *Psychology's Sanction for Self-ishness: The Error of Egoism in Theory and Therapy*. San Francisco: W. H. Freedom.

Wallach, M. & Wallach, L. (1990). *Rethinking Goodness*. Albany: State University of New York Press.

Wapner, S., & Demick, J. (eds.), (1991). *Field-Dependence-Independence: Cognitive Style across the Life Span*. Hillsdale: Erlbaum.

Wapner, S., & Kaplan, B. (eds.), (1983). *Toward a Holistic, Developmental Psychology*. Hillsdale: Erlbaum.

Warren, W. H., Jr. (1995). Self-motion: visual perception and visual control. In Epstein, W. and Rogers, S. Eds. *Perception of Space and Motion* (pp. 263-325). New York: Academic Press.

Weiner, B. (1986). *An attributional theory of motivation and emotion*. New York: Springer-Verlag.

Werner, H. (1948). *Comparative Psychology of Mental Development*. Chicago: Follett.

Werner, H. (1978). *Developmental Processes: Heinz Werner's Selected Writings*. Barton, S. S. & Franklin, M. B. (Eds.). New York: International Universities Press.

Werner, H. and Wapner, S. (1954). Studies in physiognomic perception: I. Effect of configurational dynamics and meaning-induced sets on the position of the apparent median plane. *Journal of Psychology, 38*, 51-65.

Wertheimer, Max. (1912/1961). Experimentelle Studien über das Sehen von Bewegung. *Zeitschrift für Psychologie, 61*, 161-265; "Studies in the seeing of motion. In *Classics in Modern Psychology*, (pp. 1032-1089). New York: Philosophical Library.

Wertheimer, Max. (1923/1939). Untersuchungen zur Lehre von der Gestalt. *Psychologisch Forschung, 2*, 301-350; Laws of Organization in Perceptual Forms. In Ellis, W. (Ed.), *A Source Book of Gestalt Psychology* (pp. 71-88). New York: Humanities Press.

Wertheimer, Max. (1959). *Productive Thinking* (revised edition). New York: Harper.

Wertheimer, Michael. (1951). Hebb and Senden on the role of learning in perception. *American Journal of Psychology, 64*, 133-7.

Wertheimer, Michael. (1955). Figural after effects as measures of metabolic efficiency. *Journal of Personality, 24*, 56-73.

Wertheimer, Michael. (1958). The relation between the sound of a word and its meaning. *American Journal of Psychology, 71*, 412-5.

Wertheimer, Michael. (1961). Psychomotor coordination of auditory and visual space at birth. *Science, 134,* 1692.

Wertheimer, Michael. (1985). A Gestalt perspective on computer simulations of cognitive processes. *Computers in Human Behavior, 1,* 19 –33.

Wertheimer, Michael. & Gillie, W. M. (1958). Satiation and the rate of lapse of verbal meaning. *Journal of General Psychology, 59,* pp. 79-85.

Wildgen, W. (1982). *Catastrophe Theoretic Semantics.* Amsterdam: Benjamins.

Wildgen, W. (1992). A formal imaginistic representation of narratives. *International Journal of Communication, 2,* 180-210.

Winner, E. (1982). *Invented Worlds: The Psychology of the Arts.* Cambridge, Mass.: Harvard University Press.

Witkin, H. (1950). The nature and importance of individual differences in perception. In Bruner, J. & Krech, D. (Eds.). *Perception and Personality* (pp. 145-70). Durham: Duke University Press.

Witkin, H. (1978). *Cognitive Styles in Personal and Cultural Adaptation.* Worcester: Clark University Press.

Witkin, H.; Goodenough, D. & Oltman, P. K. (1979). Psychological Differentiation: Current Status. *Journal of Personality and Social Psychology, 37,* 1127-45.

Witkin, H. (1965). Field-dependence and forms of pathology. *Journal of Abnormal Psychology, 70,* whole no.

Witte, W. (1966). Zum problem der Bezugssystem. In Metzger, W. (Ed.), *Handbuch der Psychologie* (pp. 1003-1027). Göttingen: Hogrefe.

Wuerger, S., Shapley, R., & Rubin, N. (1996). On the visually perceived direction of motion' by Hans Wallach: 60 Years Later. *Perception, 25,* 1317-1367.

Zeki, S. (1999). *Inner Visions: An Exploration of Art and the Brain.* Oxford: Oxford.

Zimmer, A. (1986). What makes the eye intelligent? *Gestalt Theory, 8,* 256-79.

Zimmer, A. (1995). Multistability: More than just a Freak Phenomenon. In Kruse, P. & Stadler, M. (Eds.). *Ambiguity in Mind and Nature.* Berlin: Springer Verlag.

Zuckerkandl, V. (1956). *Sound and Symbol: Music and the External World* (translated by Willard Trask). New York: Pantheon Books.

Zuckerkandl, V. (1959). *The Sense of Music.* Princeton: Princeton University.

Zuckerkandl, V. (1964/1973). *Vom Musikalischen Denken.* Zurich: Rhein; translated by N. Guterman. *Sound and Symbol: Man the Musician.* Princeton: Princeton University Press.

Zuckerman, C. & Rock, I. (1957). A reappraisal of the roles of past experience and innate organizing processes in visual perception. *Psychological Bulletin, 54*, 269-96.

Zukier, H. (1982). Situational Determinants of Behavior. *Social Research, 49*, 1073-1091.

SpringerMedicine

Annette Schaub (ed.)

New Family Interventions and Associated Research in Psychiatric Disorders

Gedenkschrift in Honor of Michael J. Goldstein

2002. VI, 281 pages. 16 figures.
Softcover **EUR 39,95**
Recommended retail price.
Net-price subject to local VAT.
ISBN 3-211-83700-0

This book is dedicated to the memory of Michael J. Goldstein, one of the pioneers in psychosocial interventions in psychiatry. The structure of this book follows Goldstein's footsteps in this domain and is subdivided into family factors as well as intervention strategies for severe mental illness.

Recent research on high expressed emotion (HEE) in schizophrenia (e.g., early psychosis) and borderline disorder, patients' perspectives of HEE as well as other variables predictive for relapse in recent-onset schizophrenia are covered in this book. Family treatment strategies in schizophrenia, depression, bipolar disorder, substance use disorders and illness management programs as well as pharmacological treatment strategies are illustrated and current studies presented. The book brings together basic research and therapeutic applications stimulating further research on the complex interactional components that influence the course of psychiatric illness and on treatment designed to ameliorate the symptoms, stigma, and disability experienced by patients with severe mental illness.

SpringerWien NewYork

P.O.Box 89, Sachsenplatz 4–6, 1201 Vienna, Austria, Fax +43.1.330 24 26, books@springer.at, **springer.at**
Haberstraße 7, 69126 Heidelberg, Germany, Fax +49.6221.345-4229, SDC-bookorder@springer-sbm.com, springeronline.com
P.O. Box 2485, Secaucus, NJ 07096-2485, USA, Fax +1.201.348-4505, orders@springer-ny.com, springeronline.com
EBS, 3–13, Hongo 3-chome, Bunkyo-ku, Tokyo 113, Japan, Fax +81.3.38 18 08 64, orders@svt-ebs.co.jp
Prices are subject to change without notice. All errors and omissions excepted.

SpringerMedicine

Margherita Spagnuolo Lobb,
Nancy Amendt-Lyon (eds.)

Creative License

The Art of Gestalt Therapy

2003. XV, 312 pages. 7 figures, partly in colour.
Hardcover **EUR 60,–**
Recommended retail price.
Net-price subject to local VAT.
ISBN 3-211-83901-1

The Gestalt approach is particularly known for its broad spectrum of therapeutic interventions, including artistic materials and methods from the fine and performing arts. Creativity is a significant criterion for health, well-being and intelligence. It reflects the ability to find new solutions and promotes the flexibility required to adjust productively during critical life events. Gestalt therapy employs the term "creative adjustment" to emphasize the importance of this ability for personal and professional growth.

The book focuses on the fruitful interchange between theoretical guidelines and professional practice. A strong emphasis lies on the historical and philosophical foundations of this topic, on clinical practice and case studies, and on various fields of applications (neuroscience, developmental psychology). A solid representation of American and European theoreticians bridges a divide between continents and reflects the productive discourse among schools and "streams" of Gestalt therapy.

SpringerWien NewYork

P.O.Box 89, Sachsenplatz 4–6, 1201 Vienna, Austria, Fax +43.1.330 24 26, books@springer.at, **springer.at**
Haberstraße 7, 69126 Heidelberg, Germany, Fax +49.6221.345-4229, SDC-bookorder@springer-sbm.com, springeronline.com
P.O. Box 2485, Secaucus, NJ 07096-2485, USA, Fax +1.201.348-4505, orders@springer-ny.com, springeronline.com
EBS, 3–13, Hongo 3-chome, Bunkyo-ku, Tokyo 113, Japan, Fax +81.3.38 18 08 64, orders@svt-ebs.co.jp
Prices are subject to change without notice. All errors and omissions excepted.

SpringerMedicine

Jürgen Weber

The Judgement of the Eye

The Metamorphoses of Geometry –
One of the Sources of Visual Perception and Consciousness

2002. 203 pages. Numerous figures, partly in colour.
Softcover **EUR 29,–**
Recommended retail price.
Net-price subject to local VAT.
ISBN 3-211-83768-X

The sculptor, Jürgen Weber, whose work is to be found in many parts of the world – from Washington D.C. to Nuremberg – presents his experience of how forms convey contents. He does not ask the usual questions about perception, but rather he is concerned with how the visual world expresses information over and above its mere existence.

He brings together various disciplines ranging from psychiatry, children's drawings, comparable archaeological finds and works of art, to the observation of nature, his own experiments as an artist and surveys of thousands of his students and has thus developed a new theory of perception which also considerably extends our knowledge about threedimensional sight. There is no doubt that this book represents a unique, timely contribution to the many disciplines that are concerned with the wonder of perception. It might even influence the development of computer science.

 SpringerWien NewYork

P.O.Box 89, Sachsenplatz 4–6, 1201 Vienna, Austria, Fax +43.1.330 24 26, books@springer.at, **springer.at**
Haberstraße 7, 69126 Heidelberg, Germany, Fax +49.6221.345-4229, SDC-bookorder@springer-sbm.com, springeronline.com
P.O. Box 2485, Secaucus, NJ 07096-2485, USA, Fax +1.201.348-4505, orders@springer-ny.com, springeronline.com
EBS, 3–13, Hongo 3-chome, Bunkyo-ku, Tokyo 113, Japan, Fax +81.3.38 18 08 64, orders@svt-ebs.co.jp
Prices are subject to change without notice. All errors and omissions excepted.